!thew ~~ ~lt~ ~~lle

DIGITAL VIDEO
FOR THE DESKTOP

to
Carol
and
Tony

DIGITAL VIDEO
FOR THE DESKTOP

Ken Pender

Focal Press

Focal Press
An imprint of Butterworth-Heinemann
225 Wildwood Avenue, Woburn, MA 01801-2041
Linacre House, Jordan Hill, Oxford OX2 8DP
A division of Reed Educational and Professional Publishing Ltd

 A member of the Reed Elsevier plc group

OXFORD AUCKLAND BOSTON
JOHANNESBURG MELBOURNE NEW DELHI

First published 1999

British Library Cataloguing in Publication Data
A catalogue record for this book is available
from the British Library

ISBN 0 240 51552 8

Printed and bound in Great Britain

FOR EVERY TITLE THAT WE PUBLISH, BUTTERWORTH-HEINEMANN
WILL PAY FOR BTCV TO PLANT AND CARE FOR A TREE.

Contents

Introduction

Less than twenty years ago, when the first desktop PC's were unveiled before an unsuspecting public, few would have predicted that these inconsequential-looking machines would mark the beginning of the next major revolution in the development of mankind. Just as the machines of the Industrial Revolution irrevocably altered the lives of our forefathers, so too has the PC and its associated information technology already begun to change the way we learn, the way we work, the way we communicate and even the way we play.

Today, the PC is everywhere – in offices, factories, schools, shops, hospitals, hotels, airports and, increasingly, in our homes. The technology has fuelled its own meteoric pace, as each new innovative application has extended the market, increasing sales and attracting more developers who have introduced further new developments which have extended the market, increasing sales – and so on, in a seemingly unstoppable spiral. As competition for this burgeoning market has increased, prices have plummeted as fast as processor speeds and hard drive sizes have increased, so that today's entry level 'consumer' PC offers its purchaser power far beyond that required for typical consumer applications like games, wordprocessing and balancing the family budget.

The print and publishing media were among the first to recognise the potential of the new technology, making the transition, in only a few short years, from traditional typesetting methods, which have endured for centuries, to the new digital world of DTP, or desktop publishing. Similar quiet revolutions have been taking place in the television and film media, as these industries have applied the new technology to virtually every aspect of audiovisual editing and production, discovering along the way the exciting possibilities for digital animation and special effects.

Just as the massive commercial investment in DTP brought the price of that technology within the reach of the small, entrepreneurial publisher and then of the home user in the 1990s, so now the same trend can be seen developing in the domain of digital video. The first releases of Apple's *Quicktime* software, followed by Microsoft's *Video for Windows*, provided the basic software architecture to give desktop PC users their first tantalising glimpses of moving video pictures, accompanied by sound, on machines with only 16 MHz processors, 4 Mb of RAM and 40 Mb hard drives. The initial excitement of watching jumpy images of President John F. Kennedy delivering his famous *'Ask not what your country can do for you ... '* speech, displayed in a tiny window on the PC screen, however, was soon tempered by realisation that, compared with the processing power needed to display high quality still digital images, the demands of

high quality video are enormous. It is only now, a few years on, with the processing power of new PC's increasing in leaps and bounds and with new innovative digitising and compression hardware and software becoming available, that the early dreams of desktop video (the DTV equivalent of DTP) are beginning to become a reality.

I first discussed with Jenny Welham at Focal Press the idea of writing *Digital Desktop Video* after we had worked together on two other titles - *Digital Graphic Design* and *Digital Colour in Graphic Design* - having been struck by the convergence which appears to be taking place between the software applications required by the two disciplines. In fact the two are merging to the point where they form a continuum; any still image or special effect which can be created on the screen can be incorporated in a video sequence and, conversely, any frame of a video clip can be captured and edited as a still image. The boundary is becoming blurred even further as the techniques for digital animation and morphing, which lie behind the increasingly spectacular special effects seen in recent blockbuster films, become ever more sophisticated.

As with any new book, the first task was to consider what scope it should cover. Many readers will want to edit material recorded on videotape using one of the new low cost camcorders, the majority of which still use an analogue technology, and then output the edited results to an analogue VCR, using the PC simply as an intelligent control device. Others will want to merge original footage with other clips, adding transitions and other special video and audio effects, while some will want to create original material on the desktop for inclusion in business presentations or for use on Internet Web sites. *Digital Desktop Video* explains in simple terms how to achieve all of these objectives. While it is not possible to cover the many different hardware and software products now available for such tasks, several representative examples are described and used to explain the principles and techniques involved.

Ken Pender
(ken@kpender.freeserve.co.uk)

A brief history

1

A definitive moment in the history of the moving image was the discovery, in 1824, by the Englishman Peter Roget that, if a series of drawings of an object were made, with each one showing the object in a slightly different position, and then the drawings were viewed in rapid succession, the illusion of a moving object was created. Roget had discovered what we now call 'the persistence of vision', the property whereby the brain retains the image of an object for a finite time even after the object has been removed from the field of vision. Experimentation showed that, for the average person, this time is about a quarter of a second, therefore if the eye is presented with more than four images per second, the successive objects begin to merge into one another. As the rate increases, the perception of motion becomes progressively smoother, until, at about 24 drawings per second, the illusion is complete.

It is intriguing to consider that, had the chance evolution of the human eye not included this property, then today we would be living in a world without cinemas, TV sets or computer screens and the evolution of our society would have taken an entirely different course!

Early Cinematography

With the discovery of the photographic process in the 1840s, experimentation with a series of still photographs, in place of Roget's drawings, soon demonstrated the feasibility, in principle, of simulating real-life motion on film. During the next fifty years, various inventors experimented with a variety of ingenious contraptions as they strove to find a way of converting feasibility into practice. Among these, for example, was the technique of placing a series of posed photographs on a turning paddle wheel which was viewed through an eyehole – a technique which found a use in many *'What the butler saw'* machines in amusement arcades.

Thomas Edison (Figure 1.1) is generally credited with inventing the machine on which the movie camera was later based. Edison's invention – the Kinetoscope, patented in 1891 – used the sprocket system which was to become the standard means of transporting film through the movie camera's gate.

After several years of development, the movie camera (Figure 1.2), and the projector which was based on the same sprocket and gate mechanism, were ready for production of the first commercial silent films in the United States in 1908 (Figure 1.3). The earliest film-making activities were based on the east coast, but by 1915 Hollywood on the west coast was already emerging as film capital of the new industry and, by 1927, the Warner Brothers Hollywood studio released the first major talking film – *The Jazz Singer*, starring Al Jolson – to an enthusiastic public.

The process of recording sound on magnetic tape (Figure 1.4) was as yet unknown and the early sound films used a process known as *Vitaphone*, in which speech and music were recorded on large discs which were then synchronized with the action on the screen, sadly displacing

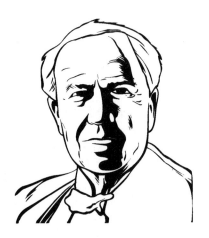

Figure 1.1 Thomas Edison

CAPTURING THE MOVING IMAGE ON CELLULOID

Movie cameras view and record more than 20 frames per second, a speed which requires a precise mechanism. Light from the subject passes through the camera lens, then a revolving, mirrored shutter and a prism are used to direct the image to the film and the viewfinder alternately. Film is advanced from reel to reel by toothed gears, which are designed to engage with its perforated edges. The camera is arranged so that each time the shutter is open, the film is still, and a new frame is recorded. When the shutter closes, the film is advanced, preparing the next frame for exposure.

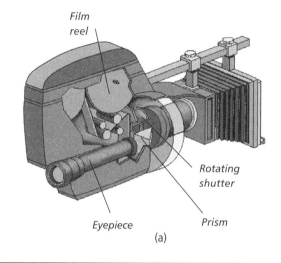

Film reel

Rotating shutter

Eyepiece

Prism

(a)

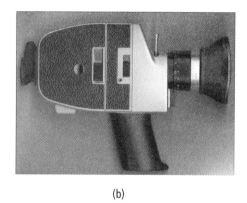

(b)

Figure 1.2 (a) Exploded view shows the basic mechanism of the movie camera based on Edison's 1891 invention. (b) A scan of the home movie camera which I bought in Vermont in 1969 and which still uses the same basic mechanism

the many piano players who had made their living by providing an imaginative musical accompaniment to the silent films.

As film audiences grew, the movie makers turned their attention to methods of filming and projecting in colour and, by 1933, the *Technicolor* process had been perfected as a commercially viable three-colour system. *Becky Sharp* was the first film produced in Technicolor, in 1935, being quickly followed by others, including one of film's all-time classics, *The Wizard of Oz*, just as war was breaking out in Europe.

While others developed the techniques which used real-life actors to portray the characters in a movie, Walt Disney pioneered the animated feature-length film, using a technique which derived directly from Roget's work nearly a hundred years earlier. Using an early form of storyboarding and more than 400,000 hand-drawn images he produced Snow White and the Seven Dwarfs (Figure 1.5), based on Grimm's fairy tale, in 1937. As we shall see later, computer animation owes much to the techniques developed by the Disney Studios over the last sixty years.

Figure 1.3 Scene from an early silent movie

SOUND RECORDING

In the direct method of mechanical recording used for the early talkies, sound waves were made to strike a very light diaphragm of metal to set it into motion. A needle attached to the diaphragm vibrated with the diaphragm. As a disc coated with wax, metallic foil or shellac moved past the needle, the needle's point cut a groove in the form of a spiral on the disc surface. This process, with minor modifications, was used for any years in the production of phonograph records.

The sound recorded was reproduced by placing the point of a stylus attached to a pick-up arm into the groove cut in the rotating disc. The vibrations of the stylus, which reproduced the vibrations of the recording diaphragm, were amplified and fed to a loudspeaker. In later audio tape recording, sound waves are amplified and recorded on a magnetised plastic tape. The information is first converted into electrical impulses, which are then impressed in the magnetised tape by an electromagnetic recording head. A playback head converts the magnetic fields on the tape into electrical impulses which are then amplified and reconverted into audible sound waves.

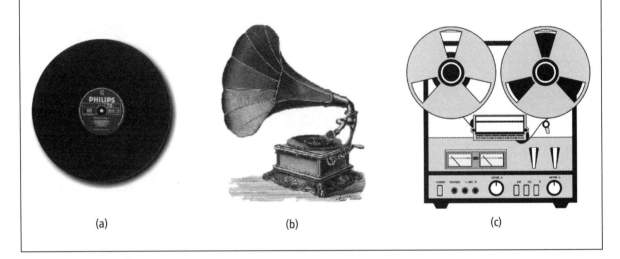

 (a) (b) (c)

Figure 1.4 (a) An old 78 rpm disc, now consigned to the museum; (b) an early phonograph and (c) a tape deck

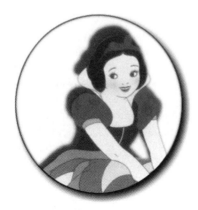

Figure 1.5 Snow White – a Disney classic

Television

The first experimental television took place in England in 1927, but it was not until the late 1940s that television began to challenge the popularity of the cinema. Unlike the movie camera, the TV camera builds up an image of a scene by sweeping a beam of electrons across the screen of camera tube (Figure 1.6). The scanning of a single image is called a field, and the horizontal and vertical scan rates are normally synchronous with the local power-line frequency. Because the world is generally divided into 50 Hz and 60 Hz electrical power frequencies, television systems use either 50 field or 60 field image-scanning rates. The television broadcasting standards now in use include 525 lines, 60 fields in North America, Japan, and other US-oriented countries, and 625 lines, 50 fields in Europe, Australia, most of Asia, Africa, and a few South American countries.

The advantage of scanning with an electron beam (Figure 1.7) is that the beam can be moved with great speed and can scan an entire picture in a small fraction of a second. The European PAL (Phase Alternate Line) system uses the 625 horizontal line standard, i.e. to build up a

Figure 1.6 (a) A TV camera. (b) The Sony camcorder – employing a CCD detection system – which I use for recording the usual family events

CAPTURING THE MOVING IMAGE ON VIDEOTAPE

The television camera resembles an ordinary photographic camera in being equipped with a lens or lenses and a means of focusing the image formed by the lens on a sensitive surface. A series of filtering mirrors splits the image into three colours, each colour falling on the sensitive surface of one of three electronic tubes called camera tubes, which have the ability to transform variations in light intensity into variations in electric charge or current.

(a)

(b)

complete 'frame' the beam scans the image 625 times as it moves from the top to the bottom, and continues to do this at a frequency of 25 frames per second. The number of picture elements in each line is determined by the frequency channels allocated to television (about 330 elements per line). The result is an image that consists of about 206,000 individual elements for the entire frame.

The television signal is a complex electromagnetic wave of voltage or current variation composed of the following parts: (1) a series of fluctuations corresponding to the fluctuations in light intensity of the picture elements being scanned; (2) a series of synchronizing pulses that lock the receiver to the same scanning rate as the transmitter; (3) an additional series of so-called blanking pulses; and (4) a frequency-modulated (FM) signal carrying the sound that accompanies the image. The first three of these elements make up the video signal. Colour television is made possible by transmitting, in addition to the brightness, or luminance, signal required for re-producing the picture in black and white, a signal called the chrominance signal, which carries the colour information. Whereas the luminance signal indicates the brightness of successive picture elements, the chrominance signal specifies the hue and saturation of the same elements. Both signals are obtained from suitable combinations of three video signals, which are delivered by the colour television camera, each corresponding to the intensity variations in the picture viewed separately through appropriate red, green, and blue filters. The combined luminance and chrominance signals are transmitted in the same manner as a simple luminance signal is transmitted by a monochrome television transmitter.

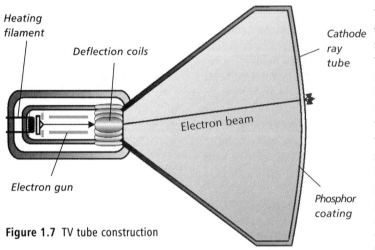

Figure 1.7 TV tube construction

Like the picture projected on to the cinema screen, the picture which appears on the domestic television screen depends upon the persistence of vision. As the three colour video signals are recovered from the luminance and chrominance signals and generate the picture's red, blue, and green components by exciting the phosphor coatings on the screen's inner surface, what the eye sees is not three fast moving dots, varying in brightness, but a natural full-frame colour image.

To prevent the flicker which can occur with a frame rate of thirty frames per second, 'interlacing' is used to send every alternate horizontal scan line 60 times a second. This means that every 1/60th of a second, the entire screen is scanned with $312\frac{1}{2}$ lines (called a field), then the alternate $312\frac{1}{2}$ lines are scanned, completing one frame, reducing flicker without doubling transmission rate or bandwidth.

Although computer monitors operate by the same principles as the television receiver, they are normally non-interlaced as the frame rate can be increased to sixty frames per second or more since increased bandwidth is not a problem in this case.

Emergence of the VCR and the camcorder

Virtually all early television was live – with original programming being televised at precisely the time that it was produced – not by choice, but because no satisfactory recording method except photographic film was available. It was possible to make a record of a show – a film shot from the screen of a studio monitor, called a kinescope recording – but, because kinescope recordings were expensive and of poor quality, almost from the inception of television broadcasting electronics engineers searched for a way to record television images on magnetic tape.

The techniques which were developed to record images on videotape were similar to those used to record sound. The first magnetic video tape recorders (VTRs) (Figure 1.8), appeared in the early 1950s, with various alternative designs evolving through the 1960s and 1970s for use in the broadcasting industry. Recorders based on the VTR technology, but using cassettes (VCRs), were developed and cost-reduced until, by the early 1980s, the VCR became a spectacularly successful new consumer product.

Figure 1.8 Early top-loading VTR

Following the market success of the VCR, consumer electronics companies now raced to miniaturise the VCR so that it could be packaged with a scaled down version of the television camera opto-electronics to create, by the late 1980s, the camcorder. Intended to be portable, the first designs were barely luggable, with power supplies packaged separately from the camera and weighing even more than it did. The public interest was aroused, however, and fierce competition for this further extension to the market, soon brought about dramatic reductions in camcorder sizes, with use of new battery technology to integrate the power supply within the camera body and adoption of a new 8 mm tape standard (Figure 1.9).

The imaging technology in amateur video cameras differs from that of studio cameras. The most recent camcorders use solid-state image sensors – usually an array of charge coupled devices (CCDs), which convert light energy into the electrical pulses that are recorded on videotape. The clarity and resolution of the videotaped pictures depend on the number of picture elements, or pixels, which the CCD array can create. The newest camcorders, made even smaller and lighter by the use of CCDs, can produce clear, detailed pictures, even in extremely dim light.

Figure 1.9 Camcorder

Since their introduction, both the °-inch and the 8 mm formats used for VCRs and camcorders have been augmented by improved versions – Super-VHS and Hi8, respectively – which can handle greater bandwidths. The result is better picture definition and detail resolution approaching that of professional video recorders.

Editing

In 1902, using an early camera based on Thomas Edison's invention, the Frenchman George Méliès discovered that, by stopping the camera in midshot and then rearranging objects in the scene before continuing to film, he could make objects 'disappear' on film. Also, by stopping and partly rewinding the film between shots, he was able to superimpose scenes or dissolve one scene into another. Méliès had inadvertently stumbled across the basic technique of film editing.

Editing in the professional domain

In the years which followed, the editing together of the hundreds of film clips, which comprise the average movie, into a smooth-flowing, rhythmic whole, became a specialized art – the art of the film editor whose job it was to supervise teams of specialists in the cutting and editing of sound tracks and film negatives. The editor's job included synchronizing the film to the sound track and providing the film director with feedback on each day's shooting by preparing daily 'rushes' for review before the next day's filming began.

Many movies are now edited on videotape and then transferred back on to film after the editing is completed. After the bulk of the photographic work is finished, the process of post-production involves the assembly of the many edited film clips to create the finished movie.

In some cases the sound editor may re-record dialogue in a studio while viewing the action on a screen (known as automated dialogue replacement), also adding further sound effects to enhance the dramatic impact of selected scenes. In parallel, the editor supervises the inclusion of special visual effects and titles which are to be inserted into the final version. In the final step of the editing process, the separate sound tracks are mixed on to one master magnetic film containing separate dialogue, music, and sound effects tracks in synchronization with the movie film.

Television programme editing borrowed heavily from the experience of film, but even with this advantage, a look back at some early BBC footage soon reveals how far the process has matured since the early broadcasts from Alexandra Palace! In spite of the significant instant playback advantage which videotape enjoyed over film, much time was still wasted in the analogue video environment, simply shuttling video tape back and forth among decks during the editing process.

Editing between decks is a linear process in which edits are created in sequential order. Linear editing is the term used to describe the process of dubbing shots from one or more tape decks to another in the precise order needed for the finished production. Video and audio maybe altered after the final production has been laid down but only if the timings do not change.

As digital technology began to emerge, at first albeit at a premium price, it quickly found its way into the professional domain, where it offered the major advantage of random access to any video frame on a

tape. While insertion of a new video segment in a tape, using traditional editing tools would require recomposition of the entire tape, which could take hours; with digital video techniques, it literally took seconds.

Called non-linear editing, the digital process involves first entering all audio and video material into a digital storage medium of some sort, e.g. a hard drive or CD ROM. Once all the shots are entered they can be called up and arranged in any order the editor or director desires. Since the shots are not rerecorded but only viewed, changes may be made in any order and at any point in the production until the desired result is achieved. The control and flexibility offered by non-linear editing undoubtedly contributes to the creativity of the editing process. Special effects, for example, are traditionally among the most expensive items to add in the traditional video editing process. Digital video editing not only made adding such effects relatively easy, it also made entirely new kinds of effects possible.

Mirroring the changes which have taken place in the publishing industry, trends toward 'digitisation' have recently accelerated in both the film and television industries, with digital technology costs falling steadily, and performance appearing to increase unabated. Although the emphasis initially was on exploiting the cost and speed advantages of digital editing, both industries were keen to explore the new and unique editing possibilities offered by the digital environment.

With hardware supporting the overlay of computer graphics on video, television was soon into visual trickery, using, for example chroma-keying to create the perfect illusion of a newsreader sitting in front of a video image seemingly projected on a screen, but with much better brightness and clarity than could ever be obtained through previous rear-projection techniques. Extension of this technique has led to the ability to create elaborate, high-tech, virtual backdrops for the staging of a range of TV shows, which would have been prohibitively expensive using traditional means.

Hollywood's use of digitally animated special effects has been even more spectacular, with box office successes like *Toy Story, Alien, The Abyss, Terminator* and *Jurassic Park*.

Editing in the private domain

As the public demonstrated their interest in Hollywood's growing output of movies, by flocking to see them in their millions, a much scaled down and simplified version of the movie camera was being developed which was to offer cinema-goers the chance to try their own hands at the skills of movie-making. I purchased my first and only cine-camera (Figure 1.2b) in Vermont in 1969, and proceeded to capture on film anything which moved – and a lot which didn't!

The long winter evenings were spent, with the aid of a shiny new Atlas-Warner manually operated home movie editor (Figure 1.10), hand cranking my series of three-minute epics through the film gate, while viewing a dim, grainy image of each frame on the editor's ground glass screen, before using the built-in splicer to connect film sections together and

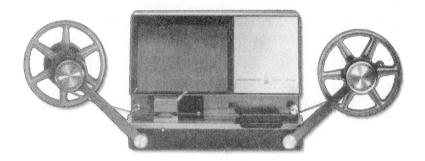

Figure 1.10 Super 8 film editor

wind them on to 400 foot reels. Given that such splicing was about as sophisticated as editing got, on the family's return to England, both camera and editor were consigned to the back of a cupboard, from which they only occasionally emerged to celebrate a new arrival to the family.

Although the low cost Super 8 camera did allow many enthusiastic home users to enter the magic world of film making, market penetration was limited because its relatively high cost per minute of developed film and its playback and other limitations. Editing was largely limited to basic insert editing – in which a sequence was physically cut out of a film and replaced by a different sequence – and assembly editing, which simply involved splicing different lengths of film to create a desired sequence. By comparison, the compact low cost camcorder has dramatically extended the possibilities for many budding video makers.

Overnight, the camcorder effectively rendered the Super 8 cine-camera obsolete. Ninety minutes of continuous recording on a low cost, reusable videotape and the ability to play back the results immediately on any convenient TV monitor made the camcorder vastly more appealing to the consumer.

Using a camcorder and VCR together, basic editing was also possible by copying just selected material in any sequence from the camcorder source tape to a VCR destination tape. For the enthusiastic amateur, simple animation effects could be added, by the crude method of setting up a scene, taking a quick shot, then adjusting the scene before the next shot and so on. Some VCRs also offered an audio dub feature which could be used to add sound retrospectively to recorded video.

As the preferred supplier of high end video editing equipment to the professional community, Sony Corporation have also responded to the interest of the consumer market in video editing, releasing products like the *Edit Studio* shown in Figure 1.11. With a camcorder, VCR and TV monitor attached to the *Edit Studio*, the user can edit the contents from various source tapes to a destination tape, as well as dubbing audio and adding simple titles, but the editor does not support more sophisticated special effects.

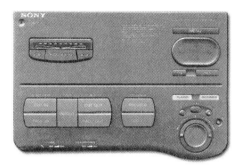

Figure 1.11 Sony's Edit Studio

Desktop video

Analogue versus digital video

An analogue device is one which uses a continuously variable physical phenomenon – such as an expanding or contracting column of mercury – to represent another dynamic phenomenon – a rising or falling temperature. Representation of time by the moving hands of a clock or of the speed of a car by the moving needle on a speedometer are other common examples of analogue devices. A digital device, by contrast, is one which employs a limited number of discrete bits of information to approximate a continuously varying quantity.

Many analogue devices have been replaced by digital devices, because digital instruments can deal better with the problem of unwanted information, or noise. The recording of sound provides a good example; on a gramophone record, any imperfections on the recording surface will be picked up by the stylus and amplified, creating unwanted noise; in the digital equivalent – the compact disc – sounds are translated into binary code, and recorded on the disc as discrete pits. Any noise which does get encoded is easily recognized and eliminated during the retranslation process.

A digital recording can also be copied many times without degradation, while the quality of analogue copies deteriorates rapidly due to the cumulative build-up of noise. Using digital video also makes it easier and far less expensive to replace and update segments of video. Using traditional methods, an entirely new videotape had to be created every time any modification to the content was needed. A digital process does have one limitation, however, in that it cannot reproduce precisely every detail of a continuous phenomenon. An analogue device, although subject to noise propagation, will produce a more complete rendering of a continuous phenomenon. The accuracy with which a digital measurement tracks the property being measured depends on the sampling rate used, i.e. the number of times per second that the changing value of the property is measured; the higher the rate, the more accurately the property is reproduced.

The monitor on the Mac or Windows PC desktop is an analogue device, using continuously varying voltages to control the position and intensity of the electron beams which excite the screen phosphors. By contrast, a digital video signal assigns a number for each deflection or intensity level. The function of the video board, or equivalent circuitry included on the motherboard, found in every Mac or PC, is to convert the computer-created digital video signal to an analogue signal for output to a monitor.

Moving video, like film, presents to the viewer a sequence of individual images, or frames, projected on a screen. Also like film, moving video relies on the phenomenon of persistence of vision, typically projecting frames at a rate of 25 to 30 frames per second, to create the illusion of a moving image. Audio tracks may be synchronized with the video frames to provide a full audiovisual presentation.

The process of importing analogue video from a VCR or a camcorder to the desktop requires that the analogue signals be digitised by processing them through an additional video digitising board, sometimes called a frame grabber or video capture board, which is normally plugged into the computer motherboard. PAL and NTSC video signals are analogue in nature and must be digitised, or sampled, via such a board, before they can be recognised by a Mac or a PC. The process of digitising video is commonly called 'capturing'. There is a growing number of video digitising boards on the market, differing widely in speed, quality, compression capability and, of course, price.

Digital recording of a video signal is very demanding in terms of disc storage, because the colour and brightness information for each pixel in every image frame must be stored. A full-screen image on a typical 14-inch computer monitor measures 640 pixels by 480 pixels. Thus, each full-screen frame of video contains 307 200 (640 x 480) pixels. Each pixel requires 24 bits, or 3 bytes, of storage (8 bits per RGB component) to describe its unique properties. Therefore, to store the information describing a full-screen, 307 200-pixel image results in a storage requirement of 921 600 bytes for *each frame* of digitized video. At a frame rate of 25 fps, storing just one second of digitized PAL video therefore requires 23 megabytes of storage space! Before today's multi-gigabyte disc drives, such use of disc space to store digitized video was not feasible for the average computer user.

Playing back stored information of such a size also requires considerable processing power to provide an acceptable frame rate. Compromise in terms of frame rate, colour depth and image resolution have, until recently, been unavoidable. Fortunately, advances in data compression technology are reducing the need for such compromises.

Image Compression

Image compression reduces the amount of storage space required to store or transmit a digital image. Because the pixel values in an image are often similar to those of adjacent pixels, an image can be compressed

by using these similarities, as it takes fewer bits to store the differences between pixels than to store the pixels themselves. Using a 'lossless' compression algorithm, which just removes redundant information, the image will reappear in exactly its original form when decompressed.

Lossless compression might be used, for example, to transmit medical X-ray images over a network, in order to reduce transmission time and cost, while ensuring no loss of clinically important detail when the image is decompressed at the receiving end.

When 'lossy' compression is used, some information is lost and, on decompression, some detail will be missing from the decompressed image. A lossy compression algorithm might be used to transmit video-conference images, where a high level of compression is needed because of the limited bandwidth of a standard telephone line and the detail in the received image is not critical.

In the case of digital video, the type and degree of compression selected depends on the hardware capabilities of the system being used and on the quality required for the output image. More information on this subject can be found in Chapter 3.

TECHNICAL DATA	
PAL Video storage on a 1Gb drive versus compression ratio	
Compression ratio	*Video stored*
1:1	*00h00m33s*
5:1	*00h02m45s*
10:1	*00h05m30s*
50:1	*00h27m30s*
100:1	*00h55m00s*

Video signal types

Video signals are normally transmitted in one of three different formats:

RGB

In RGB transmission, the video images are transmitted as three separate components – red, green and blue – on three separate cables. RGB does not specify any particular image size or frame rate; transmissions can range from standard interlaced PAL, or anything from 200 x 300 up to 2048 x 2048 pixels, interlaced or noninterlaced, with frame rates from 60 to 120 Hz. RGB just signifies that the image is sent in three parts.

Composite video

Video can also be sent in composite form which mixes all the colours together along with the sync signal, into one signal which can be carried by a single cable. The colours are encoded so that they can be reconstructed by the display device, but, because of the mixing, composite video gives a noticeably inferior picture to RGB (most consumer VCRs have composite video inputs and outputs).

S-video

A third standard, S-video, has recently emerged and is used in Hi-8 and Super-VHS VCRs and camcorders. It offers a compromise between RGB and composite video, and consists of separate chrominance (colour) and luminance (brightness) signals. Image quality is generally better than composite video, but not as good as RGB.

300 dpi

150 dpi

75 dpi

Figure 1.12 Effect of pixel density on image quality

Image resolution

The quality of a digital image can be described in terms of its image resolution – the number of picture elements, or pixels, which make up the image. This is demonstrated by comparison of the three printed images shown in Figure 1.12. The first image was scanned at a resolution of 300 dpi – i.e. as the scanner optics traversed the image 300 different points were sampled for each linear inch of travel. For the second and third images, only 150 and 75 points per inch were sampled. Comparison shows that detail is increasingly lost as the image resolution decreases.

Image resolution capability is an important parameter in the specification of a video camera's performance. Like a scanner, a video camera translates the image information which it receives through the camera lens into an array of pixels, each pixel carrying colour and brightness information about a point on the original image. Projection of this pixel information on to a screen creates a simulation of the original image and the picture quality increases with the number of pixels used to recreate the image. A resolution of 640 pixels horizontally by 480 pixels vertically is sufficient to provide acceptable full screen desktop digital video on a typical 14 inch screen. A camera capable of proportionately higher resolution will be required to provide an image of the same quality on larger screens or, alternatively, the video image can be viewed in a 640 by 480 'window' within the larger screen.

Recent trends

Over the last 10 years, as the installed base of both business and private PCs has grown by leaps and bounds, users have come to relish the freedom afforded by their shiny new possessions. Indeed, in many companies, PC usage has become a war zone as Information Systems managers have fought to retain central control of DP operations, while users have devised ever more ingenious ways of using simple PC applications to do in minutes what used to take the DP room days to deliver!

Private users are also sharing in this new age of empowerment, as they learn the skills of desktop publishing, digital drawing and photo-editing, and accessing the vast sources of information available on the Internet. Many of these users are also owners of camcorders and/or have experienced some of the many ways in which camcorders are now being used in education and in the workplace, where applications like videoconferencing have linked the two technologies together.

Moving images are, of course, not new to the desktop. With the development of Apple's QuickTime and Microsoft's AVI (Audio Video Interactive) technologies, it has been possible for some time to view short video clips in a small desktop window. Figure 1.13 shows a clip of a QuickTime MOV file playing in a window, using Apple's QuickTime *Movie Player,* while Figure 1.14 shows a clip of an AVI file playing in a window using Microsoft's simple *Media Player* application. *Movie Player* and *Media Player* can also play clips saved in other formats such as CompCore's MPG format or Autodesk's FLI or FLC animation format. Using Microsoft's

Video for Windows and Apple's *QuickTime for Windows* system utilities, video clips can be integrated into a range of Windows applications (see Chapter 9).

In addition, particularly the younger generation of users has become accustomed to the increasingly realistic looking graphics of the newest games programs.

So why has the desktop video market not already taken off? The reason is not too hard to find. Since one frame of video generally takes approximately one megabyte (Mb) of storage; and since video tape runs at 30 frames per second, one second of uncompressed video takes approximately 30 Mb of storage, and therefore the PC has to be capable of writing and reading the video data at sustained rates of 30 Mb per second. It is this hugely increased data processing demand – compared with demands of, say, a DTP or graphic design application – which has created a major roadblock, placing interactive digital video out of the reach of most users.

Fortunately, two important technology trends have been converging to help create affordable solutions for digital video editing. First, the plummeting cost of hard disc storage has led to the situation that even an entry-level PC today boasts a hard disk of a least one gigabyte (1000 Mb) capacity, making the storage of large video files feasible. Second, compression technology has developed to the point where video compression hardware and software can compress video at ratios up to 200:1 while maintaining an acceptable level of quality. This means that video can not only take up much less storage space, but can also be recorded to, and played back from, standard computer hard disks, with average read/write rates in the 500 Kb to 1.5 Mb per second range. The combination of better compression technology and inexpensive mass storage devices has paved the way for low cost digital video editing systems which offer more versatility for a few hundred pounds than their traditional counterparts costing tens of thousands of pounds!

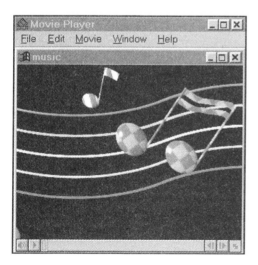

Figure 1.13 Apple's QuickTime Movie Player

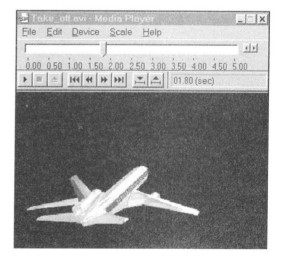

Figure 1.14 Microsoft's Media Player

Uses

So, if video on the desktop is really becoming technically possible, what can we actually do with it, apart, that is, from just marvelling at the technical wonder of it all?

In fact, potential applications range from simply cleaning up and adding titles and transitions to videocamera footage, to creating special effects for television, film, commercial presentations, teleconferences, web pages, graphic arts productions, video games and computer-based training packages. We shall look at practical examples later in the book, but at this point it is worth distinguishing between the different approaches to handling the above tasks.

Using the PC as an intelligent control device

Original video footage can run into many hours of videotape and, even using a multi-gigabyte hard drive, it is not practical to digitise and store such a volume of material. Instead, a digitising board can be used to capture the first frame of each clip on each tape to be edited. Under the control of the PC, clips from the source videos can then be rearranged and/or trimmed as required, transitions can be inserted, titles can be overlayed and then the result can be printed to a blank destination tape for viewing and distribution.

On-line video editing

On-line video editing can involve the creation and manipulation of original digital video material on disk, the import and digitisation of analogue video, or a combination of both. Once the video is in digital format, a whole battery of digital special effects and techniques can be used by the editor to alter individual frames or whole video clips. If required, the result can be output to analogue video tape, CD ROM or an Internet Web site.

Off-line video editing

The quality possible with today's on-line digital video technology is to broadcast quality video what laserjet printing is to Linotronic* printing, i.e. the quality of both is high but the difference is discernible. When a project requires the ultimate broadcast quality in the final result, pre-processing of the video can still be carried out on-line. Then, using a product like Adobe Premiere, an SMPTE timecode-compatible list, called an edit decision list (EDL) can be created at the end of the on-line process. The EDL is a record of edit decisions (which frames are to be included in the final tape and where each section should start and stop) and special effects, into a simple text file which can be read by traditional EDL readers. The final high-quality broadcast tape can then be auto-assembled at a video post-production facility, using the master tapes and the EDL produced on the PC.

(*The Linotronic is the *de facto* imagesetter employed by publishing houses to produce high quality type and graphics on film used to produce print-

ing plates at resolutions ranging to more than 3000 dpi. By comparison, laserjet printers have a resolution of typically 600 dpi).

Summary

Compared with the history of the still image, which dates back around fifteen thousand years to the cave drawings of prehistoric man, that of the moving image is very short. However the development of commercial and artistic applications of this new and exciting form of communication has been very rapid; it took only eighty-four years from Peter Roget's discovery of the persistence of vision in 1824 before the principle was adapted to enable release of the first commercial silent film in 1908. 'Talkies' followed around twenty years later, roughly coinciding with the advent of television in 1927.

The introduction of colour significantly enhanced the appeal of both media and, on both sides of the Atlantic, technical development proceeded apace to respond to growing public interest. As film and television budgets grew, investment in improved hardware and techniques led to more sophisticated and higher quality productions. The development of magnetic tape for video and audio recording and playback progressed rapidly and it was widely adopted throughout the professional domain.

Meanwhile, the Japanese skill in miniaturising electronics provided the platform needed for the development of the domestic VCR and the low cost video camera, bringing video out of the professional studio and into the home. Editing, however, remained a complex, time-consuming and expensive linear process, requiring the use sophisticated tape decks, until, as the use of desktop PCs took off, the first affordable desktop video editing applications appeared.

In the following chapters we shall look at examples of the new hardware and software which are now making desktop video a reality, at the growing range of video raw material which can be used in the creative processes, at the methods used to produce video on the desktop and at the alternative methods of publishing the results.

Milestones in the evolution of the moving image

1824 Peter Roget discovered the phenomenon of 'persistence of vision'

1840s The photographic process was developed

1877 Eadweard Muybridge used a battery of 24 cameras to record the cycle of motion of a running horse

1889 Hannibal Goodwin and George Eastman developed a form of movie file consisting of strips of high-speed emulsion mounted on strong celluloid

1891 Thomas Edison patented the Kinetoscope

1902 Using an early camera based on Thomas Edison's invention, the Frenchman George Méliès discovered the basic technique of film editing

1908 The first commercial silent film was produced

1915 Hollywood became recognised as the centre of the new film industry

1915 Work began on the American Civil War film, *The Birth of a Nation*

1925 Charlie Chaplin starred in *The Gold Rush*

1926 The Warner Brothers studio introduced the first practicable sound films, using a process known as Vitaphone, recording musical and spoken passages on large discs

1927 Warner Brothers Hollywood studio released the first major talking film – *The Jazz Singer* – starring Al Jolson

1927 The first experimental television broadcast took place in England

1933 The Technicolor process was perfected as a commercially viable three-colour system

1935 *Becky Sharp*, the first film produced in Technicolor, was released, quickly followed by *The Wizard of Oz*, one of film's all-time classics

1937 Walt Disney produced *Snow White and the Seven Dwarfs*

1950/55 The first magnetic video tape recorders (VTRs) appeared

1956 A transverse scanning system of video recording and playback, called Quadruplex, was developed

1960s Videodisks were developed as a response to the high cost of magnetic tape

1976 Apple was formed by Steven Jobs and Stephen Wozniak to market the Apple 1

1981 IBM introduced the IBM PC

1980/85 The VCR became a spectacularly successful new consumer product

1985/89 The VCR was miniaturised and packaged with a scaled down version of television camera opto-electronics to create the camcorder

2

The new desktop hardware

When I set out to write my first book on digital graphic design in 1992, the shiny new state-of-the-art machine I was using at that time sported a 50 MHz processor, a 400 Mb hard drive, 16 Mb of RAM and a graphics card which could display 16 bit colour at a resolution of 800 x 600 pixels. A few short years later, the machine I used to write *Digital Video for the Desktop* has a 400 MHz processor, an 11.3 Gb Ultra DMA hard drive, 256 Mb of SDRAM, a graphics card with 8 Mb of on-board video RAM capable of displaying 32 bit colour at resolutions greater than I could ever use, a DVD ROM drive and a 16 bit stereo sound card – all at a cost considerably less than that of its predecessor in real terms – and this machine is already looking dated and overpriced!

In the same period, digitising boards with an output quality and performance previously costing thousands of pounds, have become available for both Windows and Macintosh machines at a cost of a few hundred pounds from suppliers like FAST Electronic, Pinnacle Systems and Radius. Every week sees new 'special offers' on analogue VCRs and camcorders, which provide versatile video sources to attach to the new digitising boards. And, as if that wasn't enough, digital camcorders and affordable digital desktop flat LCD displays have joined the Christmas list!

It is this rapid advance in desktop computing and video hardware performance, coupled with rapidly falling costs, which has, almost overnight, transformed the landscape of desktop video production and editing. Just as the technology of desktop publishing has irrevocably altered the publishing industry, desktop video is set to transform the range and quality of visual communication in cinema, television and the Internet. In this chapter, we shall look at the hardware 'entrance requirements' to cross the threshold into this digital wonderland.

Hardware considerations

Before selecting hardware for a particular video editing task, it is important to consider what exactly the task objectives are. Minimum hardware requirements depend on these objectives, falling into the following categories:

○ Short video clips (e.g. animated titles for use on a Web site) can be created on a Windows PC or a Mac, using techniques to be described in Chapters 3 and 4, and saved on a hard disk without the need for special hardware

○ With the addition of a sound card and speakers, sound in the form of prerecorded audio files can be superimposed on video. A microphone and/or stereo system can be attached to the sound card to add speech or music. A midi-compliant instrument such as a keyboard can also be attached

○ By plugging a video digitising card into the PC's motherboard, footage which has been recorded on a VCR

or camcorder videotape or videodisk can be imported or 'captured' to the PC hard drive for subsequent editing. A digitising board can also be used to capture single video frames which can be included as stills – to be used 'as is' or after modification within an image editing application – in a new video sequence. Sound from the same VCR or camcorder source can be simultaneously captured to the hard disk via the PC's sound card

○ By connecting a digital video mixer board, the PC can be used as a smart controller for frame-accurate control of source and destination decks. Special cabling will be required to link the mixer board to the video source and destination

○ If the original footage is being recorded on a digital video camera then obviously no analogue to digital conversion is required, but an adapter card is still needed to transfer the video from camera to PC

○ Once the editing of a video sequence has been completed, the result can be recorded or 'burned' to a CD using a CD-R device or can be converted from digital to analogue format via the digitising card for recording to videotape in a VCR

○ A suitable modem and netvideo camera will be required if video is to be received or transmitted via the Internet

○ Either an analogue or digital camcorder or VCR can be used as an input device and the VCR will, of course, be necessary if video footage edited on the PC is to be printed to videotape. A television monitor connected either directly to the video output of a digitising card, or to the output of the VCR, is useful during video capture, preview and during output

○ Special cabling, such as switchable bidirectional Scart, will be necessary in configurations using the same deck as source and destination

Figure 2.1 shows a basic analogue videoediting configuration. Figure 2.2 shows the configuration of a system using the PC as an intelligent control device. A LANC, or Control-L driver and Smart Cable are used to control the camcorder and VCR.

Performance considerations

As we already saw in Chapter 1, video capture and playback places special demands on hardware. The following considerations should be applied when configuring a system for videoediting work.

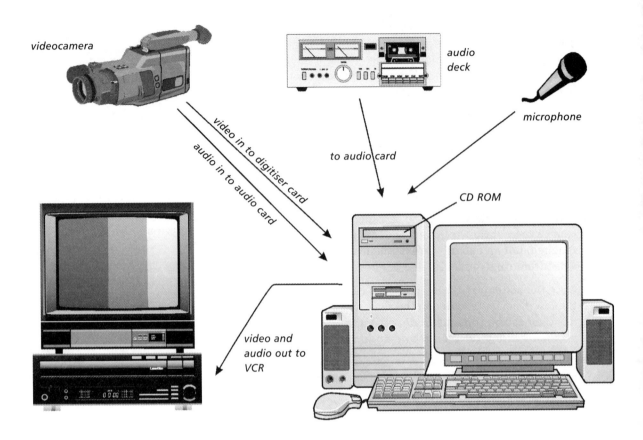

Figure 2.1 Typical videoediting
system configuration

The PC

Dealing with digital video means dealing with large volumes of
data. On older PCs or Macs with processor clock speeds around 33 MHz
this resulted in a lot of swapping of data out to disk. When processing
even a 10-minute video file, the PC has to display 15 000 images at 25
fps. Fortunately today's faster processors, with clock speeds around 400
MHz are now equal to the task.

As with processor speed, so with RAM – the more the better, since
memory is much quicker than swapping out to a temporary hard disk file;
fortunately declining memory prices have now made fast 64 Mb or even
128 Mb SDRAM modules an affordable way of juggling all that data.
Moving the data around the system has also become faster with the con-
tinuing development of the PCI bus, offering speeds of 100 MHz and
rising.

Performance of the hard drive (Figure 2.3) is particularly important
in a videoediting system, as video is fed directly to the hard disk during
the capture process. With some E-IDE and Ultra-DMA hard drives, high
video data rates can cause jitter when playing back AVI files, because the
hard drive may undergo a routine thermal recalibration while a file is

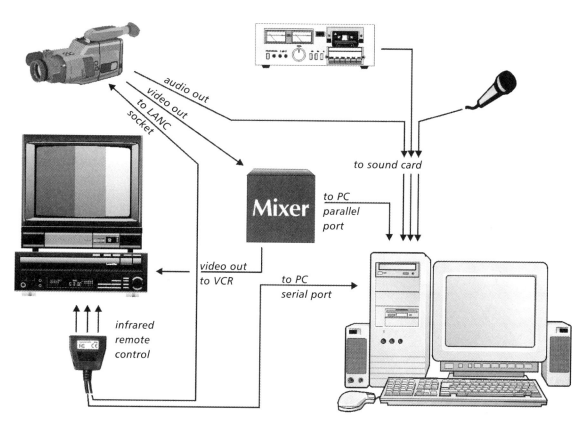

Figure 2.2 Video cutting and mixing system

being read. Improving driver design and buffering of data being processed can reduce, or even eliminate this problem, so the latest available driver should always be installed. SCSI hard drives are more expensive than E-IDE or Ultra-DMA drives, but for digital video editing they have advantages. An Ultra-Wide SCSI drive and SCSI busmaster PCI controller make an efficient combination, reducing the load on the processor. A special type of hard drive – an AV or audio-visual drive – is ideal for digital video editing as it does not interrupt data flow to carry out recalibration, so the datastream is continuous when reading or writing.

For 25 fps capture, a hard disk with an average access time of 10 milliseconds (ms) or less, and a data transfer rate of 3 Mb per second or more is recommended. Such an access time and data transfer rate are possible with drives of 5400 rpm or above. The video data transfer rate will normally be about half the data transfer rate of the drive.

Miro's *Expert* (*Ex*tended *Per*formance *Test*) utility assesses a hard disk's performance by calculating a recommended data transfer rate from the read and write speed measured for the drive. During the standard test a 20 Mb file is written to the hard disk first and then read. Figure 2.4

Figure 2.3 A fast hard drive is essential for video capture and playback

shows the *Expert* dialog box. In the example shown – a 988 Mb partition on a 7200 rpm Seagate Medalist EIDE drive – the data transfer rate is estimated at 11.4 Mb per second.

The rate depends on whether the data will be written and read on the outer sectors of the hard disk or on the inner sectors. On the outer sectors the real transfer rate is higher than on the inner sectors. The calculated value of the achievable video data rate is a reasonably accurate guide for most disk systems.

If the budget permits, then it is useful to install a second hard disk to save the complete video clips for recording and playback. During recording and playback, the operating system accesses system files. If these files are located on the same hard disk as the video clips, the head has to be repositioned, leading to one or more dropped frames. Whatever the choice of hard drive, it is important to remember to defragment it regularly, as this will make a significant difference to the drive's performance.

Redrawing the image in a video window 25 times per second puts special demands on a PC's graphic display card, but fortunately the number-crunching capability of graphics cards has improved rapidly in recent years, in line with other components. The use of bus mastering has improved performance by allowing graphics chipsets to reduce the load on the processor. PCI or AGP cards with 8 Mb of SGRAM and a RAMDAC running at 250 MHz and supporting a 32-bit colour depth at resolutions up to 1280 x 1064, with a vertical refresh rate of 85 Hz, provide an effective and affordable solution. In general, state-of-the-art DirectDraw-capable PCI graphics cards with S3 Trio 64V+ or S3 Virge graphic processors are able to support a PCI video overlay; with this feature, a video display is possible during capture and playback.

The CD-ROM drive is now almost a standard feature fitted to PC's and Macs alike and CDs providing royalty free sound clips provide a useful source of audio raw material for new audiovisual projects. Using appropriate compression, 32 speed CD-ROM drives are now fast enough to deliver full frame, full screen video to the system display; using a CD-R or CD-RW drive, completed projects can be cut to inexpensive CD blanks using an appropriate authoring application.

Figure 2.4 Miro's Expert dialog box

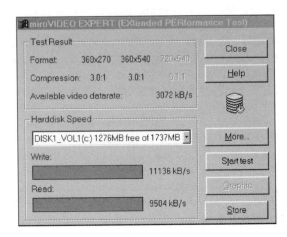

Sound system

Figure 2.5 shows Creative Labs' *16-bit Sound Blaster,* which has become almost a *de facto* standard for the PC. A few of the more expensive video digitising cards also offer onboard audio capture facilities but the majority do not, so a separate PC audio card like the *Sound Blaster* is required to capture and play back sound. The audio output from a VCR, camcorder or tapedeck can be connected to the *line in* jack socket on the sound card for recording to the hard drive. A microphone, for recording voice-over speech can be connected to the *mic in* jack socket and a MIDI instrument can be connected to the MIDI port.

Video digitising card

A video digitising card functions like a graphics card in reverse. A graphics card translates a digital image from memory into an analogue image which the system monitor can display; a video digitiser reads an analogue displayed image and converts and stores the image on disk in digital form.

In general, full-frame, 24-bit video images can only be played back in real time (that is, at normal playing speed) using hardware compression and decompression. Several video cards offer hardware compression based on the Motion JPEG format, which allows display of full-frame images at 25 frames per second. One such card is the Miro DC10 shown in Figure 2.6 – one of a series of cards from Pinnacle Systems. The DC10 offers maximum VHS image quality at data rates of up to 3 MB/s, motion-JPEG compression of up to 7:1 and PCI bus mastering including video overlay, with resolution up to 348 x 576 (PAL) and 320 x 480 (NTSC) pixels. A good

Figure 2.5 Sound Blaster AWE 64 audio card

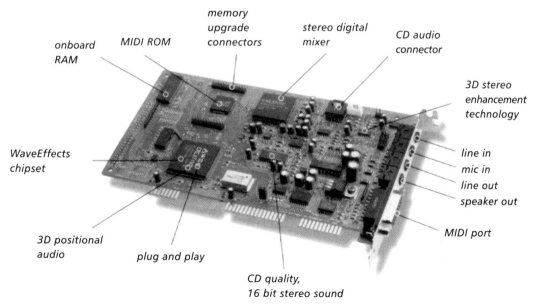

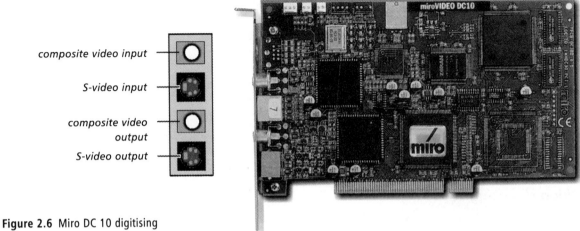

composite video input

S-video input

composite video output

S-video output

Figure 2.6 Miro DC 10 digitising card

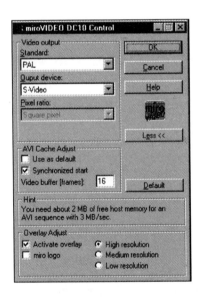

Figure 2.7 Cache size can be adjusted from within the DC10 Control dialog box

example of the range of professional entry level systems now appearing on the market, the DC10 digitises, compresses, processes, and plays back video sequences in Motion-JPEG format. When used in conjunction with a sound board, sound can digitised simultaneously, or added to video clips after they have been recorded. The card accepts input from any video source which generates a composite video signal or an S-video signal (i.e. VHS, S-VHS, Hi8, or Video 8). The provision of two input ports, one composite and one S-video (Figure 2.6), makes it possible to connect two sources in parallel, using software to switch between the two. During capture, the video image is scanned at a high colour bandwidth to produce 24-bit colour depth.

After editing, video sequences can be output in good S-VHS quality to a VCR, television, or computer monitor (the higher the quality of the video input and the higher the computer's data transfer rate, the better the output quality of the video image). The DC10 provides two output sockets for connection to a VCR and/or TV or monitor.

Bundled with the DC10, the Miro *AVI Cache* is an MCI-based driver which can be used to enhance the playback of AVI video clips in MJPG format. To ensure a non-jerky playback even at high data rates, the video and audio data are cached in RAM. When the hard disk interrupts its operation during swapping, the video clip will be temporarily taken from the RAM cache. The cache size – typically sufficient to hold 15 or 20 frames – can be adjusted from within the *DC10 Control* dialog box (Figure 2.7). A *Hint* at the bottom of the miroVIDEO DC10 Control specifies the approximate required cache size for a data rate of 3 Mb per second.

Video mixer

Video Director Studio 200 from Pinnacle Systems (Figure 2.8) is an example of an external video mixer unit which provides smart cable attachment to a video camera, a VCR and a PC, allowing intelligent and frame-accurate PC control of both the source and destination video

Figure 2.8 Video Director Studio 200 mixer

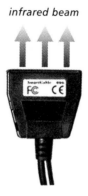

infrared beam

Figure 2.9 Video Director Studio 200 infrared transmitter

devices. When used in the configuration shown in Figure 2.2, Studio 200's features include:

○ High resolution capture of individual video frames

○ Automatic logging of whole videotapes, clip by clip

○ A storyboard for arranging clips and adding transitions

○ Controlled output to standard videotape cassettes

Control of the destination deck is effected by means of a novel infrared transmission device (Figure 2.9) which uses the same principle as a TV or VCR remote control unit. In operation, the transmitter is positioned so that it points directly at the infrared receiver on the front of the record deck (see Figure 2.2). A description of the software used with Studio 200 is included in Chapter 3.

Video cameras

Popular camcorders, like the Sony Handycam shown in Figure 1.6, provide analogue video output in either composite or S-video format; the S-video signal provides better colour saturation, sharper colour transitions and a lower background noise level. Using a camcorder as a source deck does have limitations; the tape shuttle speed is much slower than that of a conventional deck and, if used intensively, the head life is likely to be relatively short. In an intensive video editing environment, a more durable conventional deck is probably a better choice.

Camcorder audio output is available in either mono or stereo format but it is important to remember that sound takes up a considerable amount of hard disk space:

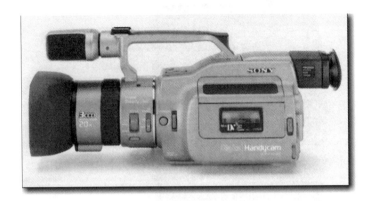

Figure 2.10 Sony's DCR-VX1000E digital video camera

O CD quality (44 kHz, 16 bit, stereo) requires about 172 Kb/sec

O Stereo quality (22 kHz, 16 bit, stereo) requires about 86 Kb/sec

O Mono quality (22 kHz, 8 bit, mono) requires about 22 Kb/sec

Recording sound also consumes considerable processor time, so when processing video associated with high quality sound, it is advisable to capture video and sound separately and then resynchronise them within a videoediting program such as those described in the next chapter.

Video cameras using the Sony DV (Digital Video) format and DV mini-cassettes provide a higher quality, but higher cost, alternative video source to analogue cameras, eliminating the need for analogue to digital conversion during capture. Avoidance of the conversion process means that there should be no picture degradation during the capture process, as the digital data is essentially being downloaded to the hard drive. Sony's cameras (Figure 2.10 shows Model DCR-VX1000E) come fitted with an IEEE 1394 Firewire adapter which is easily capable of supporting the data rates involved in the capture process.

Digital cameras offer a *Photo* mode for recording still shots and a much cleaner frame still and slow playback than is possible on analogue devices. The more expensive cameras have 3 CCDs for sharper colour re-production. Downloading from a DV camera to a PC hard drive requires a Firewire-compliant adapter card to be fitted to the PC (Figure 2.11).

On a cautionary note, DV is not yet the answer to the video enthu-siast's prayers. After originally offering professional quality images on a minicassette, common to professional and domestic users, the DV market is presently split into several competing formats which have varying de-grees of compatibility. At the low end is plain DV, as used in the majority of DV camcorders. At professional level, there are two competing for-

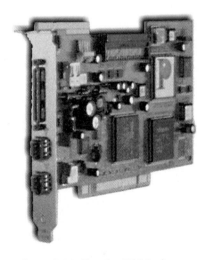

Figure 2.11 Firewire DV PC adapter card from Pinnacle Systems

mats; DVCAM from Sony, and DVCPRO from Panasonic. Although both use the same audio and video encoding scheme as the consumer DV products, there are differences in speed and track pitch of the tapes used – so both DVCAM and DVCPRO require more expensive tape to achieve the best quality. Generally, DVCAM and DVCPRO devices can play DV video, but the reverse is not always true. Compatibility between DVCAM and DVCPRO devices also varies, with some models being capable of playing back the other format and some not, so the message is *caveat emptor!*

VCR and television monitors

Most digitising cards can output to a conventional consumer VCR in either composite or S-Video format. A deck with a flying erase head provides cleaner edits. For more professional work a VCR like Sony's EVS-9000 (Figure 2.12) which can be used as either a source or destination deck, or both, provides a LANC input jack socket for remote control and uses Hi8 tapes.

A basic 14" colour TV CRT analogue monitor is sufficient for basic day-to-day composite video editing purposes. Provision of an S-Video input socket and the ability to display an S-Video signal as well as a composite signal gives more flexibility. In Europe, a monitor providing Scart sockets as well as the usual coaxial connectors simplifies the interconnection process. Subject to copyright considerations, the television tuner can also access a rich source of audiovisual material from terrestrial, satellite or cable TV channels.

An increasingly affordable alternative to the conventional CRT monitor is the desktop TFT display (Figure 2.13) which, as an intrinsically digital device, offers the intriguing possibility of working with digital video material throughout the editing process from source to destination. At present the vast majority of graphics cards fitted to PCs and Macs are designed to work with an analogue display but a number of manufacturers are developing cards specifically for this next generation of displays.

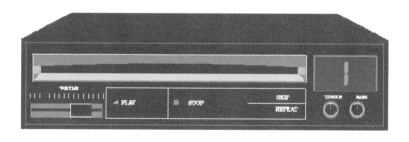

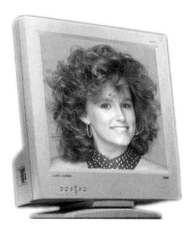

Figure 2.12 Sony's EVS-9000 Hi8 VCR

Figure 2.13 TFT desktop display

Internet requirements

It was undoubtedly the Internet's ability to act as a low-cost videoconferencing network that boosted the recent wave of digital video products appearing on the market. With videoconferencing software, such as *CU-SeeMe* being offered as a free download from Cornell University's FTP site, there was a leap in demand for low-cost video hardware which would allow users to capture and display video on their PCs.

The 'Webcams' are the cheapest digital video products currently available. Designed for the specific purpose of putting video on to the Web, these small digital cameras can also be used to capture and store small video clips on a hard disk. Connectix' *QuickCam* (Figure 2.14), originally developed for the Mac in 1994 was the pioneering product. The Windows version of the *QuickCam* has been very successful. Other manufacturers like Creative Labs have since released their own versions of the WebCam.

Webcams can only capture small images, typically no more than 320 x 240 pixels in size, and with a rather jerky frame rate of about 10 fps as they plug directly into a PC's parallel port which supports only a relatively low data rate. The universal serial bus (USB) appearing in new PCs and Macs supports a higher data transfer rate of around 1.5 MB/s but to cope with full-screen, full-motion video Firewire offers a better solution.

Even using the fastest available modem or ISDN connection, the current bandwidth limitations of the Internet make it difficult to work with larger image sizes, so the need for more sophisticated video capture equipment awaits the solution of the bandwidth problem. But lurking on the horizon is ADSL – Asymmetric Digital Subscriber Line. This is the current frontrunner among a group of technologies collectively known as xDSL. Forget ISDN – with ADSL the bandwidth of existing copper telephone lines can be boosted from their current limit of 56 Kb/s to around 2 MB/s. That's more than a 30-fold increase in capacity and it opens up all sorts of new possibilities. British Telecom (BT), although slow to implement ADSL in the commercial marketplace, has already completed trials with video-on-demand systems that use ADSL. As well as delivering films to TV sets via set-top boxes, ADSL will make videoconferencing commonplace in the corporate arena, and put videophones in people's homes. Home workers will be able to conduct videoconferences with colleagues, and children will be able to take part in distance learning programs via video links to schools and colleges.

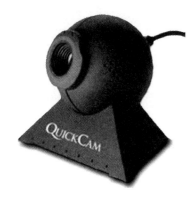

Figure 2.14 Connectix' web camera QuickCam

Summary

The hardware requirements for working with video on the desktop depend entirely on the user's objectives. Modest objectives – such as the creation of simple animated Web graphics – can be achieved using just the hardware provided with current, state of the art consumer Macs or PCs. At the other extreme, the user in a hurry, with ambitions to produce complex multimedia projects, films or documentaries, may choose to invest in one of a number of bespoke systems which are offered by several manufacturers. Such systems, which come ready-configured for video editing, with appropriate hardware and software pre-installed and tested, relieve the user of dealing with the compatibility problems which can arise when building a DIY system, but inevitably they do carry a premium price.

For the average user, who has already had some experience of, e.g., upgrading a PC hard drive, RAM or graphics card, the technical challenge of adding video capability to an existing system is an acceptable one and the falling cost of fast hard drives, RAM and digitising cards is making the DIY route attractive to an increasing number of users.

While the installed base of video cameras remains predominantly analogue, the cost of digital video cameras is falling rapidly. Already we can look forward to desktop video systems which are digital from input to output. The common desktop video system of the near future will use a DV camera as the input device, a Firewire interface card and a digital graphics card to input the digital video to a flat-screen digital display; output, after editing, will be either to digital tape or to a massive DVD ROM disk.

With this wholly digital process being driven by new processors operating at GHz speeds, hardware will no longer be a limiting factor. So what then of the software which is needed to exploit the potential offered by this rapidly developing hardware scene? More of this in the next chapter.

3

The new desktop software

The meteoric progress of desktop computing would never have happened without the catalyst of the user-friendly graphical user interface offered first on the Macintosh and later on the Windows PC. Had the capabilities of desktop machines remained cocooned within the DOS shell, with its blinking C:\ prompt and its arcane commands, the desktop would have remained the domain of the anorak.

Since the dawn of the GUI and its trusty companion, the mouse, progress has been signposted by a succession of landmark software developments. Early among these were word-processors like Microsoft Word and WordPerfect, spreadsheets like Lotus 123 and Excel, graphics applications like Illustrator and Freehand and DTP applications like Aldus Pagemaker and Quark XPress.

For desktop video to flourish in a similar way, it was first necessary for Apple and Microsoft to add to their respective operating systems the necessary video infrastructure and this they did – in the form of Apple's Quicktime and Microsoft's Video for Windows.

With the video infrastructure in place, in a close historical parallel to the evolution of DTP, developers of software for both the Mac and the PC platforms are now offering video editing applications which have borrowed heavily from their high-end professional antecedents to offer desktop users a dazzling array of features and special effects.

The different categories of software are described below:

Video and audio capture

Software required to capture video and/or audio clips so that these can be stored on the computer's hard drive for later use may be provided as part of a videoediting application, may be bundled with a video or audio digitising board or may be sold as a stand-alone application.

Video Capture

Figure 3.1 shows an example of a simple video capture utility – Microsoft's VidCap – which is supplied with Pinnacle Systems' digitising boards. With a video source connected to the input socket of the digitising card, live video appears in the VidCap screen. Using the controls provided, individual images or complete video sequences can be captured and stored on disk by using the following procedure:

1 Connect the video source to the capture board

2 Configure the frame size and video source options (e.g. Composite or S-Video, PAL or SECAM)

3 Set up the capture file (file name and hard drive destination) and set options for the video sequence (duration and compression ratio)

4 Click on *Capture/Single frame* to capture the frame being displayed in the Preview window or click on *Capture/Video* to start the capture of a video sequence

Before capture is initiated, VidCap's *Video Settings* dialog box (Figure 3.2) may be used to adjust the appearance of the image. The effect of using any one, or a combination of, sliders to adjust *Brightness, Contrast, Saturation* or *Sharpness* can be previewed in the image displayed in the capture window.

As well as features similar to those provided by VidCap, MediaStudio's capture utility (Figure 3.3) provides the ability to play back the video which has been captured in the preview window. A set of VCR-like controls is provided to manipulate existing or newly captured clips. When capturing, the *Play* button ▸• changes to *Freeze* ▸◂•. This freezes the video source on one frame, but continues to play in the background. Clicking again on the *Freeze* button displays the video in the current position. With an MCI (Media Control Interface) device connected to the video source, Video Capture can be used to control the video source directly using the buttons on the VCR toolbar. Creating a selection from a video sequence becomes a simple matter of clicking on the *Mark In* ▪ and *Mark Out* ▪ buttons in the control bar

When the video source is LANC-controlled, the capture utility provided with Pinnacle Systems' Studio 200 includes VCR or camcorder deck transport controls and an *Auto-Grab* button (Figure 3.4). The *Auto-grab* is useful for capturing a specific frame from tape when the source deck does not have a clean pause mode; clicking the *Set* button while viewing the moving image in the preview window button sets the grab time for the required frame; clicking on *Seek* causes the deck to rewind to the desired frame and, finally, clicking on *Grab* rewinds the tape to a time shortly before the grab time, then plays the tape and captures the desired frame 'on the fly'. Another useful feature of Studio Grabber is its ability to capture full colour single frames at a resolution of 1500 x 1125. Figure 3.5 shows the result of capturing a frame at this resolution, converting it to greyscale and saving it at 300 dpi. The inset shows the good distribution of grey levels retained in the captured image.

Adobe Premiere also supports the control of any device with an MCI device driver. With a controllable device, clips can also be viewed in

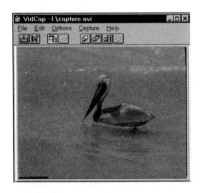

Figure 3.1 Microsoft's VidCap capture screen

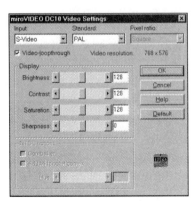

Figure 3.2 Adjusting the source image

Figure 3.3 MediaStudio's capture screen

Figure 3.4 Capturing a frame using Pinnacle Systems' Studio Grabber

Figure 3.5 Printing a frame captured at high resolution (Inset shows distribution of grey levels)

the dialog box shown in Figure 3.6 and logged with reference to their timecode and then digitised.

Whichever capture utility is to be used, to obtain the best quality result requires some pre-planning. In general, a video board using hardware JPEG compression will produce the smoothest results. CPU availability should be maximised during capture by turning off all unnecessary applications and TSR utilities. Capture should ideally be to the fastest, defragmented, hard drive on the system.

Audio capture

Audio is an important component of many media productions. Like video, analogue sound must be digitised, or sampled, to be used on the desk top (Figure 3.7). Digitising analogue sound breaks it up into discrete frequencies. Before digitising begins, the audio recording level must be set to avoid distortion and then a setting must be selected to determine

Figure 3.6 Adobe Premiere's Movie Capture dialog box

T E C H N I C A L D A T A

Video 24 frames/sec
Audio 44,100 samples/sec
Pure tone = Sine wave

T E C H N I C A L T I P

High quality digital audio needs
more than 40,000 samples per
second (40kHz). Lower rates
provide a less faithful 'picture'
of the sound

the audio resolution or quality. The quality of digitised audio and the size of the audio file depend on the sampling rate and bit depth of the audio. The sampling rate, similar to the frame rate for digitising video, measures the number of frequencies into which the sound is subdivided. The bit depth, similar to colour depth, measures the number of tones per sample. The higher the sampling rate and bit depth, the better the sound quality.

Some video digitising boards incorporate audio capturing hardware; otherwise, a separate sound card will be required to capture audio clips. Video and audio can then be captured simultaneously from a source like a camcorder by connecting *Video Out* and *Audio Out* to the video digitising board and sound board respectively. In other cases, sound in the form of a voice-over or a music clip may be captured separately for later synchronisation with video.

Sound 'LE (Figure 3.8a) is a simple sound utility from Creative Labs which has the ability to record sounds from a range of sound sources and save them as WAV files. The sound source – e.g. a midi-compatible keyboard, an audio CD player, a line input signal from a camcorder or a microphone – is first selected from the companion utility shown in Figure 3.8b and then recording begins when the record button ⬤ is clicked.

For both types of capture, options which determine the quality (and size) of the audio files are selected from a dialog box like the one in Figure 3.9. The quality of digitised audio and the size of the audio file depend on the sampling rate and bit depth of the sample. These parameters determine how accurately the analogue audio signal is reproduced when it is digitised. Audio sampled at 22 kHz and 16-bit resolution, for example, is far superior in quality to audio sampled at 11 kHz and 8-bit resolution. CD audio is normally digitized at 44 kHz and 16-bit resolution.

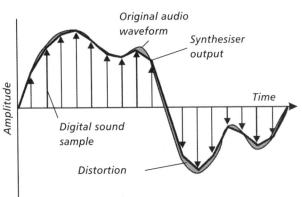

Figure 3.7 Digitising an analogue audio signal

Figure 3.8 Capturing sound

(a)

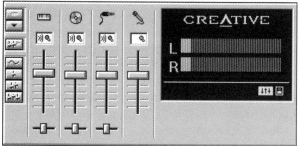

(b)

Figure 3.9 Specifying sound recording settings

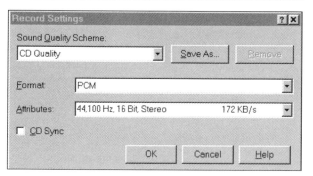

TECHNICAL DATA
CD quality sound (44kHz, 16 bit, stereo) 172kB/sec
Stereo quality (22kHz, 16 bit, stereo) 86kB/sec
Mono quality (22kHz, 8 bit, mono) 22kB/sec

Video editing applications

Once video and audio clips have been digitised and saved on disk, applications like MediaStudio or Adobe Premiere offer the user the means of arranging these clips in the required sequence, trimming them to length, inserting sophisticated transitions between clips and adding titles. The means are also provided of superimposing tracks and implementing other special effects.

Construction and integration

The first purpose of a video editing application is to allow the user to import and arrange video, audio or still image clips into a construction window, where they can be ordered into a logical sequence, or timeline. Figure 3.10 shows an example of MediaStudio's construction window containing two video clips on video tracks Va and Vb, a still image clip on track Va and an audio clip on audio track Aa. When saved as a video project file, then previewed, using the *Preview* command from within the

View menu, video clip (a) will play before video clip (b), which will play before the still image clip, i.e. the x-axis represents time within the construction window. The audio file will begin to play at the same time as video clip (a) and will continue to play over video clip (b) and then over the still image file, terminating at the end of the still image clip. Additional clips can be added to the appropriate tracks within the construction window in order to build up more complex projects.

Transitions

If the end of clip (a) was aligned vertically to coincide with the start of clip (b) then playback would result in an abrupt transition from one clip to the other; the effect of the 'Bar-Push' transition clip placed on track Fx between the overlapping ends of video clips (a) and (b) is to add a smoother and more visually interesting transition between the end of clip (a) and the start of clip (b). The 'Box-Stretch' transition clip provides the same function between clip (b) and the still image clip. MediaStudio provides a total of thirty-five transitions arranged into twelve categories. The *Transition Effects* menu (Figure 3.11) provides a dynamic thumbnail for each transition type which demonstrates how the transition will appear when applied to a video clip.

Figure 3.10 MediaStudio's construction window

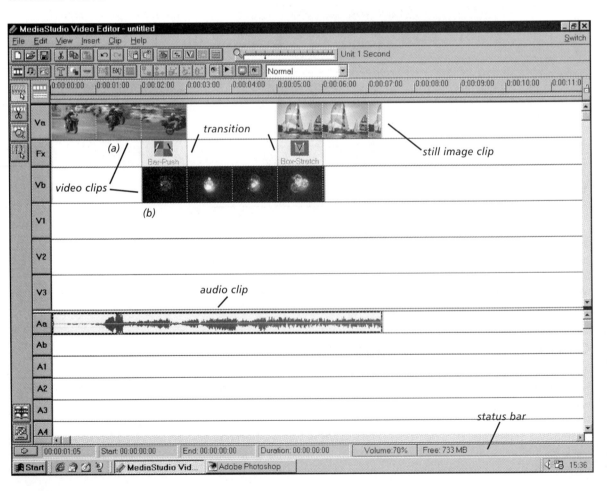

The way in which a transition interacts with an underlying video clip can be edited in MediaStudio by double clicking on a transition clip in the construction window to open the *Transition Options* dialog box shown in Figure 3.12. The *Sample* window in the box displays the selected transition effect. Clicking on the scroll bar activates a preview of the transition. The *Transition* buttons determine whether clip (a) fades to clip (b) within the transition interval, or vice-versa. The *Border* command may used to specify the size and colour for a border at the edges of the transition. Other controls permit editing of the softness of the transition edges, the degree of completion of the transition effect at the start and end frames, arrow keys control the direction of the effect. In the *Sample* window shown in Figure 3.12, the box is opening from the centre to reveal and overlay the still image of the sailing boats over video clip (b) of a fireworks display.

Tools

Reflecting the experience gained from many years of developing digital still photoediting applications like Adobe Photoshop or Corel PHOTOPAINT, videoediting applications are supplied with a range of sophisticated tools for the manipulation of video and audio clips within the construction window. Deployment and description of these tools varies from developer to developer as each seeks to find an optimum configuration, but the functions provided are broadly similar. Figure 3.13 shows the principal tools provided with MediaStudio.

Figure 3.11 MediaStudio's transitions

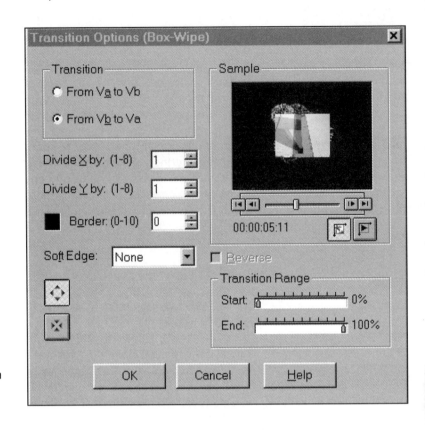

Figure 3.12 MediaStudio's Transition Options dialog box

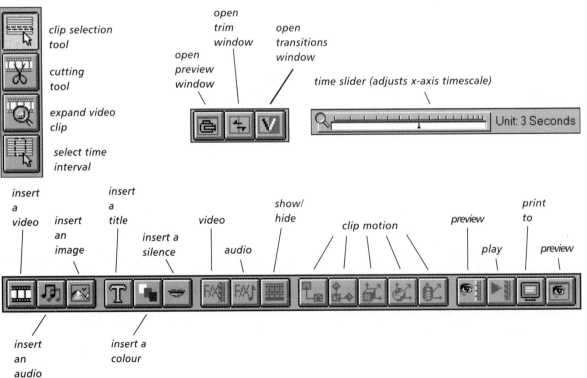

Figure 3.13 MediaStudio's editing tools

Figure 3.14 MediaStudio's Display Mode dialog box

Figure 3.15 MediaStudio's Project Window

Figure 3.16 MediaStudio's Library Window

Figure 3.17 Previewing a video clip

Figure 3.18 MediaStudio's Trim window

Figure 3.19 Video Scratch Pad

Figure 3.20 Audio Scratch Pad

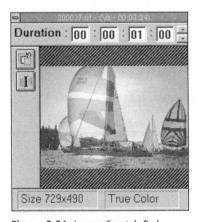

Figure 3.21 Image Scratch Pad

In addition to these, the *Display Mode* tool ▦ activates the dialog box shown in Figure 3.14 which provides options for the display of video and audio clips in the construction window, the *Project Window* tool ▦ opens the dialog box shown in Figure 3.15 which provides thumbnails and information relating to each clip within the current project, and the *Library Window* tool ▦ opens the dialog box in Figure 3.16 which provides access to a library which can be used to store regularly accessed video or audio clips.

At any stage of the construction work, clicking on the *Preview* button ▦ opens the window shown in Figure 3.17 and choosing *View/Preview* initiates a live, low resolution, preview of the work in progress. The length of a video clip can be trimmed by clicking on the *Trim* button ▦ which opens the window in Figure 3.18 showing the end frame and the adjacent one for the currently selected clip. The mark-in and mark-out frames can be chosen visually by dragging the end point for the clip.

Video projects can become very complex, consisting of many files and different effects. To assist in project management, as well as the Project Window and the Clip Library, MediaStudio provides cues as a means of marking significant points within the project. There are two types of cue; project cues appear in the bottom of the ruler and can apply to any part of a project; clip cues can only be assigned to video or audio clips, appearing in the cue bar below the track occupied by the clip. The Video Scratch Pad (Figure 3.19) can be used to create, edit and view named cues within any video clip. As well as marking significant points in a project, cues can also be used, for example, to synchronize an audio, overlay, or special effect with another track. The Audio Scratch Pad (Figure 3.20) provides a similar facility for setting named audio cues. The Image Scratch Pad (Figure 3.21) is provided for viewing and changing the length of an image clip.

All the commands for working with project cues are available from the *Cue Manager* command in the *View* menu. Cue times and names appear in the *Cue Manager* dialog box (Figure 3.22). In a complex project, the *Go To* key provides an easy way of finding a specific event within the project.

Figure 3.22 Cue Manager dialog box

Although differing in detail from those of MediaStudio, the construction windows and tool sets offered by Adobe Premiere and Corel Lumiere are similar in function. Premiere's construction window, shown in Figure 3.23, with two video clips, an image clip, two transition clips and an audio clip laid out on the timeline in the same configuration as we saw in MediaStudio's construction window (Figure 3.10). Premiere also provides a *Project* window which displays thumbnails and information about the clips being used in the active project, a *Transitions* window from which transition clips can be dragged and dropped into the transition track, a *Clip* window for selecting and trimming individual clips and a *Preview* window for displaying a movie of the project at any point in its construction.

The toolbar appears at the bottom left of the construction window; Figure 3.24 summarises the function of the tools.

Corel Lumiere's construction window, shown in Figure 3.25, again shows a set of video, transition, still and audio clips laid out along the time line. The *Media Catalog* window serves the same purpose as the *Project* windows in MediaStudio and Premiere, providing a registry of all files in use, but it also doubles as a library window, like that of MediaStudio, with the help of the file tools ▯▯▯▯▯▯ at the top of the window.

Figure 3.23 Adobe Premiere's construction window

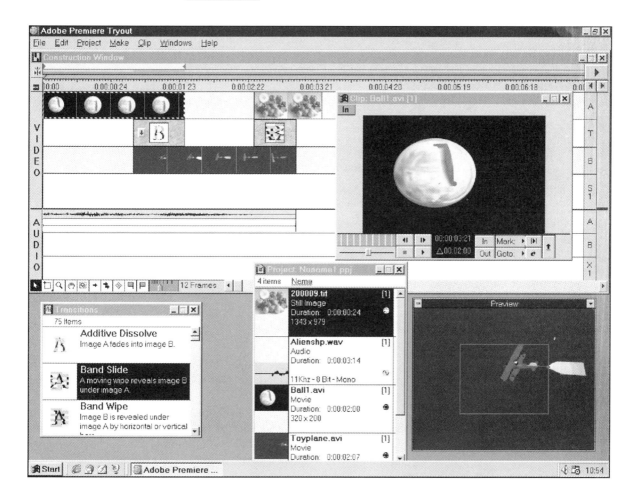

Figure 3.24 Adobe Premiere's tool bar

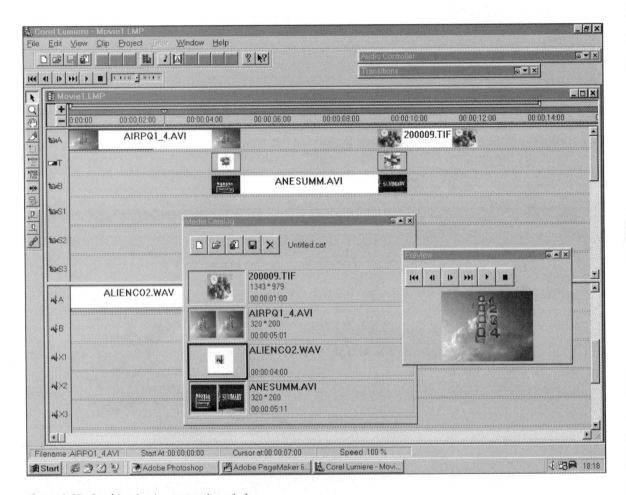

Figure 3.25 Corel Lumiere's construction window

Lumiere's tools are shown in Figure 3.26. Most have functions similar to those described for MediaStudio, but others need some explanation.

The speed tool is used to change the speed of a clip by adjusting its duration. Dragging either edge of a clip with this tool adjust the speed of all the frames contained within the duration of the clip. Shortening the duration of a clip will increase its speed and vice-versa.

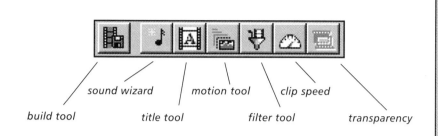

build tool sound wizard title tool motion tool filter tool clip speed transparency

single select tool
zoom tool
pan tool
cut tool
multi select tool
single track move
multi track move
speed tool
virtual clip
punch in
punch out
link tool

Figure 3.26 Corel Lumiere's tool bars (left and above)

The virtual clip tool creates a virtual clip (a single clip which points to, or represents, all the clips in a segment of a movie) by dragging over a section of the active project. The virtual clip is placed on either a video track or a superimpose track in the construction window.

The sound wizard accesses a sound editing facility which will be explained later.

The transparency tool changes the transparency settings for the selected clip. The use of transparency will be explained later.

Titles

All of the applications described in this chapter provide the means of adding an impressive range of titles to a project. Figure 3.27 shows MediaStudio's *Insert Title Clip* dialog box; title text is typed into the window in the bottom left of the dialog box and attributes can be set using the menus and buttons provided; a sample window shows how the text will appear. Clicking on the *Effects* tab opens the options shown in Figure 3.28. Clicking on the *Opaque* button activates the *Background* option which can be used to place a colour matte behind the title.

A title clip placed on a normal video track (Va or Vb in MediaStudio) will show the title by itself against a default white background, which can be changed to a colour matte. A title clip placed on a video superimposition track (e.g. V1 in MediaStudio), on the other hand, will appear superimposed over an underlying video clip. Figure 3.29 shows two examples; an introductory title clip on track Va displays 'Isle of Man Tourist Trophy' in white text on a solid

Figure 3.27
MediaStudio's Titles dialog box

Figure 3.28 MediaStudio's Title Effects

Figure 3.29 Title clips in MediaStudio

black background, while a second title clip on track V1 displays 'YAMAHA 1000 cc Privateer' superimposed on the video clip of the motorcyclist on track Va (see the overlay effect in the Preview window in Figure 3.30).

Adobe Premiere's *Title* dialog box (Figure 3.31) provides a simple tool set which can be used to create title clips containing type, straight lines, and various geometric shapes. Premiere automatically assigns anti-aliased alpha channels to type and graphics generated in the *Title* window. As in MediaStudio, a full-frame matte of a solid colour can be created as a background, for example, for scrolling titles or credits.

Corel Lumiere provides an even more comprehensive range of titling options. Opening the *Titler* menu activates the titling toolset shown in Figure 3.32. As well as the obvious tools, the toolbar includes tools for editing the points on polylines, adding shadows, and adjusting the transparency of objects in the title clip relative to the underlying video clip. By default the backdrop for the Titler is white, but the white backdrop can be replaced with a frame from a video clip. Text and objects in the Titler will then appear superimposed on the videoframe selected by placing the Time Marker in the timeline above the chosen frame. Figure 3.33 shows an example in which the title 'Digital Video' has been superimposed, in white, on a track from the clapper board clip entitled ANESUMM.AVI in Figure 3.25.

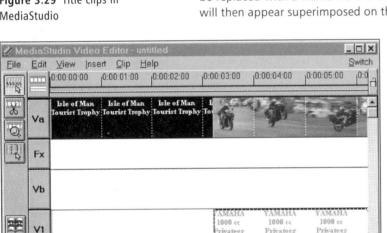

Figure 3.31 Adobe Premiere's Title dialog box

Figure 3.30 The Preview window shows the result of superimposing a title clip on top of a video clip

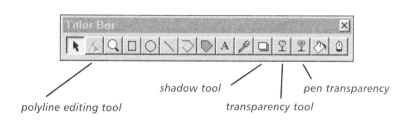

shadow tool pen transparency

polyline editing tool transparency tool

Figure 3.32 Corel Lumiere's Titler toolbar

Figure 3.33 Using a video frame as a title background

Special effects

After video and audio clips have been assembled in the construction window of one of our video editing applications, and transitions have been placed in position and title clips added, a number of special effects are available to add further interest to the finished result.

Adding motion

One of the most advanced features found in the new video editing applications is the moving path. Moving paths can be applied to video clips to make them follow two dimensional paths or to flip, rotate or spin in three dimensions; paths can also be used to zoom in or out, or to create fast or slow motion effects.

As explained earlier (Figure 3.13), five of the buttons on MediaStudio's toolbar [] are used to activate motion filters. A motion filter is used to impart movement to a clip – e.g. to cause the text credits at the end of a project to scroll from the bottom to the top of the screen while the movie is playing. Moving paths can be applied to any clip in a video track and can add visual interest to a project. Uses include creating moving pictures from still images – for example, a car moving across the screen – or producing multiple-image screens.

Figure 3.34 shows the dialog box for MediaStudio's simplest motion filter, the *2D Basic Moving Path*. Figure 3.35 shows the function of the editing tools provided within the dialog box. In the preview window at the top of the dialog box, 'S' and 'E' denote the *Start* and *End* points of the path and the video clip, to which the path is being applied, can be seen midway between the two. Either or both *Start* and *End* points can be outside the field of view (as in Figure 3.34) or inside the field of view.

Width and *Height* controls are provided for adjustment of the clip dimensions and the *X* and *Y* controls determine the horizontal and vertical locations of the selected control point within the frame. Changes to the frame dimensions apply only at the reference point where the clip is located when the changes are made, so by altering the frame size from point to point, zoom in or zoom out effects can be created as the clip traverses a path. If the *Start* and *End* points are dragged to overlap at

some point within the field of view, and if the *Start* width and length are made small compared to the *End* width and length, then the clip will appear to zoom from a fixed position as the clip plays.

The nine handles in the *Reference Point* box in the lower right hand side of the dialog box relate to the same nine points within the video clip; clicking one of these specifies the reference point on the frame for movement along the path. If required, colour, stroke width and softness can be specified for a border around the edges of the clip. Once created, paths can be saved for later reuse.

The *2D Advanced Moving Path* motion filter adds the possibility of rotating a clip either at rest or as it traverses along a path, as well as the option to distort the clip, for example to introduce a perspective effect as shown in Figure 3.36. The angle of rotation is set either using the thumbwheel or by entering a value in the *Rotate* window. In the *Distortion* window, the handles can be dragged independently to alter the clip dimensions.

Figure 3.37 shows just the extra controls available in the dialog boxes which appear when the *3D Path* (a), *3D Sphere Path* (b) and *3D Cylinder Path* (c) filters are selected.

The *3D Path X, Y* and *Z* buttons select the axis of rotation. The angle of rotation around the selected axis can be set either by using the thumbwheel or by entering a value in the appropriate box. *Rotation Order* specifies the order in which the rotation takes place, while *Perspective* changes the perceived distance of the rotation axis; the higher the value, the closer the axis appears.

In the *3D Sphere Path* dialog box, *Radius* determines the invisible sphere size around which the clip is wrapped, *Rotate* determines the sphere rotation and the X and Y settings locate the sphere horizontally and vertically in the frame; *Clip Angle 1* locates the clip vertically (on the XY

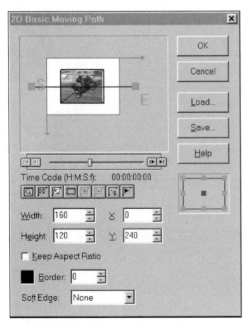

Figure 3.34 MediaStudio's 2D Basic Moving Path dialog box

Figure 3.35 Path editing tools

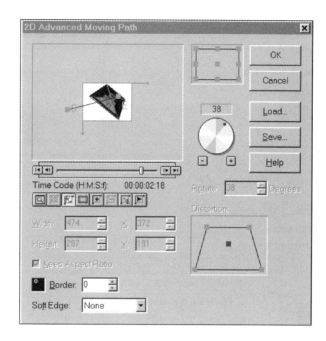

Figure 3.36 2D Advanced Moving
Path dialog box

plane) on the sphere's surface and *Clip Angle 2* locates the clip horizon-
tally (on the XZ plane) on the sphere's surface; *Adjust* selects the category
to adjust with the thumbwheel.

Finally, in the *3D Cylinder Path* dialog box, *Radius* determines the
cylinder width, *Rotate* defines the rotation of the clip in its plane and *X*
locates the cylinder horizontally in the frame; on the left of the dialog
box, *Rotate* determines the cylinder rotation about the z axis, *Angle*
locates the clip horizontally on the cylinder surface and *Y* locates the
clip vertically on the cylinder surface.

Adobe Premiere provides motion controls similar to those of
MediaStudio, but manages to squeeze them into a single dialog box (Fig-
ure 3.38). Clips can be moved in two dimensions along a path, rotated,

Figure 3.37 3D, 3D Sphere and 3D
Cylinder dialog boxes

(a) 3D Path

(b) 3D Sphere Path

(c) 3D Cylinder Path

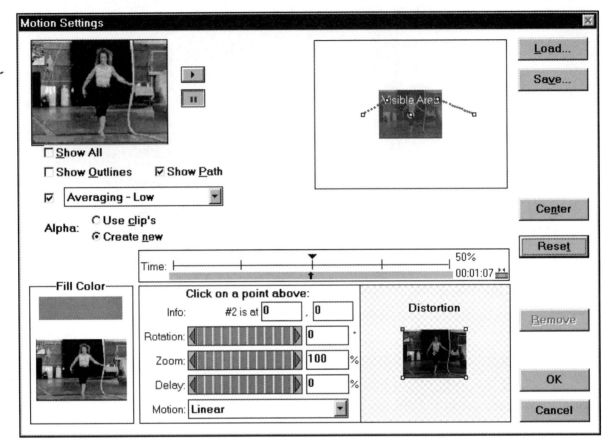

Figure 3.38 Adobe Premiere's Motion
dialog box

zoomed and distorted. Near the bottom of the dialog box, the *Delay* setting, as the name suggests, can be used to introduce a pause into the motion of a clip as it traverses a path, while the *Motion* menu contains the options *Linear, Accelerate* and *Decelerate*; selecting *Accelerate*, for example, will cause the rate of movement of the clip to accelerate as it moves along its path.

Premiere also provides a set of named preset motion settings which can be accessed via the *Load* button in the dialog box. These include examples like *Bounce In*, *Leaf* (which causes the clip to adopt the shape of a leaf, falling alternately from left to right and top to bottom of the screen), *Spin Out*, *Spiral*, *Whoosh* and *Zoom Left*.

Corel Lumiere's approach to motion control is similar to that of Premiere. Figure 3.39 shows its dialog box in which a *Cartwheel* preset is being applied to a title clip; the cartwheeling title can be seen superimposed on an underlying video clip in the *Preview* window on the right. Editing tools are ranged on the left side of the dialog box and windows for entering numerical values are in the lower right hand corner.

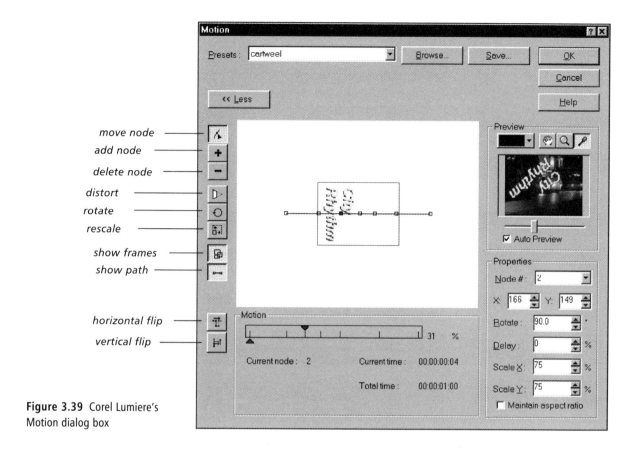

Figure 3.39 Corel Lumiere's
Motion dialog box

Panning to create motion in still image

The ability to interpose still images (e.g. scanned photographs or clipart images) with moving video clips when building a project extends considerably the range of creative possibilities in video production. A useful technique which can increase the visual interest of a still image is panning, which simulates the effect obtained when a traditional movie camera or video camera is swept across a static scene. Figure 3.40 shows an example of this use of panning, available as one of Corel Lumiere's *Special* video filters. The *Start* frame in the dialog box shows a still image of a bullfighting scene, with the matador confronting the bull. In the *End* frame, the handles at the four corners have been dragged to create a smaller frame around the matador. When the clip is played back and viewed in the *Preview* window to the right of the dialog box, the 'camera' filming the scene starts with a full shot of the bullring and then appears to travel to the right while zooming in to close-up on the matador.

Pan can also be used to create rolling credits – a list of names which scroll across the screen, usually from top to bottom. A Titler utility is first used to produce a long page with the appropriate list of names, and then the Titler file is placed on a superimpose track. By default, the pan frames in the *Start* and *End* windows of the dialog box are both set to the size of the credits page. The *Start* frame is first reset to the size of a

> TECHNICAL TERM
> *Pan - to swing a camera to produce a panoramic effect or to direct the viewer's attention between subjects*

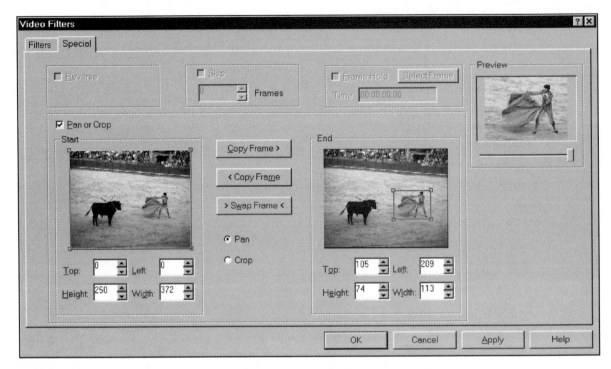

Figure 3.40 Panning to create movement in a still image clip

standard frame (so that just the first few credits can be seen) and then the *Copy Frame* button is used to copy the *Start* frame to the *End* window of the dialog box. Now in the *End* window, the copy of the *Start* frame can be dragged down until it encloses just the last of the credits. When the project is previewed, the credits now roll smoothly from the bottom of the screen to the top!

Other motion effects

Other motion editing features provided by videoediting applications include adjustment of the speed of playback, direction reversal, holding on a selected frame and frame skipping.

Figure 3.41 shows Premiere's *Clip Speed* dialog box. By selecting a video clip and reducing its clip speed – e.g. to 25% as shown – the clip will play at a quarter of its original speed, creating a slow-motion effect and extending the playback time (in this case to four times the original length). Conversely, increasing the clip speed will compress the playback time of the clip, speeding up the action contained within the clip. Caution has to be used when changing clip speed as doing so effectively reduces or multiplies the number of frames in the original clip and can affect the quality of motion in the clip.

Changing a clip's direction – so that it plays in reverse – is achieved simply by inserting a minus sign (–) in front of the percentage figure in the *Clip Speed* dialog box.

In both Premiere and Lumiere, *Frame Hold* can be used to select a particular frame within a clip to be played for the duration of the clip; this

Figure 3.41 Adjusting Clip Speed

Figure 3.42 Holding a selected frame for the duration of a clip

could be useful, for example, when that frame is to provide a static background behind an overlayed title frame. In Premiere's *Video Filters/Special* dialog box (Figure 3.42). Clicking the *Select Frame* button displays the *Video Control* dialog box shown in Figure 3.43; dragging the Time Marker advances the clip until the desired frame is displayed in the preview window

The *Skip* command can be used, for example, to convert flowing movement in a video clip to jerky, staccato, movement. To skip frames, the *Skip* button is activated in Premiere's *Video Filters / Special* dialog box and the number of frames to be skipped is entered in the window provided (Figure 3.44). For example, if the figure of 10 is entered, the project will show the first frame of the clip, skip frames 2 to 11, show frame 12, then skip another 10 frames, and so on.

Cutting and mixing

Thanks to the latest compression techniques and the large storage capacity of modern hard drives, it is possible to capture many minutes or even hours of video from a VCR or camcorder. To reduce the problems of manipulating such large files, the footage can be captured as a series of

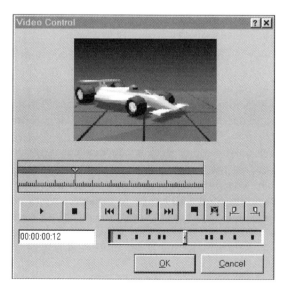

Figure 3.43 Premiere's Video Control dialog box

Figure 3.44 Setting Skip Frames

sequential files which can then be edited individually before being printed back sequentially to tape (more on this in the chapter entitled *The production process*).

In many practical cases, however, where the editing required may be confined to the cutting out of unwanted footage, rearranging and mixing video sequences from different tapes or adding simple titles or credits, a simpler solution is to use an editing package such as Pinnacle Systems' Studio 200 Video Director.

Studio 200 provides the hardware and MCI software necessary to control the video source and destination devices from virtual tape decks on the PC screen. Instead of capturing hours of footage to disk, only the first frame of each clip on the tape is captured, together with the length of the clip and the time codes corresponding to the start and finish of the clip. Thumbnails of the clips are then displayed in a library window in the same order in which they appeared in the original tape. From the library window, those required can be dragged to an *Event List* where they can be sorted into a final sequence. At this stage transitions, titles and sound effects can be added, if required.

When the *Event List* is complete, a simple *Make Tape* command initiates a process whereby Studio 200 begins to assemble the final tape by scanning forward through the camcorder source tape to find the first clip in the *Event List* sequence. As the clip starts to play, the destination deck is automatically set to record, so that the clip is copied from the tape in the source deck to the tape in destination deck. Any special effects will be added at the same time. When the first clip has been completed, the next clip is automatically located and the process is repeated. If the next clip is on a different tape from the one currently in the source deck, then a *Mount New Tape* message appears. The current tape is ejected from the source deck, the next tape is loaded and the process continues to completion.

Configuring Studio 200

Figure 3.45 shows the Studio 200 mixer unit and its I/O ports. Figure 3.46 shows the unit connected up in a typical editing configuration. When using a LANC source deck, a special cable with three separate connectors is supplied with Studio 200; two of the connections link a serial port on the PC to the LANC socket on the video deck; the third connector incorporates an infrared device which uses infrared signals, in the same way that a VCR remote control unit does, to send appropriate infrared pulses to the record deck for commands such as Start, Stop, Pause and Record.

The video-out jack on the source deck is connected to a socket labelled *From Source Deck* on the Studio 200 Mixer, using either an S-Video or composite cable. A second cable is used to connect the socket labelled *To Record Deck* on the Studio 200 Mixer to the video-in jack on the record deck. The audio and video out jacks from the record deck are then connected to the audio and video in jacks of your television monitor. The television monitor is used to view title and transition effects or to

TECHNICAL TERM
MCI – Machine control interface – used to connect a computer to an external video source such as a VCR

TECHNICAL DATA
The LANC driver is used with the Studio 200 Smart Cable to control VCRs and Camcorders with a LANC jack.
With LANC camcorders and VCR's, Studio 200 relies on the source deck's tape counter to locate segments on the tape. Unless a Time Code-equipped source deck is being used, this counter will not accurately keep track of elapsed time. Errors caused by tape counter inaccuracy will grow when dealing with clips which are far apart on the source tape, or when the stop, fast-forward, or rewind modes are used repeatedly. Studio 200 provides several tape calibration features to correct these problems.

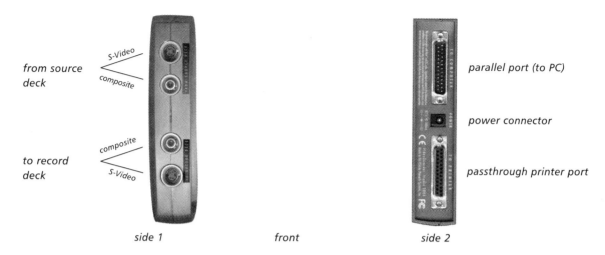

from source
deck
< S-Video
composite

to record
deck
< composite
S-Video

parallel port (to PC)

power connector

passthrough printer port

side 1 front side 2

Figure 3.45 The Studio 200 Mixer unit

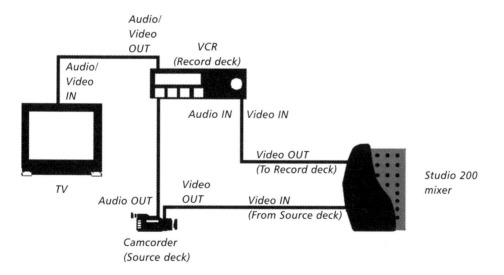

Audio/
Video
OUT

VCR
(Record deck)

Audio/
Video
IN

Audio IN Video IN

Video OUT
(To Record deck)

Studio 200
mixer

TV

Audio OUT

Video
OUT

Video IN
(From Source deck)

Camcorder
(Source deck)

Figure 3.46 Typical Studio 200 editing configuration

view the edited tapes from your record deck. Video from your source deck can be viewed using Studio 200's *Video Preview* window.

To record video and audio together, the audio out jacks of the source deck are connected to the audio in jack on the PC sound card. The audio out jack of the PC sound card is connected to the audio in jacks on the record deck.

The Studio 200 editing window is shown in Figure 3.47. The basic sequence of events is controlled by the three large buttons (1. Log, 2. Edit, 3. Make Tape) immediately below the menus at the top of the window.

After loading a tape into the source deck and naming it, using the dialog box in Figure 3.48, the VCR-like controls in the *Source Deck* window (top left corner of the screen in Figure 3.47) are used to control the source deck. Clicking Log initiates the process of Auto-Logging all the clips on the tape (Figure 3.49), adding a frame representing each clip to the *Tape Library* window as the logging proceeds (see clip thumbnails in the *Tape Library* window in Figure 3.47). If clips from another tape are to be included in the new project, then the first tape is replaced by the second in the source deck and logging of the second tape proceeds. Once in

Figure 3.47 The Studio 200 editing window

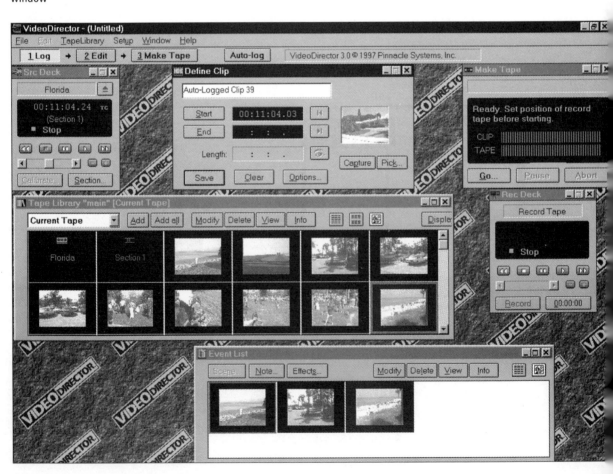

Figure 3.48 Tape naming dialog box

Figure 3.49 Auto-logging in Studio 200

the library, individual clips can be selected and trimmed, if required, using the *Modify* button at the top of the *Tape Library* window, which opens the editing window shown in Figure 3.50. *Start* and *End* time codes can be altered manually, or alternatively, by clicking the 👁 button the tape can be automatically rewound to the start of the clip and previewed before trimming. Information about any logged clip can be obtained by clicking on the *Info* button in the *Tape Library* window (Figure 3.51).

When all the required tapes have been logged, clicking on the Edit button opens the *Event List* window shown in Figure 3.49. It is in this window that logged clips which are to appear on the final tape are arranged in order, like in a storyboard, by simply dragging the corresponding clip thumbnails from the *Tape Library* window into the *Event List*. To assist in the planning and control of a project, annotations can be added at significant points in the *Event List*; Figure 3.52 shows the list displayed in text format, instead of thumbnail format, with a note which has been added by clicking on the *Note* button.

Once in the *Event List* window, transitions and other effects can be applied; clicking on the *Effects* button opens the dialog box in Figure 3.53 which provides access to a variety of audio and video effects, including transitions (Figure 3.54), over a hundred of which are provided.

Studio 200's *Title Editor* (Figure 3.55) has a comprehensive set of editing tools. Titles can be displayed full screen against an imported background, as shown, or overlayed on a video clip. Overlay titles can also be animated to move over the underlying video.

Figure 3.50 Modifying a clip from the Tape Library window

Figure 3.51 Getting information about a clip in the Tape Library

Figure 3.52 Studio 200's Event List window

Figure 3.53 Adding special effects in Studio 200

Figure 3.54 Choosing a transition

Figure 3.55 A title superimposed on an imported background in Studio 200

When the event list is complete, clicking on the Make Tape button in the toolbar sets up the process for production of the finished tape, opening up all the relevant windows – *Source Deck, Record Deck, Make Tape,* and *Event List* (Figure 3.56). Clicking *Go* in the *Make Tape* window opens the dialog box in Figure 3.57, which asks for final confirmation of the clips to be assembled and provides the means of adjusting the audio level during the recording process.

Once recording has begun, Studio 200 copies the clips and effects in the event list from the source tapes to the record tape. The only time intervention required is when a prompt appears in the *Make Tape* window requesting a change of source tape (in the event that the clips being assembled exist on more than one tape).

As the recording process proceeds, status information is displayed in the *Make Tape* window; the name of the current clip is displayed at the top of the window. Each clip is also highlighted in turn in the event list window as it is recorded, so that progress can be monitored on a real time basis (Figure 3.58).

Beneath the clip name display is the Status field which provides details on exactly what Studio 200 is doing at all times during the *Make Tape* process, e.g. *'Preparing to record'*, *'Seeking to position'*, *'Recording clip'* or *'Recording complete'*. At the bottom of the *Make Tape* window two progress bars display the status of the current clip being copied and the overall progress of the *Make Tape* process. At every stage, the source tape timecode data is displayed in the *Source Deck* window and the status of the record deck – *Stop, Rec/Pause* or *Record* – is displayed in the *Record Deck* window.

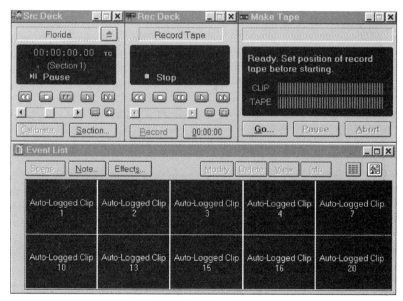

Figure 3.56 Starting the Make Tape process

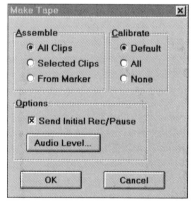

Figure 3.57 The Make Tape dialog box

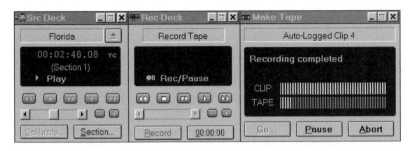

Figure 3.58 Monitoring the recording process

Compression software

While perhaps less exciting than those covered so far in this chapter, a software category which makes an important contribution to the feasibility of desktop video is that of compression software. Compression is the process of removing or restructuring data to decrease the size of a file. As already discussed, digital video files are intrinsically very large, requiring high data transfer rates during capture and playback. When a completed video project is compiled and saved in AVI or MOV format, the data is compressed to reduce the file size and to facilitate the playback of the movie. As the movie plays back, the data is decompressed 'on the fly'.

A compression algorithm is a method of compressing data. Video compression algorithms are specifically designed to handle the data created by digitising full-motion video. No single algorithm can satisfy every video compression requirement; different algorithms are designed with different objectives, some being optimised for quality at the expense of file size and data rate and others, conversely, being optimised to minimise file size and data rate with some sacrifice of quality.

Real-time, symmetrical, compression means that video is captured and compressed at full video frame rates (PAL = 25 frames per second). Video can also be compressed asymmetrically. Asymmetric compression means that the compression process is carried out after the capture has taken place. Asymmetric compression processes differ in their degree of asymmetry. This degree, or level, is usually referred to by a ratio, e.g. 100:1. A compression process with 100:1 asymmetry will take 100 minutes to compress 1 minute of video.

Several compression/decompression algorithms, known as codecs, are available for compressing Video for Windows and QuickTime movies. Codecs can be software-based or hardware-based. Hardware compression, as discussed in the previous chapter, is significantly faster than software compression but requires a special digitising card. The performance of the codec used affects the visual quality of the movie and the speed with which it plays back. Software codecs are normally used for video files to be played back from CD-ROMs, so that clips can be viewed without specialised hardware.

MOV and AVI movies can be compressed from within the videoediting applications we have been reviewing in this chapter, using

any of the software codecs that come with Video for Windows, Quicktime, or the applications themselves. Third-party codecs can also be installed to provide a variety of compression formats from which to choose. Some codecs are optimised for image quality compression while others are optimized for speed. The choice of codec depends on the type of original images being processed and on and the desired results.

Video for Windows Software Compressors

The following software codecs are shipped with Video for Windows and appear in the videoediting application *Compression* dialog box (Figure 3.59 shows MediaStudio's dialog box). The dropdown menu of compressors includes, at the bottom, the Miro Video DC10 MPEG compressor supplied with the Miro DC 10 digitising board.

Microsoft Video 1 codec

Use for compressing analogue video. The Video 1 compressor is a lossy, spatial compressor which supports pixel depths of 8 or 16 bits.

Microsoft RLE codec

Used for compressing animation and computer-synthesized images. The RLE compressor is a spatial 8-bit compressor that uses run-length encoding techniques.

Cinepak codec

Available on both Windows and Macintosh computers, the Radius Cinepac codec is used when compressing 24-bit video for playback from CD-ROM discs. The Cinepak codec attains higher compression ratios,

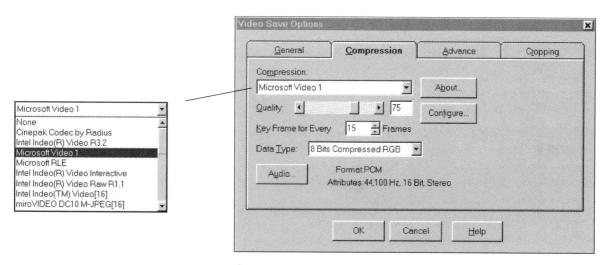

Figure 3.59 Choosing compression settings

better image quality, and faster playback speeds than the Microsoft Video 1 codec. Cinepak is a highly asymmetric codec, which means that decompression is much faster than compression.

Intel Indeo Video R3.2 codec

Also available on both Windows and Macintosh computers, this codec is used when compressing 24-bit video for playback from CD-ROM disks. This codec attains higher compression ratios, better image quality, and faster playback speeds than the Microsoft Video 1 codec and produces results comparable in quality to those compressed with the Cinepak codec.

Intel Indeo Video Raw codec

Used for capturing uncompressed video, this codec provides excellent image quality as no compression is applied! Its advantage is that captured video files are smaller than those captured with the *None* option.

QuickTime Software Compressors

As already stated, the Cinepac codec and Intel Indeo Video R3.2 codec are available for both Windows and Macintosh systems.

Video codec

Used for capture and compression of analogue video, high-quality playback from hard disk, and reasonable quality playback from CD-ROM. This codec supports both spatial and temporal compression of 16-bit video and can play back at rates of 10 fps or more. The Video codec allows recompression with little quality degradation.

MPEG

Named after the group which conceived it – the Moving Pictures Expert Group – MPEG is an ISO supported standard for compression and decompression of digital video and audio.

As explained already, many formats are lossy, which means that some of the video information is discarded during compression. Many work by comparing a series of frames and only storing the data which actually changes from one frame to the next. For example, suppose a child is filmed standing in front of a plain, fixed background. The child might be moving but the background doesn't change at all from frame to frame, so there is no need to store the image data for the background in each separate frame. Eliminating this unnecessary data allows the compressor to reduce significantly the size of the video file without affecting the overall image quality (Figure 3.60a). Contrast this with the scene in Figure 3.60b which contains many moving figures in the foreground and in the background which are changing from frame to frame.

The MPEG format is a good example of a compression method which can significantly compress redundant information. It is now used

(a) The plain background to this scene remains constant
from frame to frame and so contains redundant information

(b) This complex scene is full of movement and tones
which are changing from frame to frame

Figure 3.60 Compression potential depends on the type of image being compressed

to store full-length feature films on CD-ROM or the new DVD disks. Using
a suitable software video player, MPEG files can be played fullscreen at
30 fps, providing picture and stereo sound quality comparable with that
of a TV broadcast. Figure 3.61 shows the interface of such a player which
ATI supplies with a number of its graphics cards. When loaded on the
author's system, the ATI player delivered impressive stereo sound and full
20 inch screen video from a 32 speed CD ROM without a glitch. File size
reduction using MPEG compression is significant; 5 minutes of 640 x 480,
25 fps video and 22 KHz, 16-bit, stereo sound occupies less than 2 Gb of
hard drive space.

Video editing, of course, requires the ability to work with the detail contained within individual frames and this is not feasible if much of
the visual data for each frame has been lost during compression. Because
of this, capture cards intended for professional work often use a compression called motion-JPEG (M-JPEG). As the name implies, this is basically a
version of the JPEG compression used to store still images. M-JPEG compression has no inter-frame compression so a clip can be captured with
single-frame precision. Video files are often captured and edited using M-JPEG, then converted into MPEG when editing is complete.

Video conferencing

Until very recently, videoconferencing was a domain exclusive to
big business, due to its high cost and complex equipment requirements.
Now the advent of low cost videoconferencing software applications designed for use over the Internet is changing all that.

One of the most popular applications – around a million users are
claimed – is the appropriately-named CU-SeeMe, available as a free
download from the site of Cornell University (http://cu-seeme.cornell.edu)
which owns the copyright. With CU-SeeMe, which runs on either a Mac

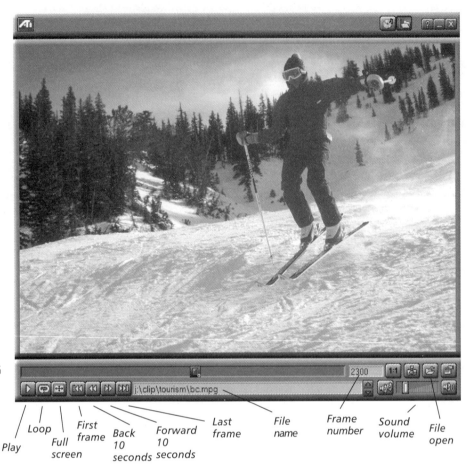

Figure 3.61 ATI's MPEG video player

Play

Loop

Full screen

First frame

Back 10 seconds

Forward 10 seconds

Last frame

File name

Frame number

Sound volume

File open

or a Windows PC, it is possible to videoconference with another site located anywhere around the world for the cost of a local call. In addition, by using what is called reflector software, multiple parties at different locations can participate in a conference, each from his or her own desktop computer.

The philosophy of the Cornell project was to extend the use of videoconferencing using available, affordable hardware and to stimulate creative thinking and create a wide base of user experience. Because CU-SeeMe uses simple but efficient video frame-differencing and compression algorithms, it opens networked videoconferencing capability to users of lower cost desktop computers, and enables broader participation in desktop video technology.

CU-SeeMee displays 4-bit greyscale video windows at 160 x 120 pixels or at double that diameter, and now includes audio. A participant can choose to be a receiver, a sender, or both. Receiving requires only a Mac with a screen capable of displaying 16 greys, or a PC with a screen capable of displaying 256 colours, and a connection to the Internet. Sending requires the addition of a digitising board and a low cost 'web

camera'. A popular example of such a camera, the QuickCam from Connectix (Figure 2.12), is now available with a USB interface. The USB version is hot-pluggable, meaning that users may attach or detach the camera without shutting down the system. The USB interface also simplifies wiring by using only one cable for both power and data. Connectix' second generation Video Digitally Enhanced Compression (VIDEC), combined with the increased bandwidth offered by USB, extends frame rates to twice the speed of earlier models. Users are no longer limited to postage stamp sized views. USB QuickCam offers full motion video at CIF resolution (352 x 288), approximately one quarter VGA, at 15 frames per second plus.

To send and receive video requires a video capture board which supports Microsoft Video For Windows and a video camera to plug into the video capture board. To send and receive audio requires a Windows sound board which conforms to the Windows MultiMedia specification (full duplex audio is desirable), plus speakers (or headphones) and a microphone. Video and audio interaction can be supplemented with written communication in a talk window – for example, a written piece of text could be presented for group comment. An individual microphone icon allows private conversations during a group videoconference without disrupting the flow of the discussion.

Figure 3.62 shows Cornell's visual user's guide to the application. The participants in a conference are listed in the main application window, which also displays data related to the transmission. The participant, or participants, within the field of view of the cameras at the two locations appear in separate local and remote video windows. Two other

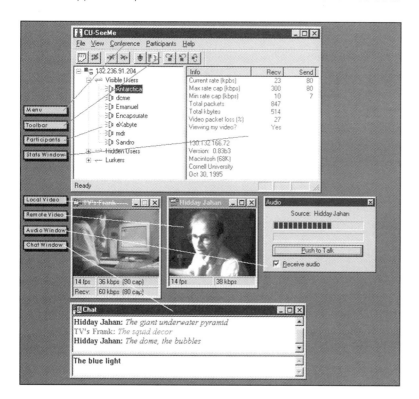

Figure 3.62 Videoconferencing with Cornell University's CU-SeeMe

windows are used to control direct audio transmission and the display of text. More information on use of the application can be found at the following Internet location: http://www.jungle.com/msattler/sci-tech/ comp/CU-SeeMe/users-guide/index.html.

Summary

The range and function of video and audio software available for the desktop is growing rapidly as application developers respond to increasing user interest in this sector of the market. In particular, advances in compression software have combined with development of the kind of video digitising hardware described in Chapter 2 to narrow considerably the gap between today's desktop video and true broadcast quality.

The editing software now available – of which we have looked at a representative range of examples – is capable of satisfying a range of needs, from simply remixing clips from different sources, to adding titles and transitions, to applying sophisticated special effects and creating hybrid multimedia productions. And all of this in a flexible, non-linear, environment.

We are already seeing results of the adoption of digital technology by the professional community in the form of exciting new films and television productions, while early Internet users have seen the Web transform from a static and relatively black and white environment to one which is increasingly vibrant with colour and animation. Video is set to play an increasing role in the realms of education, business and entertainment. Thanks to the availability of the latest video software, the desktop user has the chance to participate in these exciting new developments.

4

Video editing

Once a video signal has been digitised, it can be considered as simply a time-based series of still digital video images. From within video editing applications, single or multiple effects can be applied to all the frames within a movie or just to a selected clip within the movie. For more detailed editing, a selected clip can be exported to an image editing application as a 'frame stack' – a format which separates the clip into its individual frames. After editing of the individual frames is complete, the frame stack can be converted back to video clip format for reimporting back into the video editing application.

By temporarily exporting a frame from its location within the timebase to a digital photoediting or painting application like Photoshop or Painter, the whole array of techniques available within such applications can now be brought to bear on the contents of the frame, i.e. video editing is now possible not only at the individual frame level, but even at an individual pixel level within a frame!

It is through this level of control that digital video editing has made a quantum leap beyond the capabilities of analogue film or video editing. Now the pixels comprising individual video frames can be manipulated in much the same way that still images are manipulated in image-editing programs.

The reverse process is also possible, i.e. still images created in any drawing, photoediting, painting or 3D application – including those employing sophisticated atmospheric effects, procedural textures, etc. – can be inserted into, or overlayed on top of, a video stream. It is this ease of mixing and matching still images with video and sound which provides the basis for a breathtaking range of digital multimedia production possibilities.

In Chapter 3, we already saw a few examples of the software available for adding simple transitions, titles and motion. In this chapter we shall explore in more depth the remarkable range of video and audio special effects which digital video brings to the desktop.

Editing in the host applications

The editing techniques provided within applications like Premiere, Lumiere or MediaStudio fall basically into five categories – Transitions, Text effects, Motion effects, Video overlay and Filters. The following sections cover each of these in turn.

Transitions

The most common transition between clips is a cut – an instantaneous switch from one clip to the next one. The term derives from film editing, where edits are carried out in a 'cutting room' by literally cutting required sequences from reels of film and then splicing them together to make up a new reel.

In digital editing in the construction window, cutting between clips in a videoediting program is achieved by simply arranging the clips head

to tail on the same track in the construction window (if there is no transition effect and clips overlap, then clips in higher numbered video tracks play over the top of clips in lower numbered tracks).

Used correctly, transitions can provide an elegant and visually pleasing bridge between clips, adding value to the finished composition. Used incorrectly, they can interrupt the flow of visual information and distract attention from the project content. Because so many different transitions are available, the temptation is to use a variety, but for most projects, less is better.

In the majority of cases the simple cut from clip to clip works perfectly well and no transition is required; continuity is provided by the sound clip on the audio track. When a smooth and unobtrusive change from clip to clip is required then a simple *Crossfade* – which causes the first image to fade out as the second image fades in – works well (Figure 4.1). The choice of transition depends on the subject mood of the images on the clips being joined and on their contents; a fancy *Checker-Wipe* would not be appropriate between two slow-moving romantic scenes, but might work well in linking two motor-racing clips. Some transitions simulate physical events, such as *Side-Slide* which visually suggests the sliding back of a door, or *Center-Slide*, which suggests the opening of curtains. *Counter-Clock* simulates the movement of a hand around a clock, while Random-F/X causes the top image to break up and disappear in random fashion, revealing the underlying image. Transitions like these can help convey a particular message; for example, Random-F/X can suggest a flashback in time.

Figure 3.11 showed thumbnails of the transition effects provided with MediaStudio. These were divided into a number of categories with names like *Push, Slide, Wipe, Stretch, Peel, Clock, 3D, Roll* and *Build*, which help to suggest the nature of the transitions within each category. Media Studio's *Transition Options* dialog box (Figure 3.12) provided the means of adding borders and soft edges to the clips during the transition process.

Lumiere provides a wide range of transition types, listed in alphabetical order (Figure 4.2). Thumbnails demonstrate the effect of each transition and a descriptive message appears in the text box in the bottom-left hand corner when a transition type is selected. Figure 4.3 shows Lumiere's Transitions dialog box.

By default, the second track which the transition applies to is not visible (0%) at the start of the transition and is fully visible (100%) at the end. Clicking *Swap Sources* changes the order in which the transition is applied to the two clips and switches the clips shown in the *Start* and *Finish* preview boxes. For transitions with a direction of movement, the direction settings can be changed using the buttons in the *Direction* section of the dialog box. The *Border* slider adjusts border thickness and a colour for the border can be chosen by clicking on the colour swatch. Figures 4.4 and 4.5 show a few examples.

As well as straightforward application between two sequential videoclips, a transition clip can be used to create other effects – for example, to create 'video within video'. First a video transition clip is placed along the

Crossfade

Checker-Wipe

Side-Slide

Center-Slide

Counter-Clock

Figure 4.1 Transition examples

Figure 4.2 Lumiere's Transitions

entire length of two clips on tracks Va and Vb (Figure 4.6a), then, in the *Transition Options* dialog box, the *Start* and *End* transition sliders are set to the same value — 50% in the example shown (Figure 4.6b). The result is that the clip of the spacecraft plays in a window, while the clip of the planet plays in the background. The percentage figure set on the sliders determines the size of the window, a smaller percentage producing a smaller window.

Although there are several different methods which can be used to create a split screen, using a transition between clips on two video tracks is probably the easiest. In Lumiere (Figure 4.7a), video clips of a fire and a blizzard were first placed on video tracks A and B and a then a *Wedge Wipe* transition was dragged from the Transitions Roll-Up and placed on the transition track between the two clips (Any *Wipe* transition can be used for this effect). After double-clicking on the transition to display the *Wipe Settings* dialog box, the sliders below the *Start* and *Finish* frames were dragged until they were each set at 50%, splitting the screen in half, so that, when the video was run, the two scenes played back side by side in their separate halves of the screen.

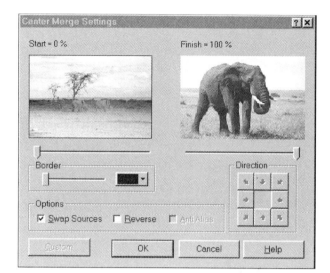

Figure 4.3 Corel Lumiere's Transitions dialog box

(a) Additive Dissolve – The first image fades out as the second image fades in

(b) Centre Merge – The first image splits into four parts and slides into the centre to expose the second image

(c) Curtain – The first image is drawn back, as if on curtains, to expose the second image

Figure 4.4 Examples of transitions applied in Corel Lumiere – (a) Additive Dissolve; (b) Center Merge; (c) Curtain

(a) Fold Up – The first image is repeatedly folded over to reveal the second image

(b) Funnel – The first image is pulled through a funnel to reveal the second image

(c) Iris Round – The second image emerges from within the first, as if through an opening iris. The marker in the centre of the iris can be dragged to offset the effect from the centre

(d) Page Peel – The first image is 'peeled off' to reveal the second image beneath

(e) Tumble Away – The first image is tumbles around, diminishing in size, to reveal the second image beneath

Figure 4.5 Examples of transitions applied in Corel Lumiere – (a) Fold Up; (b) Funnel; (c) Iris Round; (d) Page Peel; (e) Tumble Away

Figure 4.6 Using a transition to create a 'video within video' effect

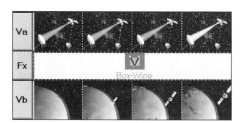

(a) Transition clip placed between two video clips

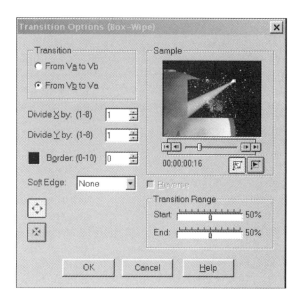

(b) Range sliders set to equal values

Figure 4.7 Using a transition to create a 'split screen' effect

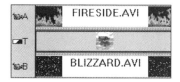

(a) First, a Wipe transition clip was placed between two video clips

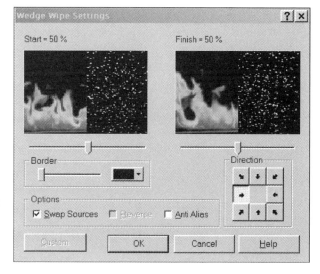

(b) Second, both sliders were set to 50%

Text effects

Although the most common use of text in a video project is to 'top and tail' the moving video with titles and credits, text also plays a wider role in training and promotional videos, where bullet text charts, tables or annotated flowcharts, for example, may be combined with video and sound to create a multimedia format.

For whatever purpose the text is being used, the first consideration should be clarity and legibility; overlaying blue type on a blue sky will not get the message across; neither will the use of a decorative script typeface at a point size which is illegible at normal viewing distance for the planned viewing device. Over capitalisation of type should be avoided; lower case type is easier to read. Brevity is also a virtue – a short, sharp, two-or three-word title is preferable to a rambling description which the viewer will probably not read to the end anyway.

The style of typeface should also be chosen to complement the video material to which the text applies. The same face will not be suitable for a business video, a pop video and a lyrical countryside travelogue. Thankfully the days of simply choosing between *Times Roman* and *Helvetica* are long gone; the titling utilities provided with video applications can access any typeface available on, or accessible by, the user's system, including hundreds, if not thousands of typefaces bundled with graphic applications like CorelDRAW or Illustrator. The range is truly spectacular and therein lies another potential pitfall – the temptation to use a variety of different faces within the same project. Generally, the fewer the typefaces used the more cohesive and integrated the result.

Traditionally, typefaces with similar attributes have been divided into five categories – Serif, Sans Serif, Script, Decorative and Machine. Figure 4.8 shows a few examples in each category. Selection of the 'right' typeface for a particular project is highly subjective; in general, Serif and Sans Serif faces provide a safe default choice, but other faces can give a project extra impact, for example by choosing a typeface with a recognised visual association, like those shown in Figure 4.9.

The typeface is just one of the text variables which can be set from within videoediting applications. Other user definable parameters are listed below:

- ○ Text alignment – left, centred, right or justified

- ○ Typeface size, style (normal, bold, italic or bold-italic) and type colour

- ○ Outline colour

- ○ Shadow offset and shadow colour

- ○ Text transparency (uniform or gradient)

- ○ Background (matte or an imported image or a video clip freeze frame, which will show behind the text as a still image)

Americana Fry's Baskerville Goudy

Times Garamond ITC Bookman

Avant Garde Blippo Black Helvetica

Bernhard Fashion BREMEN BLACK Revue

American Text Brush Script Stacatto

LIBRA Zapf Chancery

Broadway Exotic STENCIL

Parisian Hobo

Amelia KEYPUNCH PIONEER

Courier MACHINE

Figure 4.8 Examples from the five traditional type families – Serif, Sans Serif, Script, Decorative and Machine

ANCIENT GREECE (LITHOGRAPH)

CHINA (MANDARIN)

SCANDINAVIA [VIKING]

KASBAH (ALGERIAN)

KENSINGTON PALACE (CARLETON)

Deutschland (Fette Fraktur)

Figure 4.9 Typefaces with special significance (Typeface names in brackets)

Using a suitable combination of the above parameters, a text clip can be prepared and placed on a video track, where it plays like a video clip. Placing it on a superimposition track allows the background to show behind the title. The transparency of superimposed text can also be increased to let the underlying video show through the text itself.

While offering the impressive range of text editing options described above, videoediting applications cannot compete with the text manipulation features of drawing or painting applications like CorelDRAW, Freehand or Photoshop. When a project requires something special, one of these applications can be used to explore an even wider range of options. A page is simply set up in the application to match the form factor of the video clip; the required effect is created and the page is then saved in bitmap format ready for importing to a video track or superimposition track. Additional variables which can be manipulated from within drawing applications include:

○ Fancy text fills (gradients, textures or patterns)

○ Text rotation to any angle, skewing or mirroring

○ Extrusion and perspective

○ Embossing

○ Fitting text to a path or a shape

○ Blending

○ Fitting text to curve

○ Node editing of text characters

○ Masking

○ Combining text with graphics to create 'word pictures'

These variables can be applied individually or in combination to create a dazzling range of effects. A few examples, taken from an earlier book – *Digital Graphic Design* – are shown in Figure 4.10.

A technique which can be used to provide information about what is appearing on a video track in an unobtrusive way is to fade the text into view and then to fade it out after allowing time for it to be read by the viewer. Figure 4.11 shows how this fading effect is applied in Lumiere.

After creating a text clip using the titler and saving it to the *Media Catalog*, the clip is dragged on to a superimpose track, in this case *S1*. Clicking anywhere along the lower border of the clip opens the fade window immediately below the clip. By default, fade is off, as represented by a solid line running along the top of the fade window; this indicates that the superimpose clip is 100% visible. Three tool buttons to the left of the window are used to edit the fade curve. The *Fade Control* tool 🔘 can be used to move the entire fade control line up or down. The *Add/Delete* tool 🔘 is used to add or remove control points anywhere along the line. The *Adjust Control Point* tool 🔘 is used to manipulate the positioning of control points once they have been created. In the example shown in Figure 4.11, the text fades from 0% visibility to 80% visibility, where it remains for about 2 seconds before it fades back to 0%.

In Chapter 3 we saw how scrolling titles could be created using the Pan feature in Lumiere. Simple text animation is also possible from within Studio 200's titling facility (Figure 4.12). Clicking the Animation button opens the dialog shown in Figure 4.12; the *Type of Effect* drop down list in the *Entrance* group box offers a number of ways in which text (and any associated graphics) can be animated on to and off of the screen:

(a) fancy fills

(b) Extrusion

(c) Embossing

(d) Combining text and graphics

(e) Using text as a mask

(f) Fitting text to a curve

Figure 4.10 Examples of text effects created in drawing and painting applications

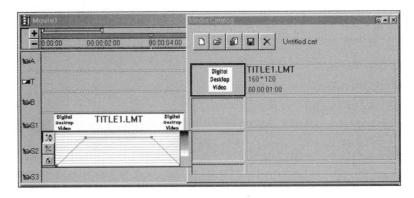

Figure 4.11 Applying Fade In and Fade Out to a title clip in Corel Lumiere

○ *Wipe* starts to reveal text starting from one edge and wiping across the text until it is all visible

○ *Slide* causes text to enter the screen from one side or corner and then to slide to or from the centre of the video frame

Repeated clicking on the *Entrance* or *Exit* arrow buttons rotates through a range of directions which can be applied to the animation effect and sliders are provided to adjust the duration of the effect. *Fade in* and *Fade Out* buttons are also provided. Clicking on *View Entrance* and then *View Exit* shows a preview of the animation on an attached TV monitor.

In Chapter 5 we shall look at more sophisticated ways of animating text as well as other objects.

Figure 4.12 Clicking the Animation button 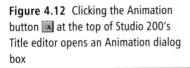 at the top of Studio 200's Title editor opens an Animation dialog box

Motion

A general rule for the use of motion effects is the same as that for the use of transitions – they should be used sparingly to avoid inflicting motion sickness on the viewer! When a motion effect is used, it should ideally complement the content of the clip to which it is being applied – e.g. the use of a 3D Sphere path to end a clip about a sailing ship circum-navigating the globe, or the use of a *Zoom Out* effect to mark the end of an episode.

The basic motion features provided within videoediting applications were described in Chapter 3 and can be summarised as follows:

○ Moving clips along two-dimensional paths

○ Moving clips around imaginary three-dimensional surfaces

○ Rotating clips in two dimensions

○ Zooming in or zooming out

○ Distorting shape, e.g. by applying perspective

○ Accelerating or decelerating along a path

○ Compressing or expanding the duration of a clip to create slow or fast motion effects

○ Reversing the direction of a clip

○ Skipping frames to create jerky, staccato movement

○ Panning to create the impression of motion in a still image clip

○ Applying presets based on a combination of the above variables

Figure 3.38 showed Premiere's dialog box which is used to apply motion effects such as rotation, zoom and distortion to video clips. Figures 4.13 and 4.14 show some examples of the results which can be created.

Lumiere also includes a menu of motion presets, including:

○ Bounce In – clip drops into view and appears to bounce before settling on the bottom of the frame

○ Falling – clips falls from frame out of sight

○ Flip – clip tumbles and flips over from left to right

○ In and Out – clip increases and decreases in size as it traverses across the frame

○ Loose – clip wobbles as if coming loose from its fixing and then drops out of sight

TECHNICAL TIP
To add slow or fast motion to a sequence, it is important to experiment with creating a moving path and positioning control points at varying places along the path. In general, the closer to the start control point, the slower the motion, the closer to the end control point, the faster the motion

○ Ricochet – clip moves around the frame as if bouncing off the sides

○ Slidehold – clip slides into view, pauses, and then slides out of view like a slide displayed on a projector

○ Sweepin – clip follows a curved path, starting from a small size in a corner of the frame and zooming along the path until it is centred, at full size

○ Swing – clip appears to swing to and fro', as if hinged along its top edge

○ TV – clips shrinks to a horizontal line and then a dot as if viewed on a television monitor being switched off

○ Walking – clip is distorted to look like a playing card walking across the frame from left to right

Video overlay effects

A technique used to powerful effect both on television and in the cinema, the overlay employs colour keying to make part of a video clip transparent, revealing an underlying clip in the transparent area. Because

The Path ### *Three frames from the playback*

(a) A simple horizontal 2D path; the clip starts to the left of the Visible Area, traverses the Visible Area and disappears off to the right

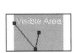

(b) Clip bounces in from upper left of screen. By adjusting the rotation and zoom settings for the different points on the path, the clip is made to grow in size and rotate as it bounces across the Visible Area

Figure 4.13 Applying motion in Premiere. (a) A simple linear path; (b) Bounce, using rotate and zoom

(a) In this more complex path, a clip starts within the Visible Area and then moves around in a random fashion. By adjusting the distortion and zoom settings for the different points on the path, the clip is made to change in shape and size as if made of elastic

(b) In this falling leaf effect, as the clip follows the path and variations in distortion, zoom and delay settings create a flowing movement which simulates the motion of a falling leaf

(c) In this example, the clip follows a two-dimensional spiral path. Variations in the zoom setting cause it to start out small and then increase in size as it traces out a spiral path

(d) Using a path consisting of a single node, adjustment of rotation and zoom settings causes this clip to spin out from the centre as it enlarges in size

(e) Using a linear path starting from the centre, adjustment of distortion and zoom settings causes this clip to zoom from the centre off to the left of the frame

Figure 4.14 Using motion to create (a) a random distortion effect; (b) a falling leaf simulation; (c) a spiralling zoom effect; (d) a spinout effect and (e) a zoom out effect

The process of overlaying or superimposition, called keying in television production and matting in film production, incorporates various methods of playing a clip over another clip. Areas of the top clip, called the superimposed clip, are made transparent to allow the bottom clip (or background clip) to show through. Transparency in the superimposed clip is created in a variety of ways, from blocking out portions of the clip (creating a matte) to specifying ranges of colour to be transparent

overlaying a clip basically conceals or reveals parts of the underlying clip, the clip used as an overlay is often referred to as a mask. The most common use of this technique is in television news or weather presentation; if the overlay clip on a superimpose track showing the presenter is shot against a solid colour background – usually blue – and the blue is selected and made transparent, then whatever image appears on the underlying clip on a video track will be revealed, so that the presenter appears to be sitting or standing in front of this virtual background image. Figure 4.15 shows an example. In MediaStudio, a shot of a great white shark set against a blue background (a) was placed on superimpose track *V1* and a shot of an underwater scene (b) was placed on video track *Va*, as shown in (c). After clicking on the shark clip, *Overlay Options* was selected from MediaStudio's *Clip* dropdown menu, opening the dialog box shown in (d). Selecting *Color Key* from the *Type* menu displayed an *Eyedropper* tool which was used to click on the blue background in the *Overlay Clip* window. The effect of this was to render the background transparent – i.e. the blue is said to be 'keyed out' – revealing the clip of the underwater scene on track *Va* and merging the shark into the underwater scene.

Media Studio provides a variety of options for keying in the colour of an image with controls offered by the *Type* and *Factor* boxes as well as the *Similarity* group box. The best option to use depends on the type of clip selected and the effect being sought. As a rule of thumb, keying on the colour of an image works well with solid colour areas such as blue screens. If the overlay clip is greyscale, then keying is done on the grey. The luma key is useful for keying on the brightness levels of an image, while the chroma is best for keying on the colour values of an image. If the overlay clip is an image, its alpha channel can be used for keying if it has one.

The overlay clip used as a mask can, itself, be modified by using image or video mattes which work also very much like masks, except that they are used to cover or reveal certain parts of the overlay clip itself, instead of the clip in the timeline, effectively 'masking the mask'. A typical example of use of a video matte seen on TV shows like the BBC's popular *Top of the Pops* is the silhouette of a dancer appearing over a background, and the silhouette of her body containing another image or video.

The MediaStudio *Overlay Options* dialog box offers a wide range of possibilities. By simply adjusting points along the *Transparency* curve for example (Figure 4.16a), the overlay clip can be made to change progressively from being fully visible, to being 50% transparent (Figure 4.16b), to being invisible, or vice-versa.

Other variables set from the dialog box are summarised below:

Alpha channels: In addition to the three RGB or four CMYK 8-bit channels into which a colour image can be separated, additional mask channels – often called Alpha channels – can be used to store masks for isolating, or masking, parts of the image. Special effects or filters can then be applied just to the areas defined by the alpha channel masks

○ The Type menu provides options for specifying the basis for selecting the overlay mask

 – *Color Key* works well when working with solid colours in the image, such as blue screens

 – *Chroma Key* works with the colour values in an image and is used to specify a colour, or range of colours. The

eyedropper tool can be used to select a colour from the clip, or a colour can be selected by clicking on the colour swatch to open the colour palette. The *Similarity* slider is used to select a range of related colours. When the *Similarity* slider is set to zero, only the selected colour is made transparent. As the slider is moved to the right, the tolerance increases so that similar colours are made transparent

– *Luma Key* works on the brightness values in an image and is useful for making dark or light areas of an image transparent

– *Alpha channel* can be used if the overlay clip is an image

(a)

(c)

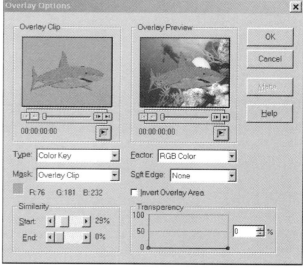

(b)

(d)

Figure 4.15 Using Overlay in MediaStudio to merge a clip of a great white shark (a) into a clip of an underwater scene (b). First the clips were placed on tracks Va and V1 (c) and then the background behind the shark was made transparent (d)

(a)

(b)

Figure 4.16 Adjusting the transparency of the overlay clip in MediaStudio

and has been saved, e.g. from Photoshop, with an alpha channel; keying takes place on the alpha channel. An example is shown in Figure 4.17. The alpha channel appears in the *Overlay Clip* window and the result is that the area outside the channel is masked, allowing the underlying clip to show through

○ *Mask* allows the use of a video or image file as the source for the overlay. In Figure 4.18, the overlay clip (the face) is masking an underlying clip of our friend, the motorcyclist. By selecting *Mask/Overlay Clip* and then using the eyedropper to click on the grey in the face, we can actually 'mask the mask' i.e. the underlying clip plays through just the grey areas of the face. Quite spectacular results can be achieved by using this effect. As well as using colour to moderate the effect of the overlay clip, by clicking on *Mask/Image Matte*, an image can be imported – such as the checkerboard pattern in Figure 4.19 – and used to edit the overlay mask. Even a video clip can be used to edit an overlay mask as shown in the example in Figure 4.20. The video clip to be used as a mask is imported by clicking on *Mask/Video Matte* and importing the video file into the *Overlay Clip* window; previewing the effect shows that the video dynamically edits the transparency of the overlay clip as the movie plays

○ The *Similarity* sliders specify the range of key colours relative to the selected one for the overlay. The higher the percentage, the more colours are used as the overlay. Two slider bars correspond to the starting and ending frames for the clip

○ *Factor* (*RGB colour, Luma* or *Chroma*) determines which colour components of the underlying clip are dominant

○ *Soft Edge* (*None, Small, Medium* or *Large*) controls how strong the transition is between the overlay and the clip. *Large* results in a less pronounced transition

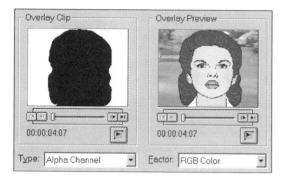

Figure 4.17 Keying on an alpha channel saved with a still image

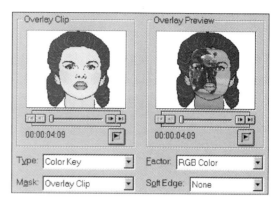

Figure 4.18 Using a colour-keyed overlay clip as a mask

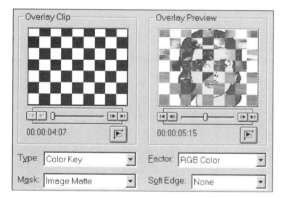

Figure 4.19 Using an image mask to mask an overlay clip

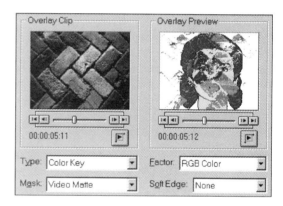

Figure 4.20 Using a video matte to mask an overlay clip

○ *Invert Overlay Area* makes all colours except the selected one key colours

Alpha Channel mapping can be applied to situations requiring high-lighting of a feature within a video clip, such as a figure appearing in a security video. Figure 4.21 shows an example. A still image clip is first created, in an application like Photoshop or Illustrator, containing only an alpha channel – in this case a simple circle – and placed on track V1, with the clip containing the feature to be highlighted placed on track Va. By setting the *Type* to *Alpha Channel* and adjusting the transparency to 50%, the head and shoulders of the figure in the Va clip becomes highlighted in the area defined by the alpha channel. By applying a simple 2D Path to the overlay clip (Figure 4.22), the highlighted area can be made to track the figure as it moves within the video clip.

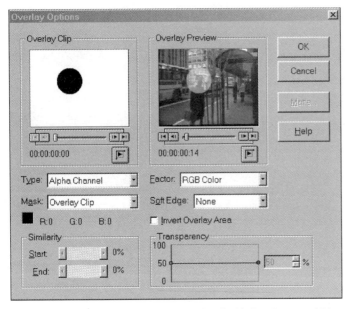

Figure 4.22 Using a 2D Path to control the movement of an Alpha Channel mask

Figure 4.21 Using an Alpha Channel mask to highlight a feature within a video clip

Via its *Transparency* dialog box (Figure 4.23), Lumiere offers seven different key types – *Chroma, Luminance, RGB difference, Blue screen, Green screen, Image matte* and *Difference matte,* providing an even wider range of possibilities than MediaStudio, when the key types are used in combination with the twenty different modes selectable from the *Merge mode* menu in the dialog box. Lumiere's *Merge modes* are similar to those found in image editing applications like Photoshop; they determine the way in which the hue, saturation and brightness values of two overlayed images interact with each other.

The *Blue screen* key type makes the colour chroma blue transparent (chroma blue is a solid blue containing little or no red or green, corresponding approximately to PANTONE 2735, and is effective in isolating skin tones). Filming a person or group of people against a chroma blue background is a common technique used to display the person or group against a virtual background.

The *Green screen* key type is the same as *Blue screen*, except that it makes chroma green transparent (chroma green is a solid green containing little or no red or blue, corresponding approximately to PANTONE 354, and is used to isolate reds and blues from a background).

The *Difference matte* key type makes the identical areas of two clips transparent and shows only the areas which are different. When *Difference matte* is selected as the key type in the *Transparency* dialog box, a clip must be selected via the *Browse* button to be used as the matte for the superimposed clip.

Premiere offers the most impressive number of different key types, available from the dialog box shown in Figure 4.24. As well as the types described already are *White Alpha Matte* and *Black Alpha Matte. White*

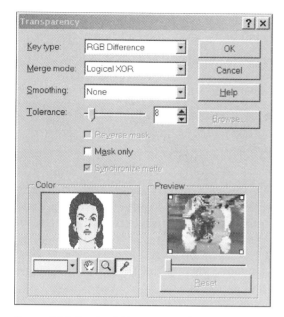

Figure 4.23 Lumiere's Transparency dialog box

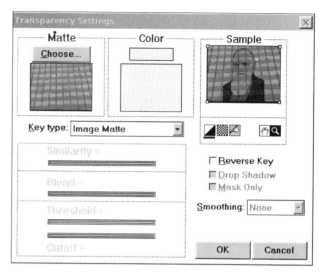

Figure 4.24 Premiere's Transparency Settings dialog box

Alpha Matte is used to superimpose an image which contains an alpha channel and which has been created on a white background (it eliminates the halo-like remnants of white around the edges of the foreground image and is useful for superimposing titles which have been created on a white background). *Black Alpha Matte* is used to superimpose an image which contains an alpha channel and which has been created on a black background. The *Multiply* key type has the effect of casting the superimposed clip on to the bright areas of the underlying image. The *Track Matte* uses a video clip to create a moving mask.

○ The *Similarity* slider is used to select a range of colours to be made transparent. To select a range of colours similar to the one in the colour swatch, the *Similarity* slider is dragged between *None* and *High*; the higher the setting, the broader the range of colours selected

○ The *Blend* slider smooths sharp transitions in colour by creating a gradual change in opacity in the pixels between the two colours

○ The *Threshold* slider is used to adjust the amount of shadow in a superimposed clip

○ The *Cutoff* slider allows adjustment of the shadow detail with the luminance and chroma keys

○ The *Reverse Key* option is used to reverse the transparent area – for example, from the area inside a matte to the area outside a matte

○ The *Drop Shadow* option applies a 50% grey shadow slightly below and to the right of the transparent portion of the clip

○ The *Mask Only* option creates a black-and-white or greyscale mask from the transparent portion of the clip – useful when exporting a clip to Photoshop for retouching

○ The *Smoothing* option creates soft edges where colour transitions occur throughout the superimposed clip. Options are *None, Low,* or *High*

Figure 4.25 Dragging corner handles to create a split screen

The three icons ◩▦◲ under the *Sample* window in the Premiere's dialog box (Figure 4.22) provide different methods of previewing transparency effects. Using the first icon, black or white can be chosen to fill the background. The second icon places a checker-board pattern in the background and the third icon allows the actual background clip to show through. The handles at the four corners of the Sample window can be dragged to reduce the visible area of the clip on the superimpose track. This can be used as another method to create a split screen (Figure 4.25).

Video filters

The use of filters, special effects which alter the appearance of still bitmapped images in photoediting or painting applications like Photoshop or Painter, has widely extended their artistic repertoire. Although as yet less sophisticated in their range, filters based on the same technology have been ported to videoediting applications.

In Media Studio, the intensity of a filter can be varied at the start, end, and intermediate stages of a clip. In theory, each clip in a project may have up to twenty filters applied at one time.

Figure 4.26 shows Media Studio's *Video Filters* dialog box which lists available filter types in the left-hand window. After selecting a video clip, clicking on *Clip/Video Filters* opens the dialog and the required filter – for example *Emboss* – is selected using the *Add* button. Clicking the *Options* button opens the window shown in Figure 4.27a, where the effect can be previewed and adjusted. The *Range* button opens window (b) where handles can be dragged to define the area of the clip affected by the filter (c).

Figure 4.28 shows the full set of filters supplied with Media Studio. The effects of applying a number of these to the same video clip are shown in Figure 4.29:

Figure 4.26 Media Studio's Video Filters dialog box

Figure 4.27 Applying an Emboss filter in Media Studio

(a)

(b)

(c)

Figure 4.28 Media Studio's filter types

○ Average: Gives the clip a softer look by moving the colour values of all pixels towards those of the average pixel

○ Find Edges: Displays the clip with outlines around the edges of objects defined by strong differences in pixel colour values

○ Fish Eye: Gives the clip a wide angle camera lens effect

○ Invert: Converts the clip to its complementary colours, creating a negative effect

○ Mosaic: Breaks each frame into blocks closely matching the average values of all pixels in these blocks

○ Punch: Displays the clip as if its centre had been pushed out

Figure 4.29 Six of Media Studio's filters

Media Studio's filters, like its transitions, can also be dragged from a window (Figure 4.30) displaying thumbnails of each effect on to the video clip to be filtered. This automatically opens the preview window in Figure 4.27a for editing if required.

Corel's Lumiere offers an impressive list of 58 different filter types. Like Media Studio, Lumiere provides a *Video Filters* dialog box (Figure 4.31) where filters can be selected and their effects previewed. When a filter is chosen from the list, a brief text description of its effect appears below the *Available* window.

Figure 4.30 Media Studio's thumbnail display of filter effects

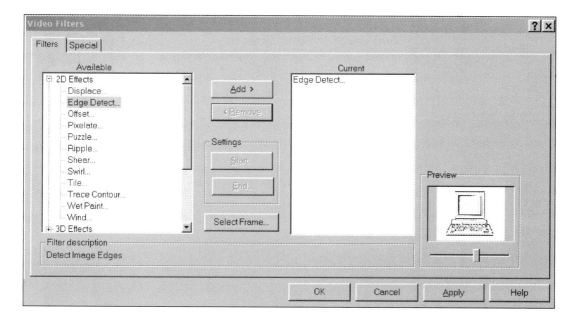

Figure 4.31 Lumiere's Video Filters dialog box

Figure 4.32 Lumiere's comprehensive filter list

The complete list of Lumiere filter types, divided into nine categories, is shown in Figure 4.32. Editing options vary with the type of filter selected. Some examples are described below and shown in Figure 4.33.

Puzzle: Breaks the image into puzzle-like pieces, or blocks, resembling a jigsaw puzzle

Tile: The Tile effect creates blocks of the image in a grid. The number of images on each axis can be adjusted

Wet Paint: Smears the image, creating the illusion of wet paint. Combinations of positive and negative wetness can be applied to the same object to produce drop shadows

Map to Object: Creates the illusion that the image has been wrapped around a sphere (in the example shown) or a vertical or horizontal cylinder

Impressionist: Transforms the image, making it look like an oil painting in the Impressionist style

Lens Flare: Produces a spot of light that resembles a reflection within an optical system

Figure 4.33 Lumiere examples

Adobe Premiere includes 58 movie and still-image filters (Figure 4.34) to distort, blur, sharpen, smooth, texture, and colour images. Not surprisingly, many of these are reminiscent of Adobe Photoshop's filter set; in fact many of the third party filters which work with Photoshop can be copied from Photoshop's Plugins directory to Premiere's Plugins directory, to extend the range of possibilities even further.

Premiere's *Filters* dialog box (Figure 4.35) is similar to that of Media Studio and Lumiere. Filters to be applied to a selected clip are selected from the *Available* list and added to the *Current* list using the *Add* button. Some filter types have their own *Settings* dialog box, such as that shown in Figure 4.36 for the *Ripple* filter. Others do not and their effect can only be seen by previewing the clip after the filter has been applied. In the Construction window, clips with filters applied to them are displayed with a blue stripe along the top.

Figure 4.35 Premiere's Filters dialog box

Figure 4.34 Premiere's filters

Figure 4.36 Premiere provides different filter editing boxes for different filter types

Editing in drawing and painting applications

Creating still image frames

For many video professionals and enthusiasts, videoediting is just that – editing video. The bulk of their work involves manipulating and editing video footage, with perhaps just the addition of the occasional title clip. For others – particularly those creating educational or promotional material – the use of drawing and painting applications gives access to (a) a much wider range of raw material which can be combined with video and audio to create what has become known as multimedia productions and (b) sophisticated still image editing techniques developed over many years. Still images produced using these applications can be interleaved with video material or shown alongside it, using a split screen technique. Some of the potential benefits are summarised below:

○ Access to a much wider range of text effects than those provided by videoediting applications, as we saw earlier in this chapter

○ Use of sophisticated vector drawing tools and techniques (e.g. blending, extrusion, enveloping) and special photoediting features such as channels, layers and complex paths

○ Inclusion of 3D effects

○ Preparation of 'slides' in a drawing application incorporating bulleted text, graphs, or tables, or design of charts using a combination of text, graphics and images

○ Incorporation of drawings from clipart libraries in creating still frames, used 'as is' or edited and combined with other elements

○ Access to Photo CD libraries of professionally shot still images

○ Use of screen grabs, fractals or public domain images downloaded from the Internet

○ Use of scanned 2D and 3D images and digital still images

○ Selection of a frame from a video clip, for clean-up, editing or embellishing before reinsertion into a project as a title background

Any of the stills created using the above sources and techniques can be displayed as a still video clip within a project, or as a still insert within a moving video screen. For example a documentary movie could

include a series of still images displayed in one half of a split screen while a narrator talks about their contents in the other half of the screen.

Figures 4.37 to 4.41 show examples of the kind of 'slides' which can easily be imported from drawing and painting applications into a video project.

Media Studio comes bundled with its own bitmap editing application called Image Editor (Figure 4.42) which is adequate for basic image manipulation. Corel provides PHOTO-PAINT, a much more sophisticated image editor, with Lumiere. Premiere does not provide an image editor but, as you would expect, works well with its market-leading photoediting application Photoshop. For the production of line drawings, any of the leading applications like Freehand, Illustrator or CorelDRAW are rich in features, while applications like RayDream Studio or Extreme 3D can be

Figure 4.37 Examples of charts created in Corel CHART. (a) Construction window and a 3D column chart; (b) a 2D bar chart; (c) 3D graphs

(a)

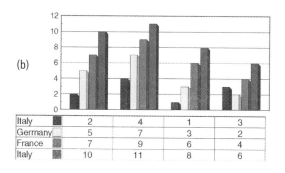

(b)

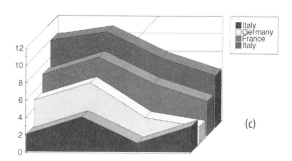

(c)

Figure 4.38 Professionally drawn clipart images can be used 'as is' or combined with other elements like text or images

Figure 4.39 Filials and ornaments can be used to decorate still frames or to create borders

Figure 4.40 Perspective grids can create a dramatic illusion of depth

Table created in Illustrator

Bullet chart created in CorelDRAW

Wiregrid sphere created in Micrografx Designer

Painter illustration

Text effects in Painter

Clipart world map

Fractint fractal moonscape

Figure 4.41 Range of still image examples

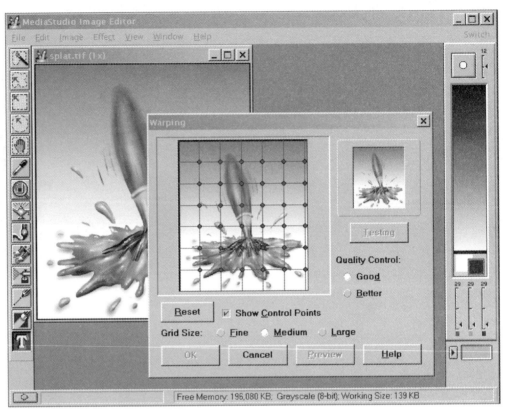

Figure 4.42 Image Editor comes
bundled with Media Studio

used to create impressive 3D graphics. In addition, specialist applications
like Bryce and Poser are capable of producing quite amazing landscapes
and posed human figures.

There is not sufficient space in this book to describe the remark-
able range of graphic effects which can be produced using a combination
of the above applications. Readers interested in learning more may wish
to refer to previous books by the author – *Digital Graphic Design* and
Digital Colour in Graphic Design – as well as other titles listed in the
bibliography.

Editing through the use of scripts

The use of applications like PHOTO-PAINT and Painter in video pro-
duction is not limited to the creation of still images; both applications
provide the means of applying special effects to a series of frames within
a video clip without the need to address each frame in turn. They do this
through the use of scripts – also called macros in some applications. Scripts
automate a series of actions which can be repeated on the same image or
on several different images. A script is a recording of the series of editing
actions which can be saved to disk for retrieval at any time. In PHOTO-
PAINT the recording of such a series of actions and the resulting script can
be edited in Corel's SCRIPT Editor and played back using the tape deck
controls and commands in a *Recorder* window which looks and behaves

much like a tape recorder (Figure 4.43a). Activating this script (Figure 4.43b) opens a box (c) into which text is entered using the script language protocols. Clicking on *OK* then triggers a series of image editing actions which create a video clip ten frames in length depicting the text – the single word INFERNO, in this case – being consumed by flickering flames. The clip is automatically displayed in a window (Figure 4.43d).

In still image work, scripts save time when performing standard operations such as resampling images, using masks to make selections or making global adjustments to different images. Using the record button in the *Recorder* window, almost all keyboard, toolbar, toolbox, menu, and mouse actions can be recorded. As the recording takes place, the actions are translated into command statements which are numbered chronologically in the command list. Playing or running a script applies the recorded actions to the active image, like the text string in the example below.

PHOTO-PAINT provides a number of prerecorded scripts which can be applied to still images or video clips (Figure 4.44). The majority of these create text effects but examples of scripts which can be applied to video clips are included, for example:

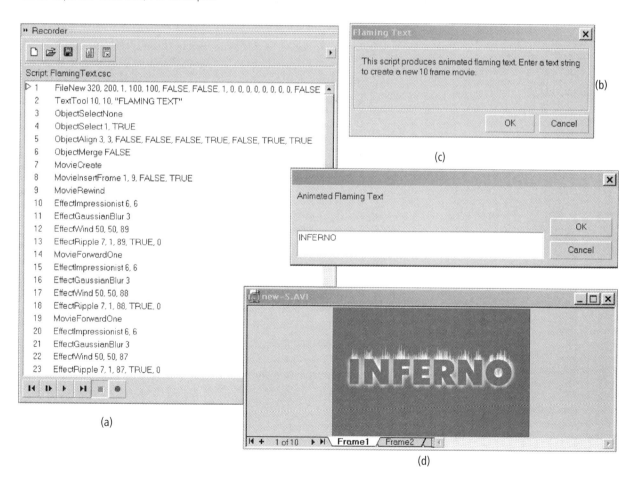

Figure 4.43 Applying scripts in PHOTO-PAINT

Figure 4.44 PHOTO-PAINT's menu of preset scripts

○ *Movie Builder* – builds a movie using sequentially numbered still image files stored in the same directory (e.g. image01.tif, image02.tif, etc.)

○ *Movie Fader* – produces a fade out effect over a series of movie frames

Once created, scripts can be edited like any text file, using cut, copy or paste to remove, modify or add actions to the same script or to a new one.

Painter employs a similar VCR deck metaphor to that of PHOTO-PAINT for recording and playing back scripts. The deck is activated by clicking *Script* in the *Objects* palette (Figure 4.45). Used correctly, a script can provide a powerful educational tool. For example, playing back the script of an art project – the rendering of the Mona Lisa in Figure 4.46 – demonstrates the step-by-step process used by the artist to create it. As the script plays, the artwork evolves and develops just as it did when it was first created. Controls on the deck can be used to pause, replay or step forwards or backwards through the development of the piece.

A Painter script can also be used to create a video clip of the process represented by the script; the editing actions described within the script become frames within a new video clip by carrying out the following steps:

Figure 4.45 Painter's Script controls

○ The recorded session is first loaded via the *Objects: Scripts* window

○ A new Painter image is opened at the size at which the video clip is to be created

Figure 4.46 Four stages of construction from the playback of a script of a painting of the Mona Lisa in Painter

○ *Script Options* is selected from the *Script* dropdown menu, opening the dialog box in Figure 4.47a

○ Clicking *Save Frames on Playback* directs Painter to create a video frame from each process step. The frame rate is also set from this box (the lower the number entered, the higher the frame rate)

○ Clicking the *Play* button in the *Script* palette opens the dialog box in (b) asking for the parameters for a new frame stack (a frame stack is a video clip separated into its individual frames – see more on this subject later)

○ After the frame stack parameters have been set, another dialog box opens, asking for a name and a *Save* destination for the new frame stack. Clicking *OK* in this box, after entering a file name, causes Painter to play the script back into a new frame stack and opens the *Frame Stacks* dialog box (c)

○ Finally, the frame stack has to be converted to a video format. Clicking on *File/Save As* opens the dialog box in Figure 4.48 where the AVI option and frame rate can be selected before clicking on *OK* to save the Painter session as an AVI file

Painter scripts can also be used to apply special effects to video clips using just a single command. Figure 4.49 shows an example of one of Painter's libraries, in which a thumbnail represents each of the effects. The procedure for applying an effect to a video clip is as follows:

○ The video clip to which the effect is to be applied is first opened and converted to frame stack format (Figure 4.50a)

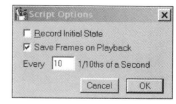

(a)

(b)

(c)

Figure 4.47 Converting a Painter session into a frame stack

Figure 4.48 Saving a Painter session as a movie

Figure 4.49 Thumbnails showing script effects

○ *Apply Script to Movie* is selected from Painter's *Movie* menu

○ Painter opens a dialog box which lists the scripts in the current library by name (Figure 4.50b)

○ When *Playback* is clicked in the Recorded Scripts dialog box, the script – in this case *Corduroy Effect* – is applied to each of the frames in the frame stack in turn (Figure 4.50c). The time taken depends on the number of frames in the stack

○ Finally the frame stack can be saved, once again, as an AVI video clip

Painter provides several libraries of special effects scripts. Figure 4.51 shows just a few examples.

Rotoscoping, compositing, cloning and tracing

Rotoscoping is the process of painting and applying effects to an existing video clip – for example, a captured video segment – or compositing a portion of the images from one clip with the images of another. This is a time-consuming process, as 25 frames have to be edited for each second of video, but it provides an enormous degree of control as all the tools and techniques of image editing applications like PHOTO-PAINT or Painter can be applied to the task. In some cases, where the changes are repetitive from frame to frame, a script can be created to apply changes made to the first frame, to successive frames.

Figure 4.52a shows an example of a frame from a clip displaying an empty, Disney-like, paved street scene. After opening the clip in PHOTO-PAINT, the application's paintbrush and object manipulation tools were used to add a figure to the scene (Figure 4.52b). The figure was saved as an object, placed in the next frame (Figure 4.52c), and edited to create the effect of the figure striding along the street. Painting the figure's shadow on the paving shows how this can help integrate the figure into the scene.

Figure 4.50 Using a script to apply a special effect to a video clip

(a) (b) (c)

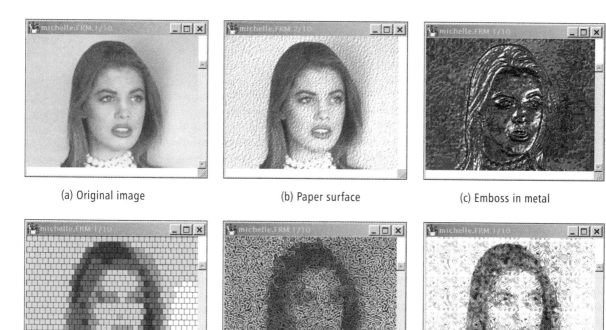

(a) Original image (b) Paper surface (c) Emboss in metal

(a) Brick stitch (b) Spaghetti (c) Crosshatch

Figure 4.51 Examples of Painter's special effects scripts applied to a video clip

Rotoscoping is often used to put the action of a person or an object filmed in one place on a background filmed in another, or to remove an unwanted element from a video clip. Figure 4.53a shows a frame from a videoclip depicting a helicopter ambulance flying over a stretch of water. After creating a feathered mask to protect the helicopter image, a second image, of a rocky terrain was opened in PHOTO-PAINT and sized to match the resolution and frame size of the first image. The terrain image was then copied to the clipboard and PHOTO-PAINT's *Paste Inside* command was used to paste the terrain 'beneath' the helicopter (Figure 4.53b). The same technique can be used to produce a wide range of effects; Figure 4.53c shows a mountain valley scene pasted beneath the helicopter.

Figure 4.54 shows how rotoscoping can be used to 'clean up' the image on a video clip. A frame from the original clip is shown in Figure 4.54a. Using PHOTO-PAINT's cloning tool, the area below the white symbol in the top left corner of the frame was selected and the *Clone* tool was used to paint out the symbol (Figure 4.54b). Next, the area to the top right corner of the frame was selected and the *Clone* tool was used to paint out the face behind the main figure (Figure 4.54c).

Before a clip is opened in PHOTO-PAINT, the *Partial Load Movie* preview dialog box shown in Figure 4.55 appears. The slider or the VCR-like controls can be used to preview the clip and the section to be opened for editing can be selected either by dragging the two markers which can be seen at the ends of the slider, or by entering frame numbers in the

 (a) (b) (c)

Figure 4.52 Using PHOTO-PAINT to add a figure – (b) and (c) – to the video frame in (a)

 (a) (b) (c)

Figure 4.53 Rotoscoping in PHOTO-PAINT

 (a) (b) (c)

Figure 4.54 Removing the background clutter from an image

Figure 4.55 Loading part of a clip in PHOTO-PAINT

boxes provided. This can reduce the memory problems which can arise when a large movie file is opened.

When opening a video clip in Painter for editing, it is also more efficient to open just the segment of the clip to be edited. When a clip is opened in Painter, it is automatically converted to a frame stack. Framestacks are uncompressed, so, for example, a 1 Mb AVI movie can easily become a 20 Mb framestack. If only the first 20 seconds of a 3-minute clip are to be edited, then these 20 seconds can be separated off in a videoediting application, edited in Painter and then returned to the original clip.

Painter can also be used to composite two video clips together into one – for example, to composite a foreground action against a new background – using the following procedure:

○ First the foreground action must be masked in each frame by creating a selection. Because the foreground image continues to move, the selection in each frame must be different. (When the background is uniform – all white, for example – Painter's automatic selection and script features can be used to mask each frame)

○ When each frame of the foreground is properly protected by a selection, the video clip to be used as a background is opened (If the background is static, a single image can be used instead of a video clip)

○ With the background clip active, *Set Movie Clone Source* is selected from the *Movie* menu

○ With the foreground movie active, the cloning brush is selected from the *Brushes* palette. Painting in the foreground movie now fills in the background from the background clip

○ After finishing the first frame, clicking the *Step Forward* button automatically advances the foreground and clone source clips by one frame. The clips stay synchronized as work proceeds

Figure 4.56 illustrates the technique. Figure 4.56a shows the first frame of a clip showing an African elephant doing what comes naturally in its natural habitat. The dotted line around the elephant shows where a selection mask has been placed around it. Figure 4.54b shows the first frame of a clip displaying a fantasy Arctic landscape. After setting the Arctic clip as the clone source, inverting the selection in the first clip and choosing the *Straight Cloners* from Painter's *Brushes/Cloners* menu, painting into the inverted selection produced the result shown in Figure 4.56c, transporting the elephant, dung and all, to a much less natural habitat!

Straight cloning reproduces exactly what appears in the source image. Painter also includes a number of other cloning tools which can be used to produce more artistic cloning effects. Figure 4.57 shows an example. A background image of a rose is shown in Figure 4.57a and a selected image from the first frame of a video clip is shown in Figure 4.57b. After inverting the selection of the girl and choosing the image of the rose as the clone source, the *Cloners* option was again selected from Painter's *Brushes* palette, but this time the *Soft Cloner* option was selected, so that painting into the background created a 'soft focus' variation of the rose image. Figure 4.57d used the *Impressionist* variant of the cloner, producing a background version of the rose image painted with bold dabs of paint, reminiscent of the Impressionist style.

Finally, for those with infinite patience wishing to produce a video with a unique, hand-finished look, Painter even allows tracing of video frames! Figures 4.58a and 4.58b show the original clip and frame stack. 4.58c and 4.58d show the result of tracing just the parrot into a new clip using different drawing styles for each frame.

Figure 4.56 Compositing video clips in Painter

(a)　　　　　　　　　(b)　　　　　　　　　(c)

(a)

(b)

(c)

(d)

Figure 4.57 Compositing using Painter's Soft Cloner

(a)

(b)

(c)

(d)

Figure 4.58 Tracing frames in Painter

Summary

In this chapter we have seen that video editing applications offer the designer a wide range of creative possibilities for the addition of titles, transitions and special effects to integrate and enhance raw video footage. For the designer experienced in the use of still image editing applications like Photoshop, Painter, PHOTO-PAINT, Illustrator or CorelDRAW, for example, the range of possibilities is even wider.

Title screens can be created using any of thousands of different typefaces and styles and a whole battery of type manipulation effects. Access can be gained to a much wider range of raw material such as professional quality clipart, high resolution PhotoCD images, scanned images and photographs. Still images can be used 'as is' or can be precisely edited before being inserted between video clips, with accompanying voice over, or can be combined with video using a split screen technique. Application of scripts to still images or video clips provides consistent and repeatable control over implementing frequently used changes.

Already in the field of still image editing there has been a significant convergence between bitmap and vector drawing applications which has allowed the designer to move effortlessly between them to combine their various features. We are beginning to see similar convergence between still and video application – particularly those developed by the same vendor. The effect of this will be to make it even easier in the future to combine the best of still image editing with the best of video editing to produce eye-catching multimedia combinations.

5

Audio editing

Fortunately, time has a wonderfully leavening effect on our memories. I can still vividly remember my early attempts to record the many and varied sounds at a family theme park in Vermont on a bulky Telefunken tape recorder, while simultaneously filming the different exhibits on my trusty Bauer cinecamera. After waiting impatiently for the film to be developed, the 3-minute reel finally arrived in the post and the projector and tape recorder were set up, side by side, the projection screen was placed in position and all the appropriate switches were pressed. Suddenly the room was filled with sound and light and we were transported, albeit only for 3 minutes, back in time to relive a unique experience. No matter the fact that sound and vision were hopelessly out of sync! No matter that I tripped over the tangle of wires in the room, dragging the projector off the table and breaking the case. Forgotten also was the sheer physical effort of lugging the Telefunken kit around the theme park for a couple of hours just to record 3 minutes of sound. What mattered was that it had all come together and a precious family experience – with all its sight *and* sounds – had been captured for the family archives!

The memory of that first success in bringing sound and vision together (well, almost) came back to me when I bought my first camcorder. How life had changed since these pioneering days. Now I had 90 minutes of synchronised sound and vision available at the press of a button and all in a package small enough to slip into a pocket (well, OK, a small carry bag).

Driven by the growing demands of the music industry, as well as by film and television, audio technology has kept pace with the rapid shift of video processing from the analogue to the digital domain. The demise of the LP – fast becoming a curiosity to be found only at car boot sales – is being followed by that of the analogue audio cassette, as it gives way to the CD ROM and digital tape.

In the professional arena, as in the case of digital video editing, the process of digital audio editing provides the editor with incredible control and flexibility in the manipulation of audio material. Once digitised, audio tracks can be cut, copied, pasted and manipulated at will, without loss of quality and all within the comfort of the editor's own hard drive!

Audio sources

Audio material which can be edited on the desktop is available from a wide range of sources:

○ Audio captured with video on video tape

○ Material recorded on analogue and digital audio tape which can be digitised via the *Line In* socket on a sound digitising card

○ A rapidly growing range of audio CD ROMs (Capturing sound from a CD ROM requires an internal audio cable linking the CD ROM drive output socket to the audio card's input socket)

○ Speech or music recorded directly to disk via a microphone and the audio digitising card's *Mic In* socket

○ Midi-compatible instruments like keyboards which can connect directly to the joystick/Midi socket on a PC sound card

○ Audio clips recorded on CD ROM in midi format

○ Audio clips recorded on CD ROM in wav format

○ Royalty free sound clips downloaded from the Internet

Material from any or all of these sources can be imported and placed on the audio tracks of any of the host videoediting applications we have been examining, where it can be edited and synchronised with video clips placed on the video tracks.

Editing in the host applications

All three of our videoediting applications offer facilities for importing and editing audio clips. Most commonly this involves downloading and working with audio which has been recorded simultaneously with video on to videotape. By connecting the audio output from the videocamera to the audio input of a suitable audio digitising card and by enabling *Capture Audio* in the capture utility (Figure 5.1), the audio track can be digitised and saved to disk with the video signal in AVI (audio video interleaved) format. When the saved file is imported, e.g. to Media Studio, then the audio clip appears in the first of Media Studio's audio tracks (see Figure 3.10). When imported in this way, the video and audio

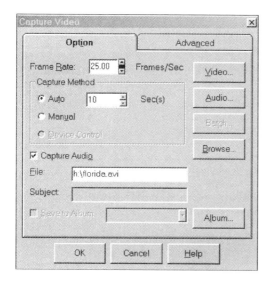

Figure 5.1 When the Capture Audio button is enabled, audio recorded on videotape is captured to disk

tracks are linked to maintain synchronisation (if one is moved horizontally along the timeline, the other moves with it), but they can be separated by selecting *Split* from the *Clip* menu. As we saw in Chapter 2, recording high quality sound (44 kHz, 16 bit, stereo) involves a data rate of 172 kB/sec, putting extra demands on the processor during capture, so it is often better to record video and sound separately and then synchronise them within the videoediting application.

While the videocamera offers the benefit of simultaneous sound and video recording, it effectively provides only one 'take' to get the sound right! Fortunately the audio editors provided with host applications provide a second chance, fulfilling several purposes:

○ Correcting problems (e.g. amplifying sound which is too quiet or deleting that unfortunate expletive when the subject tripped over a kerb)

○ Replacing or adding material such as a voice-over or musical background

○ Adding special effects, such as *Reverb*, to modify the sound as originally recorded

When a sound clip is loaded into Media Studio's timeline, the volume is automatically set to 100 % – the level at which it was recorded. A straight line running through the centre of the clip represents the volume setting. Changing the volume involves clicking a point on the line (Figure 5.2) and dragging up to increase, or down to decrease the sound level. A common use for this feature is adjusting the start of a sound clip to fade in and the end to fade out. Double-clicking on a clip opens an audio controller for setting *Punch In* and *Punch Out* points and playing the clip (Figure 5.3 shows Premiere's controller).

Figure 5.2 Clicking and dragging points to adjust the sound level in an audio clip

Figure 5.3 Premiere's Audio Controller

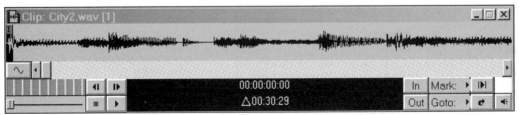

Media Studio provides a useful *Silence Clip* button to insert a block of silence into an audio track in the timeline – helpful for creating audio place-holders. Speed or duration of a whole clip can also be altered by using controls from the Clip menu (Figure 5.4).

Mixing tracks is simplicity itself. Adding a musical background behind, for example, a voice-over clip simply involves placing the music track on a new audio track vertically beneath the voiceover clip and adjusting its level as described above.

(a)

(b)

Figure 5.4 Clip speed and duration can be altered by calling up dialog boxes (a) and (b) from the Clip menu

Audio filters

More creative audio effects are provided in the form of audio filters. Applying a filter simply involves selecting the audio clip and then selecting *Audio filters* from the *Clip* menu. Filters offered by our three host applications include the following:

❍ *Amplify* – raises or lowers the amplitude of the audio clip so that it plays louder or quieter

❍ *Echo* – adds a simulated echo effect to the clip

❍ *Fade* – provides control over the rate at which the amplitude changes at the beginning and end of the clip

❍ *Flange* – creates a simple delay-based effect which produces a 'whooshing' sound

❍ *Graphic Equaliser* – allows manipulation of the tone of a clip

❍ *Long Echo* – applies a predefined echo which decays quickly after a long delay

❍ *Long Repeat* – applies a predefined echo which decays slowly after a long delay

❍ *Normalize* – resets the highest peak in the clip to 100% and then adjusts the rest of the clip in proportion

❍ *Pan* – fades from one channel to the other when applied to a stereo clip

❍ *Pitch* – changes the pitch of the clip to make it sound deeper or more shrill

❍ *Pop Removal* – removes the highest and lowest values from a window of samples

❍ *Quantize* – reduces the number of bits for the audio clip, resulting in a lower quality sound

❍ *Remove Noise* – filters out low amplitude background noise

❍ *Resonance* – an echo effect which causes the sound to vibrate

○ *Reverse* – swops the ends of the clip so that it plays backwards

○ *Stadium* – applies an echo effect which simulates that heard in a stadium

Editing controls vary from filter to filter. Figure 5.5 shows an example from Premiere, which provides both presets and good controls for a wide range of effects.

Audio editing in Studio 200

Sound effects, MIDI music and CD audio can be added to Studio 200 clips during the recording process. The sound to be added is mixed with the audio from the source deck before being recorded to the record deck. The *Audio out* from the source deck is first connected to the *Audio in* of the sound card and then the *Audio out* of the sound card is connected to the *Audio in* of the record deck. Sound can be recorded on to the finished video tape from any of three different sources – WAV or MIDI files stored on the PC hard drive or sound recorded from an audio CD. When an audio effect is encountered during recording to the output tape, Studio 200 automatically plays back the desired sound at the appropriate time.

To add, for example, background music from a music CD to a video clip, the clip is first selected by clicking on it in Studio 200's EDL window (Figures 3.47 and 3.56) and the *CD* option is selected from the *Add Effect* window (Figure 5.6). This opens the *Define CD Effect* dialog box shown in

Figure 5.5 Premiere provides controls for each audio filter such as this window for its Echo effect

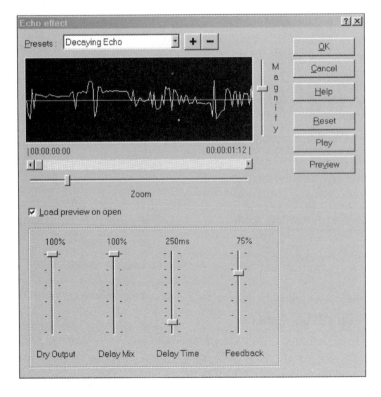

Figure 5.6 Adding sound effects in Studio 200

Figure 5.7 Preparing to add background music from a music CD to a video clip in Studio 200

Figure 5.7. After entering the *Disk Name* and *Effect Name*, a time is entered in the *Clip Offset* box (setting the time at which the background music will start to play, relative to the start time of the clip). *Play back, Play, Stop, Previous Track* and *Next Track* buttons are provided for selecting the track required and positioning a sound cue. *Range Start* and *Range End* controls are used to play a selected range of sound within the selected clip. The duration time appears in the *Duration* box alongside the selected range values.

The source deck can also be positioned exactly at the frame where the sound is to begin playing and then the start time for the music can be synchronised with this frame by clicking on the *Current* button. The amount of delay necessary to start the effect at the current point in the clip is automatically entered in the *Offset* field.

After the settings are complete, clicking *OK* adds the effect to the event list ready for recording.

Audio utility applications

So far, in this chapter, we have looked mainly at the manipulation and editing of audio material from within host applications like Premiere or Studio 200, but in many cases it is first necessary to capture audio from a live source or to retrieve stored material from disk for editing, before importing it to the host application. Before importing can take place, a sound clip also has to be in a format recognised by the application, such as WAV or AIF. Some examples of the many utility applications which are useful for such work are described below.

Multimedia Decks from Creative Labs (Figure 5.8) is a collection of players which can be used independently or concurrently to control multimedia devices such as a CD-ROM drive and a Midi device. It includes players called Creative CD, Creative WAVE and Creative MIDI. When Creative CD is used to play an audio CD, with *Record* activated in Sound 'LE (Figure 3.8), then part or all of the CD sound track can be recorded and then saved in WAV format. Similarly, when Creative MIDI is used to play Midi either from a live Midi instrument attached to the sound card, or from a

Figure 5.8 Multimedia Decks from Creative Labs can be used to play audio CD, wave or midi files

Midi file stored on disk, with Sound 'LE activated, then the Midi track can be saved as a WAV file.

Sound 'LE, or a similar recording utility, can also be used to record speech from a microphone connected to the *Mic In* socket of a sound card or sound from an audio tape deck connected to the card's *Line In* socket.

Creative Mixer (Figure 5.9) is a simple audio mixer which can be used to combine and manipulate sound from various audio sources. With such a mixer, it is possible select and mix different audio sources during playback and recording.

Creative Wave Studio (Figure 5.10) can be used to combine the data contained in any number of previously recorded Wave files. Mixing the data from two Wave files adds the data from one file to that the other, creating a new file, using the following procedure:

○ The first (source) file is opened and the portion of the data to be mixed is selected

○ Clicking *Copy* places the selected data on the clipboard

○ Next the second (target) file is opened and the location for mixing of the copied data is specified

Figure 5.9 Using Creative Mixer, input from a variety of sources can be mixed and recorded

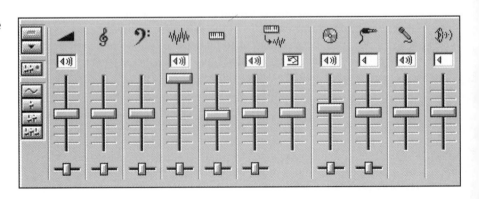

Figure 5.10 Creative
WaveStudio can be used to
combine part or all of the
data in wave files

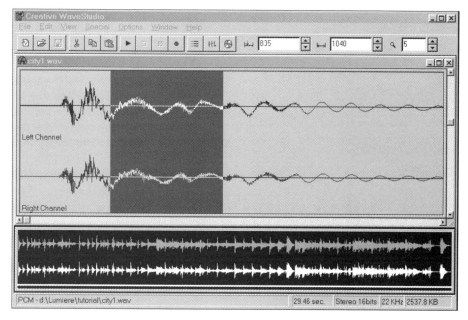

❍ On the *Edit* menu, clicking *Paste Mix* opens the dialog box shown in Figure 5.11. This dialog box is used to specify the channel data to be mixed

❍ Under *From Buffer Use*, click the channels from which data is to be copied from the source file and under *Mix With Wave* click the channels for mixing data to the target file

❍ Clicking the *OK* button adds the data selected from the first file to the data in the second file at a position indicated by the cursor, or, if a portion of the target file is selected, with the portion selected

Figure 5.11 The Paste Mix dialog box

WaveStudio also provides a range of audio filters – invoked by selecting from the *Special* menu shown in Figure 5.12.

Even without access to a Midi instrument, applications are available which provide a further whole category of creative desktop sound effects. An example of such an application is Creative Labs' AWE64 MIDI Synth (Figure 5.13) which provides a virtual keyboard for the addition and control of Midi effects. MIDI Synth uses wavetable synthesis to create musical notes using high quality, digitally recorded sound samples. Clicking on the *Instrument* menu lists a wide range of instruments and sound effects. The *Controller value* slider applies to the *Midi Controllers* menu which includes *Volume, Pan position, Expression controller, Sustain pedal, Reverb depth* and *Chorus depth*. Using the virtual keyboard in combination with these instrument and controllers, an astonishing range of effects can be created and recorded for inclusion in video projects.

Figure 5.12 WaveStudio filters

Figure 5.13 Creative Labs' Midi synthesizer dialog box

For the user with musical talents, Recording Session from Midisoft (Figure 5.14) is a simple sequencer offering standard Midi sequencing features, as well as an editable musical notation display. Three windows are used to record, play, and edit musical compositions. The *Score* view displays the music in standard musical notation. As recording takes place, notes appear on the screen. When the composition is played back the notes highlighted as they play. The *Midi List* view (not shown) displays the music as Midi events, affording minute adjustments to the shape of each note. The *Mixer* view is used to control recording and playback of Midi files. This window contains transport controls, as well as a tempo control, song location display, and controls for adjusting velocity and volume. The Toolbox contains five icons, rep-resenting tools for working with the onscreen notation.

Corel bundles a simple to use audio utility called SmartSound Wizard with Premiere for creating custom audio clips. The utility, selected from the *File/New* menu offers a choice from several categor-ies of music or sound effects (Figure 5.15). Within each category, there are several styles which offer variations of the original sound track.

Using the *Custom* setting in the first window, a Wave file can be created which matches the running time of a specific video clip.

The process for creating a custom audio clip involves the following steps:

Figure 5.14 Midisoft's Recording Session displays musical notation during composition and playback

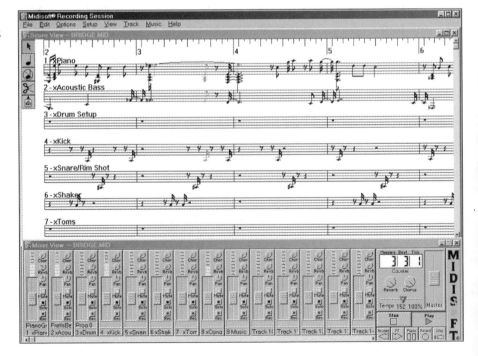

Figure 5.15 Corel's SmartSound wizard

○ In the first window, the button for either *Music* or a *Sound Effect* is selected

○ A running time is then selected for the clip

○ To create a music clip, in the next window a *Category* is selected from the list on offer (clicking on the *Preview* button plays a few seconds of the selected clip)

○ A *Style* is then selected from the style list

○ To create a sound effects clip, in the lower window a *Category* is selected

○ A *Style* is then selected from the style list

○ The default path and name of the audio file to be created is displayed. A new path and name can be entered before saving the file to disk

○ Clicking *Finish* creates the audio file and automatically loads it into Corel's Media Catalog

Specialised audio editing applications

In the same way that digital video has extended the video editor's image control down to every pixel on every video frame, the advent of digital audio brings a previously unimaginable level of precision and flexibility to the production and editing of sound. Each sample of the 44,000 which make up just 1 second of a digital audio track can, in principle, be accessed independently of the others for the purposes of editing; sound elements from different sources can be combined and manipulated to create exciting new hybrid effects and totally new and unique sounds can be synthesised and mixed with sounds from a wide range of natural sources.

Not surprisingly, as well as the simple applications we have looked at already, a growing range of sophisticated audio editing applications have been developed to provide sound editors with the means of working creatively with this new technology in the music, film and television industries. The cost of many of these applications can run into hundreds of pounds, but fortunately others are available as shareware, with only a modest registration cost. Some examples are briefly described below.

Goldwave

GoldWave is a versatile sound editor, player, recorder, and audio file converter (it can open and convert audio files of many different formats – *wav, voc, au, snd, raw, mat, aif, afc, iff, vox, dwd smp* and *sds*).

GoldWave displays its wares in three windows (Figure 5.16) – the *Main* window, the *Device Controls* window and *the Sound* windows. The

Figure 5.16 GoldWave's workspace

Main window groups together and manages all the *Sound* windows which display open files. The status bars show attributes of the *Sound* window, including the sampling rate, length, selected region, channels, and general file format information. By clicking the mouse pointer over any status item that shows time, the unit or format for that status item can be changed. Clicking over the length item, for example, opens a menu showing length in terms of storage size, time and samples.

The *Device Controls* window interacts directly with the sound card, providing buttons to play and record sounds as well as controls for volume, balance and playback speed. LED meters and oscilloscopes graphically display audio data whenever a sound clip is played or recorded. The oscilloscopes can be configured to display graphs in several different formats

Goldwave offers the following range of features:

❍ An *Expression Evaluator* to generate sounds from simple dial tones to bandpass filters. It supports more than 20 common functions and operations. *Expressions* can be stored in groups for quick retrieval. Expressions for dial tones, waves, and effects are included

❍ A multiple document interface which allows many files to be opened at one time, simplifying file-to-file editing

❍ Intelligent editing operations, such as paste and mix – clipboard audio data is automatically converted to a compatible format before the data is used. This simplifies the editing process when working with files with different sampling rates, bit resolution or number of channels

❍ Large files can be edited using hard disk editing. Small files can be edited quickly using RAM-based editing

❍ Sounds are displayed graphically and the level of detail can be changed by zooming in or out. Samples can be edited directly with the mouse when zoomed in to a sub-sample level (the level at which individual samples are easily visible)

❍ Many audio effects (see the *Effects* menu in Figure 5.17) allow enhancement, distortion, or alteration of sounds in various ways

GoldWave supports both direct-to-disk editing and RAM editing. In direct-to-disk editing, the entire sound clip is stored in a temporary file where it can be modified. This allows editing of very large files of up to about a gigabyte in size, provided the required disk space is available. Only a small amount of RAM is required for each opened sound clip. In RAM editing, the entire sound is stored in RAM. This allows very quick editing and processing of files, but is of course limited by the RAM available.

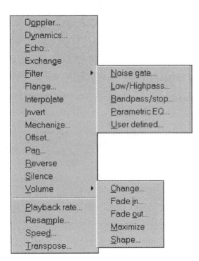

Figure 5.17 GoldWave's menu of special effects

Cool Edit

Cool Edit (Figure 5.18) claims to be a complete recording studio. Sounds can be generated from scratch with *Generate Tones, Generate Noise*, and *Generate DTMF Signals*. Audio clips can be 'touched up' with features like *FFT Filter, Quick Filter, Amplify, Compress, Envelope, Stretch, Channel Mixer*, and *Noise Reduction* . A menu of special effects includes *Reverb, Delay, Echo, 3D Echo Chamber, Flanging*, and *Distortion*. The pitch or tempo of a clip or part of a clip can be altered with the *Stretch* function. Newly created effects can be saved as *Presets* for later recall and *Scripts* and *Batch Processing* features can be used to automate many activities.

Cool Edit also offers powerful data analysis features. *The Spectral View* provides a multicolour map of the sounds in files. A *Frequency Analysis* (Figure 5.19) can be generated to see which frequencies predominate at a point or in a region of a waveform. A *Statistics* feature provides information on peak amplitude and minimum and maximum RMS power levels. The application even claims to create *Brainwave* files to induce states of deep sleep, theta meditation, or alpha relaxation!

Cool Edit can also be used to create two types of sound effect – *Noise based* or *Tone based*. Using the *Generate* functions, a clip of noise or tones is first created as a base for the effect, using either the *Generate Noise* function (Figure 5.20) or the *Generate Tones* function (Figure 5.21). Next the transformation functions are manipulated to create the desired effect. The kind of effects which can be created include:

- ○ Waterfall, wind, and rain

- ○ Thunder, snare drum, cymbals and jet engines

- ○ Fantasy sounds such as time warp

- ○ Siren, pipe organ, piano and other musical instruments

- ○ Space ship sounds, whining and whistles

Figure 5.18 The Cool Edit workspace

Figure **5.19** Performing a frequency analysis of a sound clip sample

Figure 5.20 Generating a noise clip

Figure 5.21 Creating a tone clip

Using the *Reverse* function and the features in the *Mix Paste* dialog box (Figure 5.22) like *Crossfade* and *Loop Paste*, more complex sound effects can be built up.

Using Cool Edit, the process of mixing of sound clips, of different formats or specifications – e.g. mixing a mono 8-bit 11 KHz file with a stereo 16-bit 22 KHz file – is very simple. First, a new instance of the program is opened by selecting *File/New Instance*, then the clip to be mixed is opened in the new instance. Using *Edit/Copy*, the portion of the file to be mixed from the first instance is copied and then mixed with the clip in the second instance using the *Edit/Mix Paste* command, with the *Overlap* box checked. More new instances can be created to mix additional clips.

Cool Edit also provides a noise reduction feature (*Transform/Noise Reduction*) to remove background noise and general broad band noise with minimal reduction in signal quality. The amount of noise reduction depends upon the type of background noise, and the allowable loss in the quality of the retained signal. Increases in signal to noise ratios of 5 dB to 20 dB are claimed. The function can be used to remove tape hiss, microphone background noise, 50 cycle hum, or any noise which is constant throughout the duration of the waveform. The *Noise Reduction* function can also be used to create special effects by setting the noise level to some valid signal component in a sound clip waveform, rather than the background noise. Whatever frequencies are present in the highlighted selection are removed, modifying the original sound.

Multiquence

Multiquence is a multitrack audio processor with multimedia extensions for sequencing digital audio, CD audio, Midi, and video. Figure 5.23 shows the workspace, in which the various files to be used in a composition can be assembled and edited

To the left of the timeline is a master volume slider which controls the final mixing and playback volume level for all of the tracks. Just below the master volume slider is a meter which indicates the output volume level of all the tracks combined. If the maximum level is exceeded a red warning light appears in the small box to the right of the meter. The track volume sliders control the volume of individual digital audio tracks. A

Figure 5.22 Cool Edit's Mix Paste dialog box

Figure 5.23 Multiquence workspace

mute button is provided with each track to disable the track so that it is not mixed or played. The solo button ▣ does the opposite, selecting just one track for playback.

From the *Edit* menu a number of effects can be added to a selected audio track section (Figures 5.24 to 5.26). *Flange* adds a flange effect, *Equalizer* applies a parametric equalizer to the selected audio section, *Pan* sets the left/right balance and *Speed* sets the playback speed of the selected section. The *Edit/Volumes* command can be used to crossfade between two sections (fading out one section as the other fades in – Figure 5.27). Sound clips placed within the workspace can also be selected and edited using an audio editor, such as Goldwave, which has been specified in the application's *Options* dialog box.

When placed on tracks, clips are colour coded for easy visual recognition – e.g. CD audio tracks are green and video tracks are magenta. Each track may contain a series of clips – called sections –which are played sequentially. From the *Edit* menu, *Split* divides the selected section at the vertical marker's position. A new section can then be inserted at the split point or part of the original section can be dragged and dropped to another track. *Trim Beginning* removes the beginning of the selected section up to the marker's position. *Trim End* removes the end of the selected

Figure 5.24 Applying a Flange effect in Multiquence

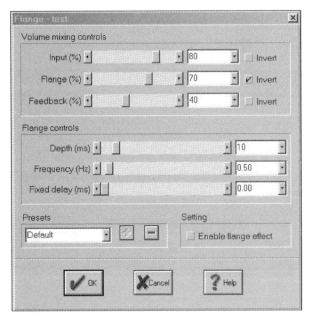

Figure 5.25 Multiquence's Parametric Equalizer

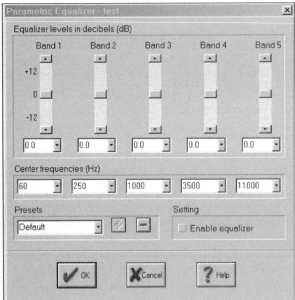

Figure 5.26 Applying a Pan effect

Figure 5.27 Crossfading between audio sections

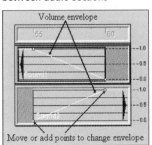

section beyond the marker's position. When a recording section is added to a track (e.g. Track 5 in Figure 5.23) digital audio can be recorded from a sound card input source such as line-in or a microphone. If the recording section is set to *Record*, the section will be recorded when the project is played. If *Play* is selected, the section will just be played when the project is played – useful to test how a recording sounds when combined with all the other tracks.

Unless any mute buttons are activated, all tracks play concurrently. This feature allows experimental mixing and playback of various file types, as well as adjustment of individual track volumes and relative positions along the timeline, before saving as a composite file. When a project is saved, the MPQ project file saves pointers to the clips in all the sections in each track. Up to 5 hours of material can be saved in a single project file. A project typically contains a combination of tracks and sections to create such things as music, audio CDs, radio programmes and multimedia presentations.

The *File/Save As* command mixes all the digital audio sections and tracks into a single Wave file for use in other applications. Only digital audio sections are mixed to the file. Midi, CD audio and video soundtrack sections must be converted to WAV format if they are to be included in the mix.

Summary

While video editing applications provide a useful range of video features for adding titles, transitions and optical filters, as we saw in the last chapter, their audio editing capabilities are generally quite limited. Audio utility applications – like Creative Labs Multimedia Decks described in this chapter – are often bundled with sound cards and provide the means of recording audio from a variety of sources in a format suitable for mixing with video. They also provide simple access to a growing range of prerecorded sounds – the audio equivalent of clipart – which can be imported for use in multimedia projects.

For more serious audio editing, a range of sophisticated (and expensive) specialised applications have appeared on the market, but fortunately low cost alternatives like Goldwave, Cool Edit and Multiquence featured in this chapter, although lacking some of the features of their expensive counterparts, provide impressive capabilities which will meet the needs of many users.

Animation 6

For many of us, the word 'animation' immediately conjures up childhood images of the characters from Walt Disney's animated cartoon classics like *Snow White* or *Jungle Book*. In fact, the cartoon dates back long before the days of Hollywood and animation has come a long way since the early days of the studio artist!

Traditional animation

The term 'cartoon' derives from the Italian word *cartone,* meaning pasteboard. In the world of fine arts, a cartoon was a full-sized drawing used as a model for a work to be executed in paint, mosaic, tapestry, stained glass, or another medium. The cartoon provided a vehicle for the artist to make alterations in the design before commencing the final project.

The simple line drawing style of the classical cartoon was developed, in the 18th and 19th centuries, by English caricaturists such as William Hogarth and Thomas Rowlandson, giving rise to the political and satirical cartoons which remain a stock ingredient of newspapers and magazines to this day.

A logical evolution of the cartoon – the comic strip – adopted some of its characteristics, such as the speech balloon, but also added the important dimension of time, as the left to right and top to bottom sequence of comic strip frames was used to represent the passage of time. From modest beginnings, the comic strip evolved to the point where series such as Superman and Dick Tracy attracted almost a cult following, and not only among the young; on a recent visit to France, while browsing in a book shop, I was surprised to see middle-aged men pouring over the latest comic strip adventures of Asterix, which has clearly developed a special Gallic appeal.

The animated movie was the offspring of a marriage between the drawing techniques developed for the comic strip and Roget's persistence of vision principle. The movie background, which contains only static objects, is drawn only once. The figures to be animated are drawn on a series of transparent plastic sheets, called cels, and then superimposed on the background and photographed in sequence, frame by frame. A chief animator sketches characters at important points in the action, called key frames. Assistant animators then draw the 'in-between' frames to complete the animation.

The stop-frame movie camera used in animation, called a rostrum camera, is placed above a special table on which layers of background and cels are held horizontally. The height of the camera and the horizontal movement of the background are controlled by very precise gearing to ensure proper scenic composition.

The animation technique for photographing three-dimensional puppets, or Plasticine characters like those featured in the popular *Wallace and Gromit* series, is very similar. Movement and changes of expression are accomplished by careful sequential readjustment of the characters between each exposure of the rostrum camera.

The creation of an animated movie normally begins with the preparation of a storyboard – a series of sketches which portray the

important sequences of the story and also include some basic dialogue. Additional sketches are then prepared to create backgrounds and to introduce the appearance and temperaments of the characters.

In some cases the series of sketches is prepared first and then the composition and arrangement of the music or other sound effects and the style and pace of the dialogue are timed to correlate with the visual content of the sketches. In other cases, the music and dialogue are recorded before the final animation is created, so that the sequence of drawings can be synchronised with the sound track. It is common for both types of synchronization to be used within the same production.

The full length animated feature films from the Disney studio represent the ultimate achievement of the application of traditional animation techniques. Created at the full 24 fps, in order to optimise the flowing quality of the action, a 90-minute feature requires nearly 130 000 frames, each consisting of a number of overlapping, individually drawn cels – an enormous labour-intensive creative task.

Computer animation

As this chapter will show, computer animation offers a number of advantages over traditional animation methods, including the following:

○ The animator has access to an enormous and growing range of 2D and 3D drawing and painting tools and techniques for the creation of still frames

○ Objects within a scene can be manipulated with CAD precision

○ Digital *Cut, Copy* and *Paste* commands, in conjunction with cloning and tracing techniques, make it simple to replicate and move objects, or parts of objects, from frame to frame

○ The use of standard colour models ensures consistency of colour from frame to frame and clip to clip

○ Digital layers or the use of 'floating objects' mimic the use of traditional cels, but provide greater flexibility, as digital layers can be easily reordered, duplicated or combined with each other or with the background. Masking and transparency controls provide further means of controlling how different layers interact

○ Objects can be selected and combined in a group, so that effects can be applied simultaneously and uniformly to all members of the group

○ After saving an animation in a format like AVI or MOV, it can be manipulated like any other video clip in a videoediting application, where it can be combined with live video, still image and text clips and can be edited using the filters and special effects filters described earlier

❍ In 3D applications, animation can be applied to object position, size, shape and shading attributes and also to cameras, lights, ambient lighting, backdrops and atmospheric effects

❍ 3D objects can be linked in a parent/child relationship and inverse kinematics (more on this later) can be used to provide realistic movement of interconnected parts

❍ 3D landscapes and figures can be created offline in specialist applications like Bryce and Poser and then integrated within the final animation

If there is a downside to computer animation then it lies in the rendering which is required to create the finished animation clip. Frames which involve the use of raytracing software to reproduce complex textures, reflections or atmospheric effects, for example, may take hours, or even days, to render even using a powerful processor. To speed up the process, professional systems distribute the work over a number of interconnected processors.

While still in its infancy, computer animation is already beginning to produce impressive results. The feature length film *Toy Story* demonstrated that it is already possible, with the benefits of the new technology, to create an animated cartoon with all the appeal of the Walt Disney classics. Later films like *Titanic* use animation techniques subtly blended with live action so that it nearly impossible to see the join! The dramatic panning and zooming shots, and the use, in a number of scenes, of animated 3D figures, gave a taste of what was to follow.

In computer graphics, animation can be accomplished in either 2D or 3D applications. In the 2D method, which simulates the traditional cel animation drawing board approach, an image is drawn on the screen of a drawing or painting application and the image is saved. Using an onion skin technique (see sidebar) a copy of the first image is erased and then redrawn in a slightly different position on the screen. Each of the frames created in this way is saved in sequence within a frame stack and the illusion of motion is created when the frames are played back at a high enough rate. Because animation drawings contain much less detail than live-action images, animations can be produced at frame rates significantly below those used for live action. Because of the smoothness of colour fills and continuity between images, animations can look quite acceptable at rates between 10 and 14 frames per second. Animation of cartoons for film, for example, usually runs at 14 fps, but each frame is printed twice so that film animation actually displays at 28 fps.

In the 3D time-based animation, which simulates the traditional use of a stop-motion camera to film three-dimensional puppets, virtual 3D characters are first created on screen in a 3D modelling application and then animated by placing the characters on a timeline and altering their shape, size, orientation, etc. at important points in the action. These changes are called key events. When the key event changes have been completed, the software fills in the gaps, or transitions, between the key

events to complete the sequence. This technique is known as 'tweening' – short for 'in betweening'.

2D animation applications

A number of simple dedicated 2D animation applications are available on the market for both the Mac and the Windows PC but most of these offer limited painting and editing tools. Increasingly, however, applications originally designed for sophisticated painting and photoediting work are including animation capabilities within their later releases. While these animation features may as yet be fairly rudimentary, the ready access to sophisticated painting and image editing features while creating animations offers an enormous range of creative possibilities.

PHOTO-PAINT

Selecting *Create a New Image* from PHOTO-PAINT's *File/New* menu opens the dialog box in Figure 6.1. After selecting *Create a movie*, the *Colour mode, Image size, Resolution* and *Number of frames* for the movie can be set from within the dialog box.

Several options are available for creating a background for the movie:

❍ It can be left as the default solid white fill

❍ A solid RGB colour fill can be applied from within the dialog box

❍ Any of PHOTO-PAINT's fountain or pattern fill types can be used to fill the background

❍ Any combination of PHOTO-PAINT's painting tools and techniques can be used to paint a custom background

❍ An imported image can be used as a background using the *Movie/Insert from file* command

Figure 6.1 Configuring a new movie in PHOTO-PAINT

Figure 6.2a shows the first frame of a 50 frame movie into which a Photo CD image of a Martian landscape has been imported as a background. Objects – like the clipart lunar excursion module shown Figure 6.2b can be inserted into the scene by opening the clipart object in a drawing application, copying it to the clipboard and then pasting it on top of the background. The dotted line appearing around the LEM means that it remains selectable after pasting, i.e. it can be dragged around, altered in size, skewed or rotated. It can also be masked from the background by applying the *Mask/Create from Object* command so that paint, filters or special effects can be applied to the object without affecting the background. The opacity slider can also be used to allow the background to show through the active object if desired.

While it remains active, an object will appear in every frame of the movie. To incorporate an object into a single frame, the *Object/Combine/*

(a)

(b)

Figure 6.2 (a) Using a Photo CD image as a background and (b) pasting an object into the scene

Combine Objects with Background command is used. A copy of the object can then be pasted into the next frame, where it can be manipulated, combined with the background, and so on. Figure 6.3a shows a copy of the LEM pasted into Frame 2 of the movie, where it has been scaled rotated and repositioned to give the impression that it has blasted off from the Martian surface. Any number of objects can be created within a frame using the *Object/Create New Object* command. All objects in the frame remain individually selectable and editable until incorporated into the background. Figure 6.3b shows a second object – an astronaut – pasted into Frame 3 of the movie as the LEM starts to move out of the frame leaving him alone on the surface.

PHOTO-PAINT provides an onion skin feature in the form of its *Frame Overlay feature* (Figure 6.4), selected from the *Movie* menu. With the slider in the *Current* position, only the contents of the current frame are seen, but as the slider is dragged to the left the contents of the previous or next frame (depending on whether the *Previous Frame* or *Next Frame* button has been selected) gradually become visible, to assist correct positioning of objects in the current frame. Figure 6.5 shows how the LEM in Frame 2 can be positioned relative to its position in Frame 1 with the use of *Frame Overlay*.

Like the layers in the stack of cels making up a traditional animation frame, the order of objects in a digital frame can be altered. Figure 6.6a shows three geometric objects in a frame, with a square (Object 2) sandwiched between a circle (Object 1) and a triangle (Object 3). As objects are added to a frame, thumbnails are displayed and numbered sequentially in PHOTO-PAINT's *Objects* palette (Figure 6.6b). The position of an object in the *Objects* palette corresponds to its relative position in the frame, e.g. the black triangle appears at the top of the palette because it is the top object in the frame. The relative position of an object can be changed by simply dragging its thumbnail up or down within the *Objects* palette.

T E C H N I C A L T E R M

Onion Skin – Traditional cartoon animators work on an onion skin paper that allows them to see a sequence of frames through the transparent layers. They then draw successive frames using the previous frames for reference. Seeing several images superimposed helps in incrementing the action evenly

(a)

(b)

Figure 6.3 (a) Modifying the original object and (b) pasting in a second object

PHOTO-PAINT also provides full control over the duration of each frame within a movie, making it easy to create slow motion or speeded up effects. Clicking on *Movie/Frame Rate* opens the window shown in Figure 6.7. Frames can be selected contiguously or non-contiguously and a frame delay (the time that the frame is displayed on screen) can be typed into the Frame delay window. The *Select All* command can be used to apply the same delay to all frames in the movie clip.

Controls are provided for copying, deleting and moving frames within the same movie and also to add frames from another movie. This is accomplished by:

❍ clicking *Movie/Insert From File*

❍ choosing *Full Image* from the *Loading Method* list box in the *Insert A Movie From Disk* dialog box

Figure 6.5 Using Frame Overlay in Frame 2 to reveal the position of the LEM in Frame 1

Figure 6.4 PHOTO-PAINT's Frame Overlay dialog box

(a)

(b)

Figure 6.6 Overlapping objects in a frame (a) and their corresponding thumbnails in PHOTO-PAINT's Objects palette (b)

○ double-clicking the movie or image to be inserted and clicking *Before* to insert the frames before the frame specified in the Frame box or *After* (Figure 6.8) to insert the frames after the frame specified in the Frame box

○ typing the frame number where the new file is to appear

For navigating around the frames of an animation project and for previewing the work as it progresses, PHOTO-PAINT provides the special toolbar shown in Figure 6.9.

The default format for a PHOTO-PAINT animation is AVI, but when work is complete, it can alternatively be saved in GIF, MOV or MPG format. Saved animations can be opened in a video-editing application where sound effects and other finishing touches can be added.

Painter

In Painter, original animations can be created by:

○ drawing each frame by hand

○ manipulating 'floaters' (Painter's term for selectable objects)

○ cloning or tracing video

Figure 6.7 Setting Framer delay times in PHOTO-PAINT

Figure 6.8 Specifying the frame for file insertion

Go to Frame

Move Frame(s)

Insert Frame(s)

Figure 6.9 PHOTO-PAINT's Movie control bar

Overlay Frame

Delete Frame(s)

Insert from File

The first step in creating a new animation is to create a new movie file by opening the *New Picture* dialog box (Figure 6.10a). After selecting frame size, number of frames and background colour and naming the new file, the *New Frame Stack* dialog appears (Figure 6.10b). After choosing the *Layers of Onion Skin* and the *Storage Type*, which determines the colour depth for the new movie, clicking OK opens the Frame window and displays the *Frame Stack* control panel window (Figure 6.10c). The VCR-like controls at the bottom of the window are used to preview the project either dynamically or frame by frame. As objects are added to frames, they appear in thumbnail windows in the *Frame Stack*; between two and five successive frames can be displayed. The project is automatically saved as work proceeds from frame to frame. When work is complete, the *Save As* command is used to export the animation to other formats.

Figures 6.11 and 6.12 show the way the onion skin effect works in Painter. The animation in Figure 6.11 is using a two-layered onion skin, while the animation in Figure 6.12 is using a five-layered onion skin. The onion skin feature can be switched off and on by selecting or deselecting *Canvas/Tracing Paper*. Within the Frame Stack window, the down arrow positioned above one of the frame thumbnails indicates the active frame. Any frame can be selected by clicking on its thumbnail

Figure 6.10 Starting a new movie in Painter: (a) setting frame size, length of movie and background colour; (b) choosing the number of onion skin layers and; (c) displaying the first frame in the Frame Stack

Painter's full suite of natural-media tools and effects can be used to work on each image in a frame stack, offering unprecedented potential for creating original animation. Readers interested in the results which

(a)

(b)

(c)

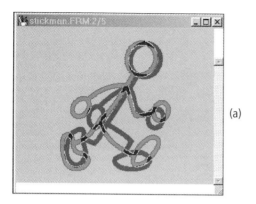

(a)

(b)

Figure 6.11 (a) The current frame (Frame 2) showing the current figure position in black and the figure position from the previous frame (Frame 1) in grey and (b) The Frame Stack window showing thumbnails of Frames 1 and 2

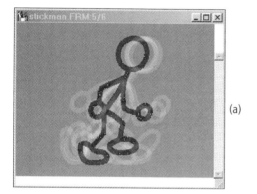

(a)

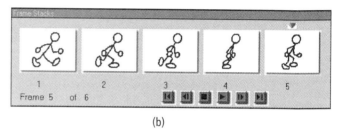

(b)

Figure 6.12 (a) The current frame (Frame 5) showing the current figure position in black and the figure positions from the previous four frames (Frames 1 to 4) in grey and; (b) the Frame Stack showing thumbnails of Frames 1 to 5

can be created are referred to one of several publications devoted to the application, or to the author's earlier book *Digital Graphic Design*. Figure 6.13 shows an example in which the tools have been used to create an animation depicting the movements of a butterfly's wings.

Figure 6.14 shows another example, in which letters build up the word 'Painter 5' by first overlaying and then displacing four hand prints. The effect, when animated, is similar to that of a cycling neon sign.

Another method of creating an animation in Painter or PHOTO-PAINT is to move a floating object across a series of frames. Figure 6.15 shows an example. The object to be animated can be painted or imported into the first frame. In the example the bicycle was imported from Painter's *Objects library* (the dotted outline indicates that the object is floating) and dragged to the left so that only the front section appeared in the frame. Clicking the *Frame Forward* button on the *Frame Stack* palette adds a frame and advances to it, dropping the floater (the bicycle) in the first frame. The bicycle becomes merged with the background in the first frame, but keeps floating above the second frame. After repositioning the bicycle to the right in the second frame, the above sequence is repeated so that the bicycle moves incrementally to the right in successive frames (Figure 6.15b).

Figure 6.13 A Painter animation depicting the fluttering wings of a butterfly

When the required number of frames has been completed, clicking the *Play* button on the *Frame Stacks* palette animates the movement of the bicycle across the screen.

The action contained in the few bicycle frames can be repeated, or looped, if the beginning and ending images are the same, i.e. if the end of one cycle is hooked up to the beginning of the next, the action can appear to continue smoothly. It is only necessary to draw the cycle once, as it can then be duplicated as many times as required. Many animated actions, such as a person walking, cycle repeatedly through the same sequence of actions. Scrolling a background is another example of a cycled action. Commonly, a subject remains in one place while the background slides by.

Scrolling a backdrop is another example of a cycled action. Commonly, a subject remains in one place while the backdrop scrolls by. This technique is illustrated in Figure 6.16. After placing a walking figure in the first frame of a new Painter clip (a), the image to be used as a backdrop (b) was opened in a separate window, selected, copied and pasted behind the figure in (a). Using Painter's positioning tool, the background was dragged to the position shown in (c). Both objects were then merged with the background. The *Forward* arrow in the *Frame Stacks* window

Figure 6.14 (Top) Frames 1, 7 and 14 of a fourteen frame animation and (Bottom) the corresponding Frame Stack window

(a)

Figure 6.15 Creating an animation in Painter by manipulating a single object. The object is created or imported into the first frame (a) and then copied and moved in stages in subsequent frames (b)

(b)

Figure 6.16 Animating a background in Painter by means of scrolling

(a)

(b)

(c)

(d)

(e)

was then clicked to advance to the next frame and an edited copy of the walking figure was pasted into the frame. The backdrop was next pasted behind the new figure and dragged to the left as shown in (d). Once again, both images were merged into the background before the *Forward* arrow was used to advance to the third frame. The process was repeated to produce the result shown in Figure 6.16e and so on. As the frame stack is played back, the background image scrolls from right to left, as the figure cycles through a walking motion, creating the impression that the figure is walking from left to right.

Power Goo

An application generally used to apply grotesque distortions to facial images, Power Goo by MetaTools, has sophisticated image manipulation capabilities. The effects which can be produced are reminiscent of those achieved in still image editing applications using distortion filters or distortion brushes. After opening an image either from a bitmap file or from a video clip, Power Goo's many tools can be used to push, pull, tweak, twist and otherwise redistribute the pixels comprising the original image. The effect is like working on a painted image with a dry paintbrush while the painting is still wet – real-time liquid image editing as MetaTools calls it.

After importing an image into the workspace, either of two sets of tools can be called up by clicking on one of the two coloured 'necklaces' in the top left of the screen (Figure 6.17); a tool is selected by clicking on one of the large buttons encircling the image. Dragging in the image with the mouse then causes the image, e.g. to *Bulge* or to *Smear* at that point. The effect can be localised to one part of the image or repeated to affect a wider area. Figure 6.18 shows an example in which repetitive use of the *Nudge* tool was used to extend a particular anatomical feature. The frame

Figure 6.17 Power Goo's two sets of manipulation tool buttons

(a)

(b)

Figure 6.18 Working on an image in the main PowerGoo window (a) and then saving a series of progressively edited frames as video clip frames (b); (c); (d) and (e)

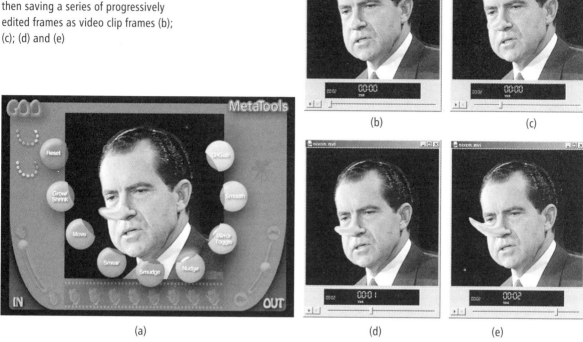

(b)

(c)

(a)

(d)

(e)

being worked on appears in the film strip which can be seen faintly at the bottom of the main window. Clicking on a frame of the film clip pastes a copy of the edited image in the main window into that frame. Extra frames can be added to the end of the film strip as required. At any time, clicking on the movie camera which can be seen faintly at the right hand side of the main window, plays back an animation of the frames so far completed.

When the work is finished, individual frames can be saved as bitmapped files or the whole film strip can be saved as an AVI file or else saved directly to videotape via a digitising card. Figure 6.19 shows the output options.

Combining 2D animations with live video

By using a solid background like chroma blue when creating an animation, it is a relatively simple matter to merge the animation with a live video clip. Figure 6.20 shows an example. The animation clip is placed on the overlay track V1 (in this case, in MediaStudio) and the live video clip is placed on track Va (Figure 6.20a). Opening the *Clip/Overlay Options* window (Figure 6.20b) shows just the animation clip which is overlaying, and therefore obscuring, the live video clip. Clicking with the *Eyedropper* tool selects the background colour of the animation clip. When *Color Key* is selected as the overlay type (Figure 6.20c), then everything in

Figure 6.19 The Power Goo Save As window. The current image can be saved as a bitmap file or the series of images can be saved either as a native Goo file, as an AVI movie clip, or direct to videotape via a digitising card

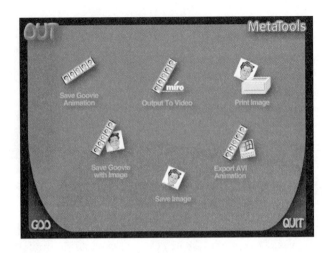

Figure 6.20 Combining animation with live video: (a) placing the live video and animation files in MediaStudio; (b) viewing the overlay clip and; (c) sampling the background colour and choosing Color Key as the Overlay Type

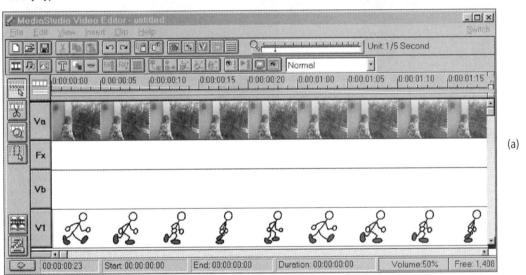

(a)

(b)

(c)

the animation clip which is the same colour as the background (in this case including the hands and face of the figure), become transparent, revealing the live video clip below. When the result is played back in MediaStudio, the animated figure strolls across the screen, showing the live clip in the background.

3D animation applications

Animating in three dimensions is about much more than adding a fourth dimension – time – to illustrations created in 3D drawing applications. It is about the creation of virtual reality, giving the animator the ability to design unique characters, scenes and landscapes with attributes paralleling those found in the real world.

Because of the hugely expensive demands that such applications place on hardware, the use of such techniques has been largely confined to the film and television industries, but now, with the power of desktop PCs increasing in leaps and bounds, access to such techniques is increasing rapidly. A growing market will fuel increased investment in both 3D hardware and software, expanding the desktop video environment into challenging new territory.

With the limited space available in this book, it is not feasible to cover this subject in depth, but the following pages show examples of desktop applications which are already available and the exciting possibilities which they provide.

Ray Dream Studio

In Ray Dream Studio (RDS), 3D animation can be applied to:

❍ the position of objects in a scene

❍ object sizes, shapes, and shading attributes

❍ the motion of objects, lights, and cameras

❍ camera and light parameters (e.g. colour or intensity)

❍ ambient lighting, background, backdrop, and atmospheric effects

RDS uses the tweening technique described earlier in the chapter; after movements within a scene have been set at key points, corresponding to key frames within the video clip, the application software fills in the gaps to complete the animation. The animation process involves four distinct stages:

❍ Creating an object or objects

❍ Building a scene

❍ Animating the scene

❍ Rendering the final animation

The RDS workspace is shown in Figure 6.21. Objects, cameras and lights are manipulated in the *Perspective* window to create 3D scenes. The *Browser* window gives access to stored 3D *Objects*, *Shaders* (for applying colours and textures to objects), *Deformers* (for applying controlled deformation to objects), *Behaviours* (like bounce or spin), Links (like balljoint or slider), *Lights, Cameras* and *Render Filters*.

Movements within a scene are controlled by means of a *Time Line* window which provides a visual representation of the key events which make up an animation. Controls within the window are used to manipulate key events and move to different points in time. The *Time Line* window which consists of two main areas – the *Hierarchy Area* located on the left side of the window which displays the scene's hierarchical structure and the *Time Line* area to the right of the hierarchy area which displays a time track for each item (object, effect, or property) appearing in the hierarchy area. The time axis extending across the bottom of the window acts as a time ruler, with marks indicating time increments.

Figure 6.21 Ray Dream Studio's workspace consisting of the Perspective window, where scenes are assembled, the Browser window, from which shaders, etc. are selected and the Time Line animation window

Key event markers on the *Time Line* tracks represent key events in the animation – e.g. changes to the properties of objects, intensity of lights, position of cameras in the scene, at specific points in time. Key events are created by moving the vertical *Current Time Bar* to a position along the time line and then modifying an object or rendering effect. A key event marker then appears on the appropriate track in the time line. RDS automatically calculates the state of the objects and effects in the scene in between the various key events.

Figure 6.22 shows a simple example. The scene in Figure 6.22a involves a camera, two copies of a spotlight and an object described as a *Tire*. All of these items are listed in the *Objects* hierarchy in Figure 6.22b. A default key event marker appears at time zero on each track. After rotating the tire 90° around the vertical axis (Figure 6.22c), a new marker was set at Frame 12 (Figure 6.22c). The tire was then rotated by another 90° and a marker was set at Frame 24 and so on. The positions of the tire corresponding to the frames between the key frames were calculated by RDS, so that when the animation was played back using the animation controls (Figure 6.23), the tire rotated smoothly from its starting point, through 360° and back to its starting point.

When RDS calculates the in-between frames, it does so using one of four different types of tweener. By specifying which tweener should be used for each transition, the rate of change between key events in the animation can be controlled:

Figure 6.22 Using key events to animate a 3D object in Ray Dream Studio

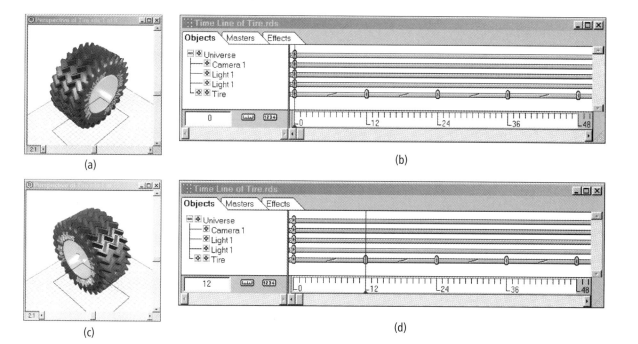

(a)　　　　　　　　　　(b)

(c)　　　　　　　　　　(d)

◯ The *Discrete* tweener produces instantaneous change, i.e. objects move abruptly from position to position

◯ The *Linear* tweener produces a constant rate of change, i.e. objects move at a constant velocity from position to position

◯ The *Oscillate* tweener (Figure 6.24a) creates alternating back and forth movement between key events

◯ The *Bézier* tweener (Figure 6.24b) produces smooth motion paths and greater control over acceleration and deceleration

Tweeners make it easy to create more realistic and subtle changes in the transitions between key events and save time by automatically creating movements and changes which would be very time-consuming with key events alone.

The construction tools provided with RDS can be used to create a wide range of objects and scenes like those shown in Figure 6.25. Objects can also be saved to, and imported from, a library in native RDS format; objects created in other applications and saved in DXF or 3DMF format can also be imported and included in scene composition.

RDS provides a number of powerful features for manipulating objects within a scene:

Figure 6.23 Ray Dream Studio's animation control tool bar

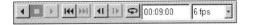

Figure 6.24 Applying tweeners – Oscillate (a) and Bézier (b)

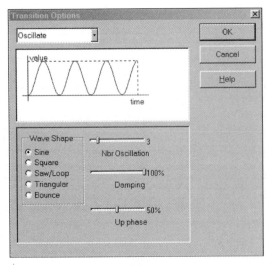

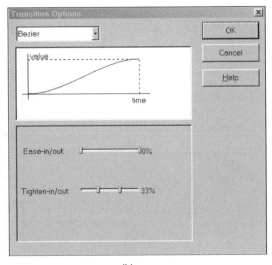

(a) (b)

Figure 6.25 Ray Dream Studio objects (a, b, c) and Scenes (d, e, f)

❍ *Cloaking* causes an object to enter or exit (appear or disappear) during the course of an animation. Cloaked objects can be manipulated in the *Perspective* window; they simply are not included in the rendering of the animation

❍ *Shaders* are texture maps simulating a wide range of organic and inorganic materials. Dragging a shader on to an object applies the texture to that object

❍ *Behaviors* apply sets of instructions to objects, which determine or modify their behaviour during the animation (e.g. *Bounce* or *Spin*). *Inverse Kinematics* is a specialised behaviour applied to linked objects such as a hand linked to an arm. *Inverse Kinematics* allows simulation of organic movement, so that raising the hand is accompanied by natural movement of the arm

❍ Specialised links – *Ball Joint, Lock, Slider, Axis, Shaft*, or *2D plane* – between objects, constrain the way one object moves in relation to movements of another, e.g. in the *Shaft* link, the child object can both rotate around one of its axes, while it slides up and down the same axis

○ *Rotoscoping* allows the playing of video within video. Animations or live video files can be applied to objects as texture maps or as backdrops within an animation

Figure 6.26 shows an example of rotoscoping in which the stick man animation we saw in Figure 6.20 has been mapped on to the surface of a sphere. By animating the sphere to rotate about its vertical axis, the stick man can be made to 'walk around' the surface of the sphere. A similar technique can be used to animate, for example, the screen of a television set or the view from a window contained within a scene.

Before an RDS animation can be brought into a videoediting application, for the addition of sound or compositing with other video clips or stills, it must first be rendered and saved in AVI or MOV format. Rendering is analogous to taking a photograph of each frame of the animation. The result is photorealistic because the final rendering procedure includes all of the objects and the background in a scene simultaneously and calculates not only objects, colours and textures, but also the interaction of ambient and fixed lights with the various objects within the scene. Rendering also includes any atmospheric effects, like fog or smoke, which have been specified during the design process.

In post production work, rendered animations can be opened in an image-editing program like Painter. A mask can be included during rendering to facilitate such editing.

Figure 6.26 Using rotoscoping to map an animation clip on to an object in Ray Dream Studio: (a) importing the animation file into the Shader Editor; (b) applying the animation to the surface of a sphere object and; (c) rendering the frame

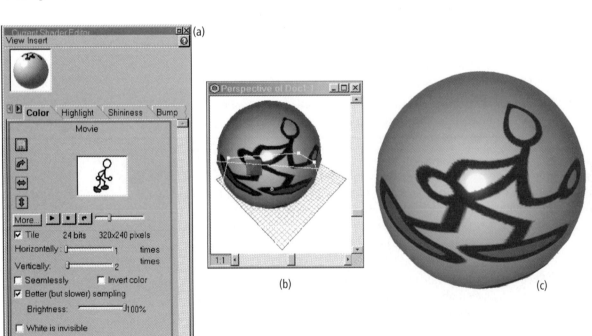

(a)

(b)

(c)

Poser

Poser is a remarkable application from MetaCreations designed to pose and animate figures in three dimensions. Using key frame animation, Poser makes it possible for the animator to pose and animate human motion with almost uncanny realism.

Figure 6.27 shows Poser's workspace, with the default clothed male adult figure displayed in the central document window. Surrounding the *Document* window are a number of palettes which are used to control and edit what appears in the *Document* window. The *Libraries* palette, seen on the right-hand side of the screen, gives easy access to all the figures and poses available from the application's libraries, as well as to libraries of facial expressions, hair styles, hand positions, props, lighting effects and camera positions. Clicking on any of these categories opens the corresponding palette, where previews of the contents are provided (Figure 6.28).

The *Editing Tools* – displayed above the document window – are used to adjust the position of the figure's body parts to create specific poses. Controls include *Rotate, Twist, Translate, Scale* and *Taper*. These can be used in combination to pose figures in an infinite number of ways. All the models in Poser employ inverse kinematics, so that body parts interact just as they do in the real world. Moving a figure's hips downwards by dragging down with the *Translate* tool causes the knees to bend in a natural way as shown in Figure 6.29a and rotating the chest using the *Twist* tool causes the shoulders, arms and head to rotate in harmony (Figure 6.29b). Figure 6.30 shows just a few samples of the figure types and poses which can be created using the *Editing Tools*.

Figure 6.27 MetaCreations Poser workspace

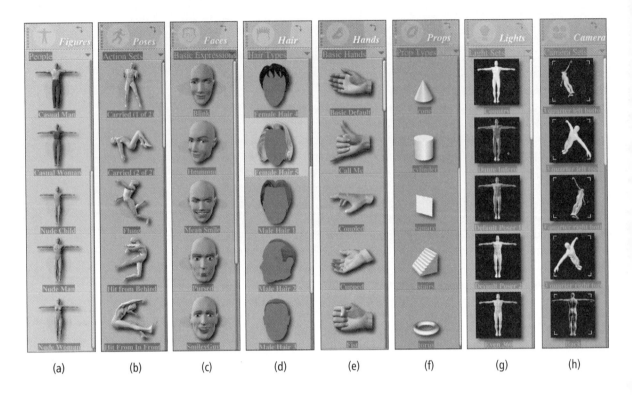

(a) (b) (c) (d) (e) (f) (g) (h)

Figure 6.28 Poser's Libraries palettes

Figure 6.29 Using the Editing Tools to alter figure poses

(a) (b)

Figure 6.30 A few examples of Poser figure types and poses

The *Parameter Dials* – displayed to the right of the document window – work exactly like the *Editing Tools* except that they provide numerical precision for posing a figure. Other palettes within Poser's workspace provide control over lighting parameters, camera angles and document display styles – e.g. *Lit Wireframe* or *Flat Shaded*.

Animation in Poser – with the inverse kinematics feature built into every model – is relatively simple. All that is required is to set up a pose, move to a different point in time, and set up another pose. Poser then fills in the gaps between the two poses. Three tools are provided for the animation process:

○ The *Animation Controls* (Figure 6.31) located at the bottom of the workspace, are used to set which poses are saved as key frames as well as to delete frames or preview an animation. The main area displays the *Timeline*. The *Current Time Indicator* is used to move through time, setting up key frames. The counters in the centre of the panel display the number of the frame currently appearing in the working window and the total number of frames in the animation. The VCR-like controls on the left side of the panel are used to control preview and playback. The controls on the right side are used to edit the key frames on the *Timeline*. Clicking the button bearing the inscription of a key provides access to the *Animation Palette*

○ The *Animation Palette* (Figure 6.32) is used to edit key frame positions and create more complex animations. When first

Figure 6.31 The Animation Controls panel

displayed, the palette shows all the keyframes previously created using the *Animation Controls*. It can be used to animate individual body parts and to edit all the keyframes within an animation. The palette displays the timeline of the current animation and shows all the key frames created for the project. The *Animation Palette* is divided into three sections – the *Setup Controls*, the *Hierarchy Area* and the *Timeline Area*. The *Setup Controls* are used to set the frame rate, duration, frames, and display options for the *Timeline Area*. The *Hierarchy Area* displays a listing of all the objects in the studio. The *Timeline Area*, displays all the keyframes stored for each of the body parts

○ The *Walk Designer* (Figure 6.33) provides the means of applying walking motions to figures. The deceptively simple act of walking actually involves a complex interaction between many body parts and would normally be a very time-consuming posing exercise. With the use of *Walk Designer*, creating incredibly realistic walking motions is a simple task.

Creating a walking figure is a two step process. First the path to be followed is created in the document window and then the walking motion is applied to the figure. The *Walk Path* is used to define the path, which can be a line or a curve, which determines the figure's course as it moves about the scene. Selecting *Create Walk Path* from the *Figure* menu causes a path to appear on the ground plane of the document window. The position or shape of the path can be adjusted using one of the *Editing Tools*.

Figure 6.32 The Animation Palette

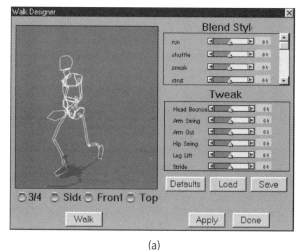

(b) (c) (d)

Figure 6.33 The Walk Designer dialog box (a) and the alternative Side, Front and Top views which can be selected – (b); (c) and (d)

(a)

After the path has been defined, applying a walk simply involves opening the *Walk Designer* window, clicking the *Walk* button to start the real-time preview of the walk, dragging the *Blend Styles* sliders to set the motions of the walk and then clicking the *Apply* button to apply the walk to a *Walk Path*. When the walk is applied, the figure starts walking at the start of the path and stops at the end of the path

Figures 6.34 and 6.35 show examples of key frames from two Poser animations created using the above tools.

Poser can import sound clips which are added to the beginning of an animation and play every time the clip is played. The start and end point of the sound clip can be set by dragging on the *Sound Range* bar which appears at the bottom of the Animation Palette when the sound is imported. The *Graph Palette* (Figure 6.36) displays a waveform representing the sound, showing where marked changes in amplitude occur. Key frames in the animation can be positioned to synchronise with these changes; for example, speech can be simulated by matching the peaks in the sound waveform with changes in mouth position. Within its *Faces* library, Poser includes a number of phonemes – faces posed such that the position of the teeth and tongue correspond to particular sounds. A series of phonemes linked together, produce speech. Thus by posing the face to represent different phonemes, speech can be represented visually. By synchronizing the sounds of speech on an audio track with key frames of an animation consisting of the correct series of phonemes, the sound can be married to the movements of the face.

Poser is a truly amazing application with enormous creative potential. As well as offering the possibility of creating and animating figures using an infinite range of poses, it allows replacement of a body part with

Figure 6.34 Applying Walk Designer to a Poser figure (Figure mode is Lit Wireframe)

Figure 6.35 Animating this Velociraptor model in Poser produces an amazingly lifelike motion

Figure 6.36 Using Poser's Graph Palette, an imported audio clip can be synchronized with the key frames of an animation

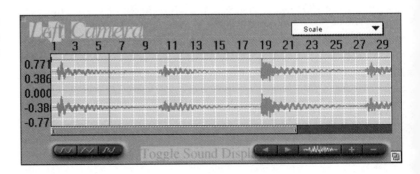

a prop – e.g. by importing props of body parts from other creatures, mythical figures like Pegasus or the Minotaur can be recreated. After replacement, the new parts can be manipulated just like other elements of the figure; even their colour can be changed and texture and bump maps can be applied to them.

Poser figures can be exported in DXF format to other 3D applications like Ray Dream Studio for inclusion as objects within a 3D scene. Animations can be saved in AVI or MOV format, with an alpha channel masking the figure, for easy compositing with other video clips in a videoediting application.

Bryce 3D

Like Poser, Bryce 3D is a unique application designed for a particular purpose – in this case to create and animate virtual environments from mountain ranges to seascapes, from cityscapes to extraterrestrial worlds. Bryce 3D provides separate controls for combining water planes, terrains and skies to create stunningly realistic scenes and for creating and importing a wide variety of objects into the environment. Once a scene is complete, objects within it can be animated or a camera can be animated to fly the viewer through the scene.

Figure 6.37 shows the Bryce 3D workspace. The scene which appears in the window is viewed through a camera which can be moved to show different perspective views. During construction, planes and objects appear in wireframe form but a *Nano Preview* in the top left corner of the screen shows a real time rendered version of the scene as work proceeds. Below the *Nano Preview*, the *View Control* is used to select different views of the scene and, below the *View Control* are *Camera Controls* similar to those we saw in Poser. At the top of the screen are three selectable palettes for creating all the types of objects which can be used in the scene (*Create Palette*), for transforming objects and accessing editors (*Edit Palette*) and for creating the atmospheric environment for the scene (*Sky & Fog Palette*).

After a terrain is placed in the scene it can be selected and edited using the *Terrain Editor* (Figure 6.38) which contains tools for reshaping and refining terrains. Once a terrain, water plain or other object has been selected, a material preset can be applied from the *Material Presets Library* (Figure 6.39).

If a suitable material cannot be found among the presets, the *Materials Lab* (Figure 6.40) can create textures which simulate virtually any material found in the natural world as well as many which are not.

Using the above array of tools and palettes, even an inexperienced user can create and render scenes of quite breathtaking realism – or surrealism (Salvador Dali would have loved Bryce 3D!). Figure 6.41 shows just two examples, although, sadly, colour is needed to do them justice.

Animating a scene in Bryce involves setting up the arrangement of objects and scene settings and then adjusting the settings over time. The application software fills in the gaps between adjustments. The steps to creating an animation are as follows:

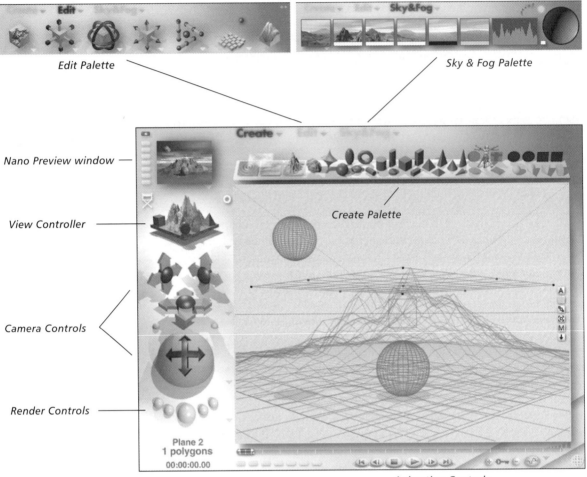

Edit Palette

Sky & Fog Palette

Nano Preview window

Create Palette

View Controller

Camera Controls

Render Controls

Plane 2
1 polygons
00:00:00.00

Animation Controls

Figure 6.37 The Bryce 3D workspace

○ Objects are first created using the *Create* tools or the *Terrain Editor*

○ A scene is then built by arranging and transforming objects, lights and camera settings

○ The position, orientation and/or scale of objects is adjusted as required

○ A key event is created as each change is made

○ Next the shape or placement of the motion path is adjusted

○ The speed at which the object moves along the motion path is set using the *Advanced Motion Lab*

○ Finally the animation is rendered as a video clip

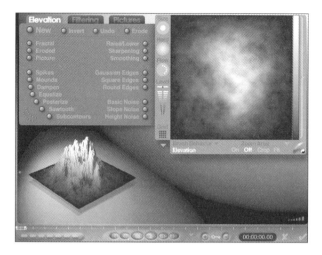

Figure 6.38 Bryce 3D's Terrain Editor

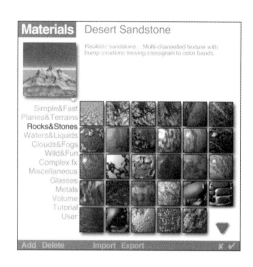

Figure 6.39 The Materials Presets Library

In *Auto Record* mode, Bryce automatically adds key frames and each change made to a scene is recorded as a key event. Changes can include things like moving an object, changing a material or changing the shape of a terrain. The *Advanced Motion Lab* button 🔘 located at the bottom right of the workspace opens the *Advanced Motion Lab* which contains tools for controlling the detailed properties of an animation. The lab is used to view object hierarchies, remap key events, adjust the position of key frames on the timeline and preview the animation. The four areas of the Lab window can be seen in Figure 6.42.

The *Hierarchy List* area, located in the bottom-left corner of the window, displays a visual representation of the object hierarchies in the

Figure 6.40 The Materials Lab

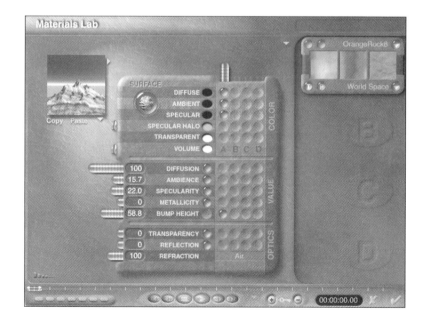

Figure 6.41 Scenes from MetaCreations Bryce

scene. The *Sequencer* area, in the bottom-centre of the window, displays timelines containing all the key events in the animation. A timeline is displayed for each object or scene property in the animation. Every time an object property is changed, the change is registered as a key event in the *Sequencer*. The *Time Mapping Curve Editor*, located at the top-left of the window, displays a curve for each object or scene property listed in the hierarchy. The editor is used to control the length of time between key events. The time to complete an action can be adjusted by changing the shape of the curve – a time mapping curve can speed up events while slowing down others or even reversing them. The *Preview* area, located at the top right of the window, contains tools for previewing the animation.

Figure 6.42 Bryce 3D's Advanced Motion Lab

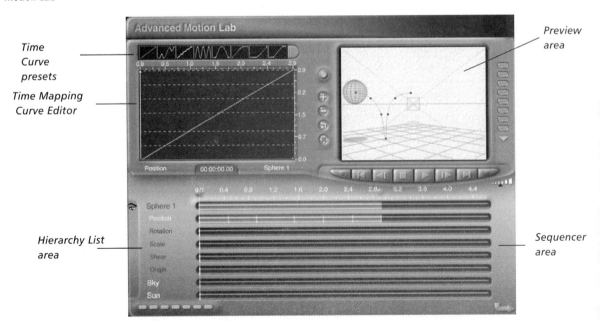

In the simple example shown in Figure 6.42, the *Preview* window shows a sphere following a simple bouncing motion path. The sphere is listed as 'Sphere 1' in the *Hierarchy* window. The key event markers which appear along the sphere's 'Position' timeline in the *Sequencer* window correspond to the dots along the sphere's path in the *Preview* window. The path can be edited by dragging the points on the path to adjust its trajectory through the course of the animation. The straight line shown in the *Time Mapping Curve* means that the sphere will travel at uniform speed from start of motion to end of motion. The speed at different points along the path can be adjusted by changing the profile of the curve.

Figures 6.43, 6.44 and 6.45 show examples of animation in Bryce 3D. Dramatic effects can be obtained by setting up a scene and then using camera panning and zooming to create a 'fly through' effect. Figure 6.43 shows three frames from such an example using a scene consisting of a water plane bounded on either side by steep rocky terrains creating the illusion of a river flowing through a gorge. By panning and zooming the scene camera between key events, the viewer has the impression of flying through the gorge, low above the water. In the second example, in Figure 6.44, the fly through effect is combined with object animation; the central terrain was first animated to create the impression of mountains rising up out of the plain, using the animation controls provided at the bottom of the *Terrain Editor* (see Figure 6.38) and then, using camera animation, the viewer is taken on a ride through the new mountain range to the valley beyond.

In Figure 6.45, the texture applied to the surface of a sphere has been animated using the animation controls at the bottom of the *Materials Lab* window (see Figure 6.40), to simulate the swirling surface of a

Figure 6.43 Animation in Bryce 3D using camera panning and zooming

Figure 6.44 A combination of object animation and camera animation

gas covered planet. To add to the effect, a group of meteorite-like objects have been added, textured and animated to travel around the planet, as if in orbit.

The *Environment Attributes* dialog boxes (Figure 6.46) are used to control every aspect of the Bryce environment. Controls are provided to edit the look and motion of clouds, the position and look of the sun or moon and to add atmospheric effects like rainbows or the rings sometimes seen around the sun due to light scattering effects.

Bryce 3D supports import of DXF, OBJ, 3DS and 3DMF files, so figures from Poser and objects from Ray Dream Studio and other 3D application can be imported and included within animation projects.

Figure 6.45 A combination of texture animation and object animation

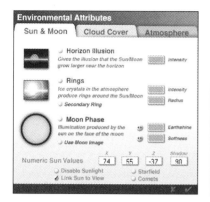 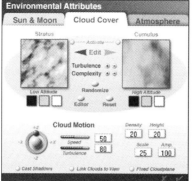 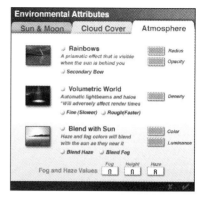

Figure 6.46 Editing environmental and atmospheric effects in Bryce 3D

Tips and Techniques

Animation is the process of simulating the passage of time. In the real world, we perceive time through the changes in our environment – the simplest examples being the moving hands of a clock or the changing position of the sun. The most obvious type of change is motion. The skill of animation is the skill of portraying that motion convincingly, whether in a realistic or 'cartoonish' way. When an object changes position at different points in time, it appears to be moving. But, an object doesn't have to be moving to indicate the passage time. A change in colour, texture or geometry can also serve the same purpose.

Over the last 50 or so years, traditional animators have developed methods and techniques to perfect their art. Many of these still apply today to the work of the 2D or 3D digital animator and are included in the following list of tips and techniques.

○ Storyboarding – A technique used by traditional cel animators to plan the sequence of events in an animation. A storyboard is a series of drawn images which describe an animation, scene by scene, as it develops over time. Outlining the animation sequence at storyboard stage, before drawing or modelling begins, can help avoid unnecessary work and save considerable time. The storyboard can be a series of simple sketches showing the overall action of the animation as viewed through the rendering camera, accompanied by diagrams showing the position of objects, lights, and cameras at key points. Sample storyboards can be created by drawing a series of horizontal screen outlines on a sheet of paper, using a 4 to 3 aspect ratio. Space for pencilling in narration or annotations should be left below each row of drawings

○ Simplifying Scenes – Because the eye tends to be drawn toward motion and elements in the immediate foreground, static objects and background elements need not be drawn or modelled in detail. Reducing unnecessary detail reduces rendering time dramatically and keeps the size of scene files to a minimum

○ Smooth Motion with Hot Points – Complex motion is generally animated by moving an object through a sequence of positions along a motion path, with key events created at each position. When animating along simple curved paths in an application like Ray Dream Studio however, it is often easier to offset an object's hot point and animate its motion using rotation rather than translation. For example, after pointing a camera at an object, the camera's hot point can be moved to the centre of the object and then the camera can be rotated around its own hot point to animate a fly-around of the object. This approach generally requires fewer key events than creating a similar motion path in the normal way, and produces equally good results

○ Inverse Kinematics – A specialized behaviour applied to linked 3D objects in a hierarchy, inverse kinematics creates organic movement, reduces the time it takes to create realistic animations and provides versatile child to parent control. Normally, movement is transmitted downward from parent to child in the hierarchy. When a child is linked to a parent object using inverse kinematics, movement can also be propagate upwards, i.e. when a child object moves, the parent follows. Motion cannot propagate from a linked child to its parent without the use of inverse kinematics

○ Rendering without Compression – Unless hard disk space is severely limited, rendering without compression provides the highest quality animation clip to work with. Working from the uncompressed original, copies can be used for experimentation with different compression settings to determine an acceptable image quality and playback rate. Rendering should always be carried out without compression if post-processing in another application is planned

○ Duplicating Relative Motion with Groups – Duplicating a 3D object or effect also duplicates its animation data, such as key events and tweeners. Used carefully, this can avoid the unnecessary work of having to recreate the same data for different objects

○ Animating with Deformers – Deformers in 3D applications are used to alter the shape of an object dynamically. Deformers like *Stretch, Bend, Twist, Explode, Dissolve* and *Shatter* produce interesting animated effects that cannot be achieved by other means. Deformers can be used to

animate the shape of entire groups and imported DXF objects, which cannot be edited directly in a modeller

○ Animating Textures – Some spectacular animation effects can be created simply by animating object textures. Virtually any type of change to a texture can be animated, from a simple colour change to a shifting geometric pattern. An object can appear to change from metal to stone, or from glass to wood. Editable parameters include values for attributes like transparency or shininess and procedural function parameters like the number of squares in a checker pattern

Over the years, tradition cartoon cel animators have also developed a set of motion and timing principles which contributed significantly to the success of the cartoon as a form of entertainment. Again, many of these principles still apply in the new digital environment:

○ Squash and Stretch – The animator's terms for the exaggerated redistribution of an object's mass as it changes position, conveying the qualities of elasticity and weight in a character or an object. An example is a bouncing ball; as it falls it stretches; as soon as it hits the ground it is squashed. Without the change of shape, the viewer would interpret the ball as a solid, rigid mass

○ Lag and Overlap – When an object moves from one point to another, not every part of it has to move at once. To simulate real-life movement, action that is secondary to the main activity can lag or overlap. For example, when a car stops abruptly, the car body is thrown forward by its own momentum, before settling back on its springs. The cartoon animator exaggerates this real-life observation for effect

○ Arc versus Straight Line Movement – Character motion appears more realistic if it follows an arc or curved path instead of a straight line. Most objects affected by gravity also follow curved, rather than straight, trajectories

○ Secondary Motion – Secondary motion adds realism and credibility to a scene. A character turning his head to stare at something in surprise should not just turn his head; his jaw should drop and his eyes should open wide as well. The viewer focuses on the main action, but registers the secondary motion as supporting it

○ Exaggeration – Exaggerating an action emphasises it, making it more pronounced. For example, if a story line calls for stealth, the character should sneak, not just walk. Virtually

any type of action can be exaggerated to ensure effective communication with the viewer

○ Timing – Timing is as important in cartoon animation as it is in any form of dramatic presentation. In general motion which continues at a constant pace lacks interest and seems unnatural. To animate realistic character action, it can be helpful to 'act out' the sequence, timing how long each pose is sustained and how long each action takes. Key events defined at different points on the time line need to be synchronized with those which come before and after. A key advantage of computer animation is the ability to fine-tune timing

Summary

By its nature, traditional animation has always been a labour-intensive task. While the work of traditional lead animators requires a high degree of skill and creativity, that of the rank and file animators – who are responsible for creating the 'in between' frames – is largely repetitive. Fortunately, computers are particularly good at repetitive tasks and take much of the drudgery out of animation work. The advantages of computer animation, however, go far beyond just reducing the tedium and improving the productivity of the task.

As we have seen from the examples in this chapter, the 2D and 3D animation applications now available to the desktop animator offer enormous flexibility through the ability to re-order layers and to manipulate and reuse all or parts of objects within any scene; objects can be effortlessly scaled rotated or skewed, their transparency can be adjusted and they can be cloned and edited using precise masking techniques.

In 3D applications, animation can be applied to object position, size, shape and shading attributes and also to cameras, lights, ambient lighting, backdrops and atmospheric effects. The use of inverse kinematics and specialised links like ball-joints assist the animator in achieving realistic three-dimensional motion with minimal effort.

The ability to work at pixel level within individual frames provides an unprecedented degree of drawing and editing precision, while digital colour control assures consistency of colour rendering across all the elements of a project and between projects. Electronic archival and retrieval techniques put backgrounds and objects at the instant disposal of the animator, while specialist applications like Poser and Bryce 3D significantly reduce the effort needed to generate new figure poses or landscapes.

The long rendering times for animated 3D sequences does present an obstacle, but the relentless progress of CPU speeds into the Gigaherz range and the exploitation of multiprocessing techniques will reduce and eventually resolve even this problem.

7

The raw material

Many users of the first generation of PC's will remember the excitement of acquiring, at not inconsiderable expense, their first set of new bitmapped fonts, which came in only a few fixed point sizes, and watching proudly as they printed out on a noisy matrix printer, giving a whole new style to the printed page.

Font collectors later became clipart collectors, as many of the early painting applications bundled a miscellaneous assortment of black and white bitmapped clipart images on an extra diskette included with the software. With the advent of drawing applications, vector clipart started to appear, with quality improving rapidly as the market developed. Then, as CD technology arrived on the desktop, whole CD libraries of high quality, royalty-free images became available to the user.

Already, the same trend is being followed in the domain of desktop video, as many video editing applications are now bundling short video clips on CD ROM with their software and the first commercial video clip libraries are beginning to appear.

Subject to normal copyright considerations, the sources of material for use in the production of desktop video, including multimedia projects, can be summarised as follows:

- ○ Composite VHSC or Hi8 analogue video/audio clips captured from a VCR or a camcorder or from terrestrial, cable or satellite TV

- ○ Video/audio clips captured from a digital camcorder via a Firewire adapter card

- ○ Animation or morphing video clips and audio sound effect clips supplied with video hardware or application software

- ○ Video and audio clips sold like clipart by commercial suppliers, e.g. Corel's Gallery

- ○ Animated GIF video files (e.g. Corel Gallery Webart) for use in projects designed for the Internet

- ○ Still digital camera images which can be downloaded from the camera and incorporated within multimedia projects

- ○ Other still images such as scans, vector or bitmap clipart and 3D modelled objects. These can be used as still images or incorporated in animations via applications like Bryce 3D

- ○ Stills can include business charts like graphs, histograms, pie charts, bar charts, etc. for inclusion in business multimedia presentations

- ○ Adobe Type 1 and Truetype typefaces can be used for creating titles and text overlays on video or stills

- ○ Colour washes, textures and fractal images for use as backgrounds or overlays

○ Analogue sound captured from a stereo system via the PC's audio digitising card and suitable recording software

○ Speech captured via a microphone, digitising card and recording software

○ Musical sound clips in MID or WAV format either bundled with audio hardware or software or purchased from a clip library

○ Digital music captured from music CD ROMs

○ Digital video and audio clips capture from Digital Versatile Disk (DVD)

○ Audio clips downloaded from Internet sources

Having acquired raw material from sources such as those described above, the challenge facing the user is how to organize it all in a way which does not involve rummaging through countless videotapes, diskettes and CD-ROMs to find that clip showing a sailing boat disappearing into the sunset that would provide the perfect ending to the project due to be delivered to the customer tomorrow! Fortunately, a number of applications are available which help to address this problem.

Where hard disk storage space considerations rule out the digitisation and storage of many hours of raw videotape material, Studio 200 provides a simple and space-saving means of cataloguing video clips. As mentioned earlier in Chapter 3, Studio 200 can detect each of the different scenes shot on camcorder tapes and then automatically log the start and end tape positions for successive scenes, capturing an image of a frame at the beginning of each scene. Figure 7.1 shows thumbnail images of a series of clips logged in a *Tape Library* in this way. When a library

Figure 7.1 Autologging video clips in Studio 200

is reopened, double-clicking on a thumbnail opens the *Modify Clip* window (Figure 7.2) which displays the clip duration and *Start* and *End* positions on the tape. With this information, a selected clip can then be digitised and imported into a videoediting application. As well as providing a thumbnail image to help indicate the contents of each clip in a library, Studio 200 provides the means of recording archival information to describe and categorise the contents of each clip. This information, which is entered via the aptly named *Clip Information* window (Figure 7.3), can be retrieved by clicking on the *Info* button in the *Tape Library* window.

Studio 200 also provides a library search function which can be used to search through clip names, comments and categories to find specific text. The text string to be searched for – e.g. *Gulf coast* or *Travel* – is first entered into the *Search Text* window in the *Library Search* dialog box (Figure 7.4) and then the search is initiated to cover the entire tape library, or just the current library list. All clips matching the search text are identified and listed by tape and clip name. Clips on the list can then be

Figure 7.2 Studio 200's Modify Clip window displays the clip's Start and End tape positions and also the clip's duration

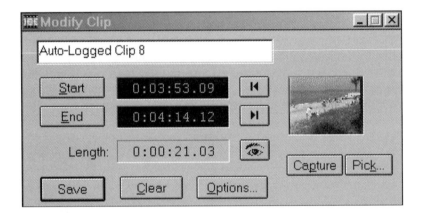

Figure 7.3 Descriptive information can be entered to facilitate clip retrieval

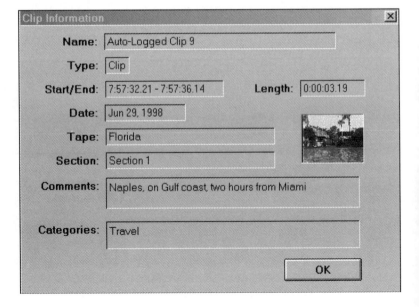

Figure 7.4 Searching for clips in a Studio 200 Tape Library

modified, deleted, or added to the event list as they can be in any tape library mode.

Video clips which have already been digitised and saved to disk can be logged using the cataloguing facilities provided with a videoediting application. Lumiere's *Media Catalog*, for example (Figure 7.5), normally just provides a registry of the clips used in a particular Lumiere project, but a *Media Catalog* file can be named, saved and opened independently of the original project and other files can be added to or deleted from the catalogue as required, using the *Import* and *Delete* tools included in the toolbar at the top of the *Media Catalog* window. It is important to note that the catalogue file remains relatively small as it points only to the location of the clips, rather than maintaining copies of them. As well as logging video clips, a *Media Catalog* file can include pointers to sound files and still image files.

MediaStudio's *Clip Library* can also log video and other file formats. In *Thumbnail* mode (Figure 7.6a), only the clip thumbnail and clip

Figure 7.5 Lumiere's Media Catalog window

Figure 7.6 MediaStudio's library offers Thumbnail mode (a) and Expanded mode (b)

(a)

(b)

name shows. In *Expanded* mode (Figure 7.6b), the window shows a thumbnail of each clip along with detailed information including mark in, mark out, and file information. The button in the top right corner of the window gives access to facilities for annotating files contained within a library and for carrying out searches for clips with information matching the search criteria.

Premier's *Project* window (Figure 7.7) is used to stockpile clips for importing into a project. For each clip, the default *Project* window displays the name, a thumbnail, the general type (*Movie, Audio, Still Image, Filmstrip, Background Matte*, or *Title*), the duration, a *Comment* box and two *Label* boxes. The *Comment* box and two *Label* boxes to the right of the clip name are used to attach notes to a clip. Adding a comment or a label simply involves clicking the appropriate box and typing the text to be associated with the clip. Clips can be alphabetized according to comments or labels. While providing the above functions, Premiere's *Project* window is designed for use with its associated project rather than to provide a more general library function.

As an alternative to using the logging facilities provided within a videoediting application, clips can be logged in an independent library application designed for the purpose. Corel GALLERY Magic, for example, is a multimedia file manager designed to organise files into albums for the purpose of editing, performing batch operations and creating slide shows. The desktop (Figure 7.8) contains four windows. The *Drive Directory* window is in the lower left, the *Drive* window is in the lower right, the *Album Directory* window is in the top left, and the *Album* window is in the top right. Multiple album windows can be open on the desktop at the same time.

In the *Drive* and *Drive Directory* windows, drives, folders and files are represented by icons. In the *Album Directory* window, open book icons represent expanded albums, and closed book icons represent collapsed albums. In the *Album* window, thumbnails represent graphic files, and icons represent non-graphic files such as video or audio clips (Note: In order to provide an image thumbnail for video clips, the first frame from each clip can be captured and saved as an image file in any video capture

Figure 7.7 Premiere's Project window

🗀 Project: Sample.ppj					_ □ ×
19 items Name		Comment	Label 1	Label 2	
Black matte Color Matte Duration: 0:00:02:01 640 x 480	[1] ✦				
Circus.wav Audio Duration: 0:00:21:06 11Khz - 8 Bit - Mono	[1] ∿				
Closeup.avi Movie Duration: 0:00:02:15 160 x 120	[1] ✦				

Figure 7.8 The Corel GALLERY Magic desktop

application and displayed in the album alongside the video file). New files are added to an album simply by dragging their icons from the *Drive* window into the *Album* window.

The application supports a wide range of vector, bitmap, video and audio formats and provides filters for converting between formats. Many features are included for creating, accessing and working with albums, clipart, photos, video files, and audio files. A *Properties* button gives quick access to information about the contents of an album, by filename or keywords (Figure 7.9). A *Browser Database* provides the facilities to enter each album file into a database where it is assigned a library name, filename, title, caption, and several unique keywords. A powerful search feature (Figure 7.10) can then be used to perform sophisticated searches, using this information, to locate any item in the database.

Figure 7.9 The Corel GALLERY Magic
Properties window

Figure 7.10 The search engine

After selecting an album, clicking on a *Slide Show* button gives access to a full screen display of the image files contained within the library. The show can either be run using a preset delay between images, as they are displayed sequentially in the order in which they appear in the library, or controlled by clicking with the mouse.

Summary

As desktop video hardware and software increase in power and the market continues to grow, we can expect to see a rapid increase in the availability of audio and video clip libraries offering material for purchase or license. Such material can be integrated 'as is' with new, original footage, or edited to adapt it to meet the specific requirements of a new project. The increasing use of videoconferencing on the Web is likely also to act as a stimulus to desktop video as technology is developed to manipulate video within the Internet environment. Subject to the restrictions of copyright, such developments could fuel an exponential increase in the amount of material which becomes available to the user.

The desktop video editor has the same need as a writer or desktop publisher to establish a reliable filing and retrieval system – perhaps even more need, considering the range of raw materials from audio clips to still images, animations and captured video which may be required for composition of new projects. Already, as this chapter has shown, simple solutions are available for this purpose. No doubt, faster and more sophisticated search engines are already in the pipeline to help cope with the increased raw material which is becoming available.

8

The production process

A design objective which was common to many early desktop applications was the emulation of the traditional approach to whatever function the application was offering, be that typing a letter, painting a picture or designing a newsletter layout. Whatever the application, the emphasis was on creating a desktop metaphor. It is only some years later, as these applications begin to mature, that we are seeing the emergence of features which set these applications apart from their traditional counterparts, as developers discover and exploit features and functions which are uniquely digital.

Compared with these more mature applications, desktop video is still at an early stage of development. As digital technology and techniques have steadily infiltrated the analogue worlds of film and television, the skills of the two communities have increasingly overlapped. It is not surprising, therefore, that the early video editing applications which have evolved for the desktop have much in common with their analogue ancestors. In previous chapters we have looked at the nuts and bolts of this evolving digital videoediting environment. In this chapter, we shall examine how these nuts and bolts can be used together to help assemble a finished product.

For the purpose of exploring the various aspects of the production process, we shall plan and develop a business multimedia video for an imaginary corporate customer. Such a project will cover the widest possible range of content and will involve the same basic considerations as we would have to apply to any of the above project categories. The outline specification for the project is summarised below:

○ Customer – Caledonian, a multinational petroleum company with headquarters in London

○ Objectives – To inform and motivate employees

○ Fifteen-minute video to be shown to employees at worldwide locations, summarising company results and achievements during the previous year and looking ahead to prospects and challenges in the coming year

○ Output to be in a format, or formats, which can be viewed by all employees, including some at remote sites

○ Content to be proposed by the design team, but to include introduction by the company's chief executive, business results and an outlook versus the competition

○ Budget £30 000. Completion of outline for management review within 4 weeks and delivery of completed output media ready for mailing in 12 weeks, with progress checkpoints at weekly intervals

The production process

The precise details of the production process depend, of course, on the nature of the project in hand but, broadly speaking, the following sequence applies to most cases:

- ○ Planning – defining clearly the objectives for the project, the resources required to create it and the target date for completion, if appropriate
- ○ Creating scripts for audio clips
- ○ Assembling the raw material, including the required hardware and software, as well as video and audio sources
- ○ Placing and synchronising elements within the timeline of a videoediting application
- ○ Adding video transitions, filters, paths and overlays where required
- ○ Adding audio special effects
- ○ Testing and saving the project
- ○ Compiling the project and generating output to disk in AVI or MOV format
- ○ Producing output to CD ROM or to videotape

Planning

The level of detail required in the planning of a project will, of course, vary according to its content, length, complexity, intended output method, and audience. Production categories range from simple, video-only Web animations lasting for a few seconds, to promotional videos, advertising clips, educational or business multimedia videos, to documentaries or feature films lasting up to an hour or more.

The complexity of our Caledonian business video project is high and will require detailed planning and implementation by a design team consisting of a director who has overall management responsibility for the project and for ongoing liaison with the customer, an editor with technical and artistic responsibility for integrating the various audio and video components of the project into a cohesive whole which meets the design objectives, a script writer and various audio and graphics specialists.

Consideration should first be given to the objectives, which are to create a blend which communicates business information clearly and

simply to an audience ranging from production workers to business managers, with footage designed to recognise achievements and to motivate viewers to identify with the company's objectives for the year ahead.

Budget constraints dictate that, while limited resources can be applied to video-taping new footage – such as the chief executive's introduction – as far as possible, existing footage shot by the company's Communications Department during the course of the year, will have to be edited and adapted.

A first pass brainstorming session by the design team produced the following outline for the project:

○ An animated introduction zooms in from space through a global view of planet Earth to the company's European headquarters building in London, accompanied by background music. As the music fades, a professional 'voiceover' introduces the company chief executive and subsequently provides the voice links between the different sections of the video

○ The headquarters shot fades to the CEO's office, where he speaks directly into the camera

○ Shots of the CEO are interspersed with stills of business charts, newspaper cuttings and FTSE trends, which he refers to as he describes the company's results for the past year, including comparisons with the competition

○ Cutaway shots of different locations appear as he refers to the performance of different divisions and countries

○ References to achievements of the past year are supported by video and still shots depicting these achievements, such as major projects completed on schedule

○ As he looks to the future, satellite and aerial shots show sites of new deposits. Stills show artist's impression of how new sites will look when developed, a proposed new tanker terminal and pipeline construction. Reference to developments in technology are supported by shots of new drilling platforms and underwater shots of submersibles

○ Theme changes to importance of employees to future success of the company, showing award presentations to outstanding employees, shots of retiring and new employees, with reference to winning by the company of a health and safety award

○ In the final section, the importance of good communications within the company is stressed. Shots of department meetings and company conferences back this up, with shots also of screens from the company's intranet pages and Web site pages

○ As the CEO ends by thanking all employees for their efforts, the closing sequence reverses the starting sequence with an animated zoom out from London showing city features like Tower Bridge and St Paul's and then continuing to zoom out, as if filmed from a space shuttle camera, showing Europe and then the globe, with supporting music rising to a climax as the video comes to an end

The above simple outline can now be expanded into a description of the sequence of major actions, or shots, in the video. This will include a series of storyboard sketches, like the example in Figure 8.1, which outline the beginning, titles, transitions, special effects, sound, and ending of the video.

As well as planning the video content, consideration has to be given to how the video will be played back in order to decide what frame size, frame rate, colour depth and compression settings should be used to for production. In this case, the plan is to cover the majority of viewers using videotape played back on TV screens distributed around conference rooms, therefore the video will be created at a frame size of 640 x 480 pixels, frame rates of 25 fps and 30 fps and 24 bit colour to ensure good quality. Different compressors will be tried to obtain the best result.

Any of the videoediting applications described in Chapter 4 could be used to manage the project. MediaStudio will be used for our sample project to maintain consistency. As the project will be large in terms of disk space and file size, it will be separated into several more manageable files. This can help speed up the work as well as making it easier to focus

Figure 8.1 A high level storyboard shows frames representing the major sections of the video

Dramatic introduction, zooming from space to a view of the Earth rotating on it axis and then into Europe and an aerial view of the City of London. Stereo musical backing

City of London shot continues to zoom into financial district and then fades to shot of Caledonian HQ. Pan from street level to executive floor

Fade and voiceover intro to CEO speaking to audience from office in HQ building. Speech to be illustrated with titles, video clips and stills

While CEO is speaking, still to zoom out from top right corner to fill screen. When topic completed, zoom still back to same corner

Information called up during speech will include video clips showing, for example, a new North Sea oil rig on which construction has just been completed

Other background shots will include satellite photographs of new areas of exploration and new finds

Closing sequence to mirror opening sequence i.e. after CEO completes his speech, fade and zoom back outside building

Final clip zooms back from aerial view of London to Europe, to revolving globe and then out into space, accompanied by closing music

on the scene in hand. To help keep track of the work and to avoid confusion, features such as the MediaStudio's *Clip Library, Project Window, Browse function*, and *Packaging* commands will be used. When managing a complex project, it makes life easier to keep all the relevant files in a single directory. The *Package* command in the *File* menu copies or moves all files in the current project to a specified directory.

Cues, cue names, and file descriptions provide the means of remembering where clips are in the project and which effects and filters are being used. Cues are used to name and identify portions of the project and clips. For example, to synchronize an audio, overlay, or special effect with another track, a cue can be used to help line up all the clips properly. Also, a cue can mark a part of the project to be later returned to for further work. There are two types of cue in MediaStudio. Project cues appear in the bottom of the ruler and can apply to any part of the project. Clip cues can only be assigned to video or audio clips and appear in the cue bar below the track the clip is in.

Creating scripts

Scripts will be needed for the CEO presentation and for the voiceover introduction and some links between sections of the project. Time slots need to be booked in advance with the CEO's secretary to preview and fine tune his script to his satisfaction.

In preparing scripts for any project, care needs to be taken to ensure that the language used (e.g. when covering financial or technical subjects) is appropriate to the level of the target audience.

Assembling the raw material

Our Caledonian project will use a wide array of materials including the following:

○ New video and audio footage (e.g. CEO presentation) and existing video and audio footage on both tape and disk

○ Still images in the form of scans (e.g. from award presentation photographs or slides), business graphics designed in a charting application, screen captures and CD ROM images (e.g. for introduction and ending)

○ Analogue audio recordings and synthesized music and sound

○ Animated flythrough sequences showing artistic impressions of new sites

○ Animated title clips

The following quality guidelines need to be kept in mind when video-taping and then capturing video and audio clips, to ensure the highest quality results are obtained:

○ Careful and effective use of lighting enriches colours and shows details more clearly. The use of a flat lighting scheme which illuminates the subject from all sides eliminates shadows, reduces colour variations and improves playback performance. The use of such a scheme can, however, produce a dull, uninteresting scene, so a balance has to be struck to achieve the best compromise

○ The masters, rather than copies of existing tapes should be used as source material. Copies introduce background noise, which affects playback quality, and results in lower compression ratios. High-quality video formats such as Hi-8 should be used to create new tape footage

○ Regular geometric patterns such as tartans, venetian blinds, tiles or check patterns can cause visual interference and should be avoided when shooting new footage

○ To improve compression, creating smaller compressed files and reducing the demands on the system during playback, the degree of the change in the image between frames should be limited. In the extreme case, a still image clip yields a high compression ratio, while panning or zooming the camera during recording decreases the compression ratio. Areas of flat colour compress better than fine textures

After video-taping the new footage, the sequences to be used in the project are captured to disk using MediaStudio's capture utility and the procedure described on page 34. For each sequence, a capture file is pre-allocated on disk, ensuring sufficient space for storing incoming video and audio data. After allocating a capture file, a disk-defragmentation utility is used to defragment the hard disk on which the capture files are to be stored. If the capture file does not reside in contiguous sectors of the hard disk, the system will be forced to perform a disk seek during the capture session, which could result in dropped video or audio data. During capture, as much processor capacity as possible needs to be dedicated to the capture process by turning off all unnecessary applications, minimizing all open windows except the capture window and turning off TSRs.

Before capture is initiated, option settings which are consistent with the plans for the overall project are set for the colour depth, frame size and audio format. Capturing and compressing video can be a time-consuming process, so it's important to adjust settings carefully and then test the setup by capturing a few test frames before capturing a lengthy sequence. Once the right setup has been created, to capture the CEO sequences, for example (Figure 8.2), it can then be used for other footage to be used in the project.

Some existing digitised video clips received from remote sites are in MOV format and some are in AVI format but this should not pose a problem as MediaStudio can import both formats. While one member of the design team continues to collect and, where necessary, digitise the video footage called out on the storyboard, a second member collects and digitises the audio footage. Music will be used for the project's introduction and ending and

Figure 8.2 Capturing and digitising the CEO's introduction

some synthesised sound effects will be used in conjunction with the business charts and animated flythrough scenes. The voiceover, which will introduce and link the different sections of the project, will be added in the final stages, after the visual elements have been placed in the correct order. Two 3D graphic artists will work together to create the animated flythrough graphic sequences in Ray Dream Studio and Bryce 3D.

As the material begins to accumulate, work can begin to place the first clips roughly in position within MediaStudio's timeline.

Placing elements on the timeline

To ensure that the system works at optimum efficiency, as files are imported and placed in the timeline, a number of preparatory steps have already been taken:

❍ In MediaStudio's *Video Director* preferences dialog box (Figure 8.3), a RAM cache of 48 Mb and a disk cache of 100 Mb have been set to allow MediaStudio to maintain a cache of files, making it easier to recall information quickly

❍ Using *Proxy Manager* (Figure 8.4), available from the *File* menu, proxy files will be created, modified, and tracked. The proxy files are used to show preview information and other intermediate results. By using proxy files in place of the larger original files, memory utilisation is improved and work can proceed more quickly. When the project is complete, the *Save to Video* command from the *File* menu will automatically replace the proxy files with the original clips

❍ Using *Preview Options* (Figure 8.5) from the *View* menu, a frame size of 320 x 240 and a frame rate of 12 fps have

Figure 8.3 Setting cache sizes in the Video Editor dialog box

Figure 8.4 Creating proxy files to speed processing

Figure 8.5 Setting Preview Options

been set to speed up the preview process. Later, as work nears completion, these settings will be adjusted to produce a preview representative of the final project dimensions and frame rate

We are now ready to place the first clips in the timeline (Figure 8.6). An opening standard video clip of outer space, placed on Track Va, is accompanied by a stirring celestial stereo music clip on Track Aa, to capture the attention of the audience. The effect of travelling through space is created by panning and zooming towards one of the more prominent stars in the galaxy, using the technique described on pages 51 and 52. After placing the second video clip on Track Vb – depicting planet Earth rotating on its axis – adding a *Crossfade* transition, which overlaps the two clips, causes the Earth to fade in, with stars and the blackness of space in the background. As the clip runs, the Earth rotates and becomes larger as if we are approaching it. Another *Crossfade* transition takes us to a still image aerial shot of central London placed on Track Va. Panning and zooming in towards Big Ben identifies the city, which then crossfades to a third video clip showing the Caledonian headquarters building. This clip opens with a shot of the lower part of the high-rise building with its

Figure 8.6 Placing the first clips and transitions in the timeline

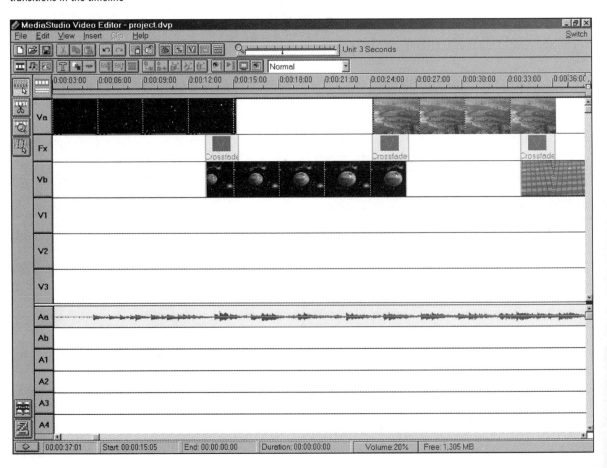

(a)

(b)

Figure 8.7 As clips are placed in the timeline, they are simultaneously added to the Project Window

characteristic blue tinted glass facade, and then the camera pans up the building facade until it reaches the top floor.

As video and audio clips are added to the timeline, thumbnails appear in the *Project Window* (Figure 8.7a). Clicking the button 🔳 to the top right of the window rearranges the thumbnails into a vertical left-hand column, providing space in the right column to add notes or comments (Figure 8.7b).

Note: When placing audio clips in the timeline, the *Level* button in MediaStudio's *Audio Format* dialog box should be used to adjust the audio level so that the loudest audio passages are about 80% of the full range. Ideally all audio clips to be used in the projects should be recorded at a consistent audio level.

After completing this first stage of the project, it's time to check how well the video clips, audio clips and transitions are working together. An quick preview of part of the project – e.g. the transition between two clips – can be seen by clicking, holding down the mouse button and dragging from left to right in the time ruler at the top of MediaStudio's workspace. Alternatively, selecting *View/Preview* initiates the compilation of an AVI file of the work completed so far, using the preview options set earlier. The *Preview* window appears (Figure 8.8a) and, below it, another window which displays real-time data relating to the compilation of the new file (Figure 8.8b). On completion, the movie appears in the preview window and begins to play. Such previews, carried out periodically as work proceeds on the project, identify any obvious problems related to clip duration, smoothness of transitions, synchronisation of sound with video, etc. Clips can be trimmed using the *Scissors* tool 🔲, which is permanently displayed to the top left of MediaStudio's workspace. When the tool is selected the mouse pointer changes to a pair of scissors and a clip can be cut into two by simply clicking the scissors at the point where the cut is to be made. When it is important to make the cut accurately, the *Magnify* tool 🔲 can be used to zoom in repeatedly in the vicinity of the cut point until the boundaries between individual frames in a video clip can be seen. (The tool can also be used for precise editing of an

Figure 8.8 Previewing the work in progress by compiling an AVI file

(a)

Estimated Time: 00:01:59
Elapsed Time: 00:00:13
Remaining Time: 00:01:46
Estimated Disk Space: 751 KB
Used Disk Space: 83,964 Bytes
Free Disk Space: 1,223,104 KB
Current Data Rate: 15,745 Bytes
Maximum Data Rate: 17,974 Bytes

(b)

audio clip). Another convenient editing tool, displayed beneath the *Magnify* tool is the *Time Selection* tool which can be used to select an area with high precision by dragging with the mouse in the timeline over the area to be selected. Using this method, clips can be selected over multiple tracks.

At any time during construction of the project, clicking on *View/Project Information* or *View/Clip Information* will open the windows shown in Figure 8.9a and 8.9b respectively. *Project Information* displays data about the current project including file, size, description, and configuration information. It also lists all clips and other files used in the project so far. *Clip Information* displays data about the selected clip including file, size, format, path, and mark in and out data.

Since no major problems have been revealed by previewing the project up to this point, fine tuning can be left until a later stage and we can proceed with the next stage of the project. As the introductory music fades, the voiceover begins with the introduction of the CEO and the building clip fades to a clip showing the CEO seated at his desk and looking into the camera. The CEO videotape, which runs to 20 minutes, was prepared in parallel with the business charts to which he refers. The relevant sections of the videotape and the business charts and other visual aids – which were prepared using Lotus Freelance – now have to be converted to digital clips and placed in the timeline. To provide continuity to the pre-sentation, a set of animated title clips will also be inserted at appropriate points to introduce each new section.

Figure 8.9 The Project (a) and Clip (b) Information boxes provide reference data as work on the project proceeds

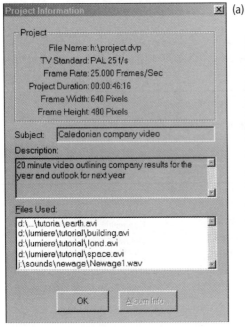

(a)

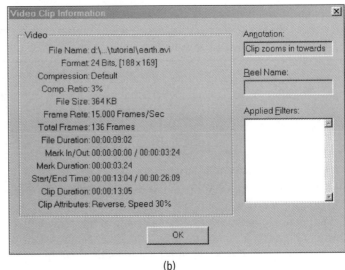

(b)

Creating title clips and business charts

Figure 8.10 shows four sample frames from each of two title clips. Such animated titles are easily created in an application like Ray Dream Studio, using the techniques described in Chapter 6. The same typeface, colour and size is used consistently throughout the presentation to provide other titles covering Financial Highlights, Accomplishments, Competition, Research and Development, Market Outlook and Future Strategy.

To blend the project introduction with the start of the CEO presentation, the introductory music clip is faded out by selecting the clip and adjusting the volume profile by dragging down with the mouse as shown in Figure 8.11 and then a professionally recorded voiceover clip is added to Track Aa, welcoming the audience to this annual event and introducing the CEO. As the introduction is made, the first title clip plays on Track Va and is followed immediately by the clip showing the CEO seated at his office desk, also on Track Va. The CEO voice clip is placed on Track Aa and carefully aligned to synchronise with the video clip.

As the CEO speaks, the plan is to emphasise and illustrate his words with title clips, stills of business information and video clips of material supplied by the company's Communications Department. For example, after his introduction, he moves on to speak about the business results of the last four quarters and a title clip displaying Q1 Q2 Q3 Q4 provides added visual emphasis to this. As shown in Figure 8.12, by using a 2D moving path, the title clip – which has been placed on Track V1 – appears

Figure 8.10 Sample frames from two of the animated title clips

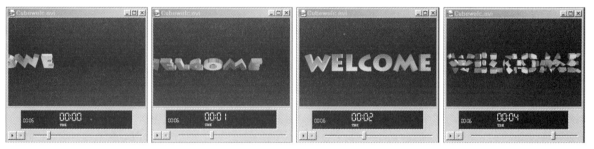

(a) An animated Welcome title spins in from the left, pauses and then breaks up and flies apart

(b) A title introducing quarterly business results scrolls into view from the top as letters take shape, until they can be read as Q1 Q2 Q3 Q4, before zooming towards the viewer and then out of shot

Figure 8.11 Placing the clips which start the CEO presentation

Figure 8.12 Using a 2D Moving Path to zoom the title clip to full screen

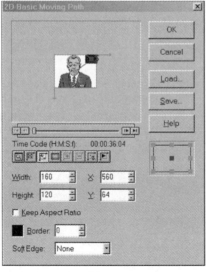

(a)

(b)

over the CEO's left shoulder and zooms out to fill the screen, before disappearing. The same 2D moving path will be used to display other titles and charts, as the CEO continues to speak.

In parallel with video-taping the CEO's presentation, work has been proceeding to create a set of supporting business stills. A number of charting applications can be used for this; Figure 8.13 shows an example – a three-dimensional bar chart – prepared in Lotus Freelance, summarising company sales in Europe and around the world during a five-year period. After preparing the chart in Freelance using the same frame size and aspect ratio as for the video clips, the chart was saved in TIF format so that it could be imported using Media Studio's import image button and placed at the appropriate position on the V1 track of the timeline. The same 2D moving path as that used for the title clips was then applied to the chart clip.

In addition to business charts, the CEO, in his presentation, refers to general business trends and important events reported in the Press related to the oil industry. Figure 8.14 shows two examples of charts to be used to illustrate points to be made about relative performance of different divisions of Caledonian around the world (a) and about press

Figure 8.13 A business chart prepared in Lotus Freelance

(a)

(b)

Figure 8.14 Still images used to support points in the CEO's presentation

coverage of the company's performance versus competition (b). Chart (a) was constructed in CorelDRAW using a clipart world map and an envelope special effect applied to the text, before saving in TIF format. Newspaper clippings or spreads, such as chart (b) can be scanned and saved as TIF files for use as image stills.

As construction of the project continues (Figure 8.15), further video clips, titles and still images are introduced, with video showing work proceeding on a new drilling platform and the use of a new design of submersible craft for underwater maintenance work on deep-sea drilling rigs and for underwater exploration work. A new title clip introduces the section of the presentation covering strategy and the first illustration in this section is a still of a series of satellite shots being used in the search for evidence of new oil deposits.

At regular intervals during construction work, each new section is previewed and adjustments are made to synchronise the start, duration and finish of clips with the CEO's words and to ensure that the visual aids will be easily readable by the audience.

As the project nears its end, still shots and video clips are added to mark significant employee achievements and communications events which have occurred during the course of the year. Visual consistency in the way in which these clips are presented is maintained throughout by using the same 2D moving path.

The end of the project mirrors its beginning. As the CEO finishes his monologue by encouraging all employees to greater efforts in the coming year, the camera zooms back out of the office to show briefly the headquarters building and then continues to zoom out to the aerial view of London, fading to the view of the Earth rotating and finally to a view of space, as accompanying music rises to an appropriate crescendo (Figure 8.16).

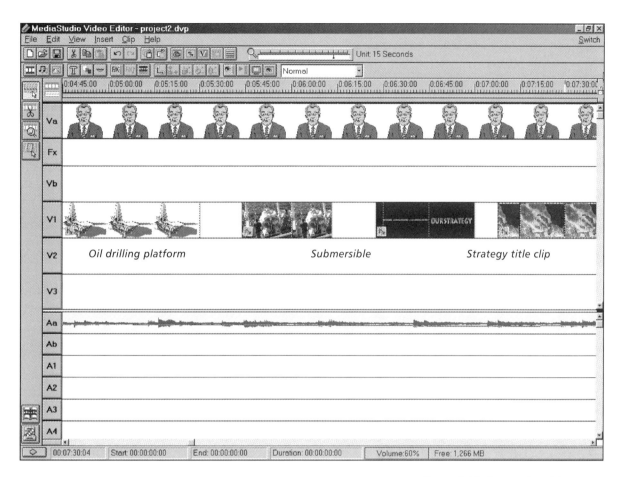

Figure 8.15 Construction of the project proceeds with the addition of further video, title and still image clips

Testing and saving the project

As the project has been previewed and obvious problems have been corrected during the course of construction, the purpose of the final preview is to fine tune the precise synchronisation of the many video, audio and still image clips which it now contains and to carry out a final check of legibility, particularly of text and business chart contents, and of audibility of the sound tracks. This is best done by setting up a test configuration in a conference room facility typical of those to be used around the company and running the videotape in front of a live volunteer audience. Before this can be done the project file must first be saved in the videoeditor's native format ready for compiling.

Compiling the project

The penultimate stage in completing the project is to compile it to create an AVI file. This is done by selecting the *File/Create Video* command. After compilation is complete, the file can be played back on screen or imported into other applications which support the AVI format.

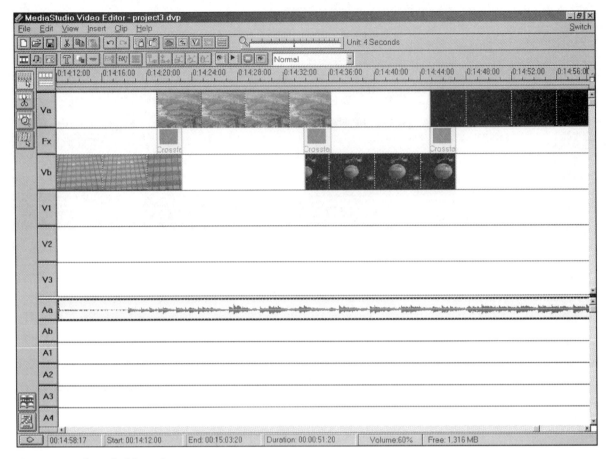

Figure 8.16 The end of the project mirrors its beginning

The quality of the finished video clip depends on a number of factors, such as the type of image compression used, the frame rate selected, and the speed of the computer system used to play back the clip.

To compile the finished project, we have to:

○ check to ensure that there is sufficient free disk space to store the new file

○ choose *Create Video File* from the *File* menu. The *Create Video File* dialog box appears (Figure 8.17a). Here a *Subject* name as well as a *Description* of the file contents can be entered, before clicking on the *Options* button

○ set the *Frame Rate* and *Frame Size* using the controls provided under the *General* tab (Figure 8.17b)

○ specify the compression settings – compression type, quality, key frames and data type – using the controls provided under the *Compression* tab (Figure 8.17c)

(a)

(b)

(c)

Figure 8.17 Specifying settings before creating a video file

A live preview appears in the *Preview* window and below it an information window displays data describing progress as the video compiles.

The *Key Frame* option is available if a codec which uses frame differencing has been selected. A key frame is the baseline frame against which other frames are compared for differences. The key frames are saved in their entirety, while intervening frames, called delta frames, are compressed based on their differences from the key frames. The *Key Frame* option specifies the rate at which the movie is sampled for key frames. Using this option allows for greater compression and increased playback speed, but can affect quality where the video depicts fast motion or rapidly changing scenes.

When creating a video file, settings can be saved by clicking on the *Save* button in the *Create Video* dialog box. Then each time a new file is created, clicking on the *Load* button recalls the saved settings.

Output

Now that we have created an AVI file of our Caledonian project, we can click on *Print to Video* in the *File* menu to open the dialog box in Figure 8.18a, where we can select the file in readiness for printing it to videotape. Before initiating the copying process, the *Options* button gives access to the two windows shown in Figure 8.18b and 8.18c. From within these windows, we can specify the frame size for the image to be printed to tape and the activation method to be used to initiate the copying process.

(a)

(b)

Figure 8.18 Specifying settings before printing to videotape

(c)

To cater for language considerations and different country video formats, several versions of the videotape will be created. Copies of the AVI file will also be written to CD ROM for use by employees at remote sites who will view the video on desktop PCs or Laptop machines. Before this is done, the first tape will be used, as explained earlier, to test the results on a live audience in a conference room environment. After making adjustments based on feedback from the audience, the project is re-saved and re-compiled and a small number of videotape copies are created for review by key executives, including the CEO. After making changes resulting from these previews, the final compilation is done and the final videotapes and CD ROMs are produced and distributed around the company in readiness for the agreed review date.

Summary

Fundamental to the production process is careful planning. Unless project objectives and responsibilities are clearly defined from the outset and the necessary resources are available, then time will be wasted and the quality of the project will suffer. A storyboard can provide a useful tool for crystallising ideas and sequences and highlighting and resolving inconsistencies before work commences.

The simple quality guidelines described earlier in the chapter, regarding, e.g. lighting and colour, need to be kept in mind when videotaping and then capturing video and audio clips, to ensure that the highest quality results are obtained. Before capture is initiated, option settings for colour depth, frame size and audio format should be selected which are consistent with the plans for the overall project. The setup should then be tested by capturing a few test frames before capturing a length sequences.

Compared with relatively mature applications like desktop publishing or image editing, desktop video applications are still at an early stage of development. This is reflected in different approaches used by developers of the applications studied in this chapter to the design of toolsets, menu functions and the means of applying filters, etc. In future application releases we can expect to see progressive improvements in ease of use. Tighter integration with image editing, animation and charting applications will also simplify the task of integrating elements produced in these applications into the mainstream project.

Output 9

Output methods

Output to videotape – the example used in the last chapter – is just one of several methods available to bring digital video to an audience. Once the video is in one of the standard video formats, copies can be distributed by a variety of methods:

○ Embedding AVI or MOV files in documents created in wordprocessing applications such as Microsoft Word

○ Copying the video file to a Zip disk (Figure 9.1) or Jaz disk and sending it by mail

○ Writing the file to a master CD and sending copies by mail

○ Sending the video over the Internet for viewing onscreen by any user with an Internet account

○ Projecting the video on to a screen using one of the latest LCD projectors

○ Printing to VHS / VHSC / Hi8 tape

Figure 9.1 Small video files can be transported on Zip disks. For larger files, 2 Gb Jaz disks can be used

Embedding files

Video files in AVI or MOV format and audio midi and wave files can be inserted into a document produced on a wordprocessor like Microsoft Word using the *Object* command in the *Insert* menu. This opens the dialog box shown in Figure 9.2a. Selecting *Media Clip* from the *Object* dialog box displays the list of options shown in Figure 9.2b, from which the type of clip to be inserted can be selected. Figure 9.3 shows a Word document with three objects embedded – an AVI video clip, a midi clip and a wave clip. When the recipient of the document clicks on the AVI clip, the video plays in a window which can be resized by dragging on the corner with the mouse. If the system has a sound card, then clicking on either the midi or wave clip plays the embedded sound track.

Using removable media

Removable media such as Zip disks or Jaz disks from iomega provide a convenient way of copying and distributing multimedia files. Their respective capacities of 100 or 250 Mb and 1 or 2 Gb can effectively be doubled using a compression utility such as Microsoft's *DriveSpace*.

Writing to a CD

Equipment for mastering CDs is becoming increasingly affordable and the 650 Mb capacity of a CD combined with its light weight makes it an attractive vehicle for copying and mailing files. With a worldwide installed base of 200 million CD ROM drives (and growing), there must be someone out there who is just itching to receive your latest video masterpiece. Hewlett Packard's 8100i CD-Writer Plus (Figure 9.4) for example offers write at 4x speed, rewrite at 2x speed and read at up to 24x speed.

(a)

(b)

Figure 9.2 Selecting objects for insertion into a Microsoft Word document

Figure 9.3 Three objects – an AVI clip,
a midi clip and a wave clip –
embedded in a Word document

Writing a 650 MB CD takes about 18 minutes, but this technology is moving so fast that, by the time this book is published, that time will probably have come down even further.

Writers are also becoming available for copying video and audio files to DVD ROM disks which offer significantly increased storage capacity compared with CD ROM.

Distribution via the Internet

While sending video files via the Internet is possible, this option is really only practical for very short clips because of the transmission time and therefore cost involved in sending large files. However, as we saw in Chapter 3, the transmission of full motion video at CIF resolution – 352 x 288, approximately one quarter VGA – at 15 frames per second plus is already feasible and we can expect this capability to be extended in the near future.

Video is appearing increasingly on Web pages in the form of animated text and graphics. Using an application like Painter or PHOTO-PAINT, animated GIFs are easy to create and include in Web pages. They are given the same HTML tag as any GIF image, the only difference being that the browser displays the file as an animation. Playback performance can be optimised by limiting the frame size and the number of frames and restricting the number of colours (ideally to the colour set used by the most common browsers like Netscape). The resolution of an animation should not exceed 96 dpi, as this is the maximum resolution a colour monitor can display. Choosing a greater dpi value reduces playback performance. The client browser must support GIF animations for the images to display properly. The latest versions of Netscape and Internet Explorer support GIF animation.

Projection

For users preparing video or multimedia presentations for use in a marketing or educational environment, an attractive and portable solution is one of the latest LCD projectors. Such projectors can take the video output from a Windows PC or a Mac and project it on to a screen of up to 300" diagonal. Figure 9.5 shows two examples. The Sony VPL–V500Q (Figure 9.5a) offers 640 x 480 resolution and 16.7 million colours, wireless remote mouse control and a built-in stereo sound system. It can be ceiling mounted for front or rear projection.

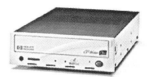

Figure 9.4 Hewlett Packard's 8100i CD-Writer Plus

TECHNICAL TERM

Graphics Interchange Format – *Originally developed by Compuserve, GIF is a graphic file format designed to take up a minimum of disk space. It is commonly used for exchanging images on the Internet with 256 colours or less.*

Figure 9.5 LCD projectors from Sony (a) Model VPL-V500Q and Epson (b) Model 7000XB

(a)

(b)

The Epson PowerLite 7000XB (Figure 9.5b) claims a true 1024 x 768 resolution and a bright projected image with a light source rated at 650 ANSI lumens. Like the Sony projector, it can accept input from either a Windows PC or a Mac and in fact has dual computer inputs, allowing attachment to two computers at once; a wireless mouse is used to select which computer output should be projected. A 'Spatializer' stereo sound system provides rich, three-dimensional sound.

Although presently expensive at around £4000 in the UK, the prices of such projectors will undoubtedly fall as sales volumes increase.

Printing to videotape

Finally, because of the ready availability of VCRs and television monitors, printing to VHS / VHSC / Hi8 tape offers an output format which is readily accessible to a wide audience.

Pros and cons of the different methods

The output method chosen will depend both on the nature of the material to be shown and on the anticipated audience. For example the embedding method is normally used only for short video 'footnotes' within a document and, of course, to view the file and embedded video, the recipient has to have the appropriate word processing application installed. For complex files resulting from projects such as the one described in Chapter 8, videotape remains the popular option, because of its low cost, large storage capacity and the fact that VCR players are so widely available

In some cases a combination of the different methods described may offer the best solution, such as the use of both video tape and CD ROM in Chapter 8.

In the longer term, as DVD technology evolves, we can expect to see a progressive move to this non-linear medium, which, with appropriate compression software and/or hardware, can already store a full length feature film on a single disk.

Summary

As we have seen in earlier chapters, by its very nature the saving and storage of video requires a high capacity storage medium. Fortunately, storage within a PC has become feasible due to the advent of low cost, high capacity hard disk drives, but this does not solve the problem of portability.

By virtue of the fact that the VCR, like the television set before it, is finding its way into millions of homes and businesses around the world, the VHS videotape cassette has become the *de facto* medium for transporting and viewing video. While scoring top marks for ease of 'playability', however, the video cassette suffers a number of disadvantages; recording to analogue tape results in some loss of quality; a VHS cassette is a relatively heavy and bulky object to mail and, of course, the contents can only be viewed in a linear fashion.

Removable media like zip disks or recordable CD ROMs offer an alternative to videotape for relatively short clips, but much more promising is the Digital Versatile Disk, which, as the technology develops, will provide low-cost, light-weight, non-linear storage running into tens of gigabytes. Mailing cost will be low and the contents of the disk can be viewed by the recipient in a non-linear fashion.

The ultimate way to transmit video – via the Internet – is presently impractical because of the file sizes, but streaming of video over the Net (viewing video on demand, rather than downloading the video file by means of a software video player) is already a reality. As bandwidth and compression technology improve, this could be the way of the future for many video projects.

SUMMARY

As we have seen from the examples included in this book, the age of video editing on the desktop has truly arrived, making possible the integration of a wide range of exciting video and audio effects with the aid of quite moderately priced hardware and software. Remarkably, this new capability includes the capture and conversion of analogue video for storage and editing on the hard drive and merging with new digital video sequences created on the desktop, before conversion and output of the hybrid results back to analogue tape.

Already it is possible to apply to individual video frames, or to whole video clips, many of the sophisticated image editing effects now available in leading edge drawing, painting and photoediting applications. Fast developing animation techniques on the desktop are also making it possible to integrate sophisticated animation into video productions, using complex reflection, texturing and transparency techniques and environmental variables like mist and fog. Simulated studio lighting and camera effects can further enhance the realism of scenes.

Television pictures are recorded – and are now being transmitted – in digital rather than analogue form. For television broadcasting, this will mean elimination of interference, while for video recording, it will mean virtually perfect reproduction

Digital video cameras are becoming available which allow direct down-loading to the desktop, avoiding the complexity of analogue to digital conversion. After editing, the digital footage can be uploaded to a fresh tape in the camera's digital VCR, once again avoiding digital to analogue conversion.

With the rapid progress towards digital film and television, movie and TV images will soon be as much at home displayed on the family PC screen as on the cinema screen or TV set and DVD technology will dramatically extend the range of digital material available as well as the capacity to store, update and distribute new material. In this new digital world, truly interactive multimedia will realise its full potential and virtual reality will become, well, a reality!

Just as the boundaries between digital vector drawing, photoediting and painting applications have becoming increasingly blurred in recent years, as many of their features have converged, we are now seeing this convergence extending to videoediting applications; already, many of the image adjustment tools, filters, and text generators familiar to the still-image graphic designer, can be found in video editing applications.

It is the arrival of the PC which has empowered the individual to enter the arena of editing the moving image. Video on the desktop has arrived, but is still only in its infancy. As the cost/performance of desktop hardware continues its relentless progress, and as the video editing process becomes digital from input to output, the next decade is set to see a DTV revolution which will rival the DTP revolution of the last decade.

BIBLIOGRAPHY

Anderson, G.H. *Video Editing and Post Production,* Oxford: Focal Press, **1998**.

Benford, T. *Introducing Desktop Video,* IDG Books, **1995**.

Bunzel, T. *Digital Video on the PC – Video Production on Your Multimedia PC,* Micro Publishing, **1997**.

Cross, T.B. *Understanding Desktop Video – Being There, Without Going There,* VHS Tape: Cross Market Management Company, **1996**.

Feerer, M. *Premiere 5 With a Passion – The Essentials Guide to Video Editing, Effects and Production with Adobe Premiere 5,* Peachpit Press, **1998**.

Grebler, R. *Desktop Digital Video,* Prompt Publications, **1997**.

Hart, J. *Storyboarding for Film, TV, and Animation,* Oxford: Focal Press, **1998**.

Jennings, R. *Special Edition Using Windows Desktop Video,* QUE Education and Training, **1997**.

Johnson, N. *Web Developer's Guide to Multimedia and Video – Your Complete Guide to Creating Live Video for the Internet,* The Coriolis Group, **1996**.

Kindem, G. and Musburger R.B. *Introduction to Media Production – From Analog to Digital,* Oxford: Focal Press, **1997**.

Luther, A.C. *Using Digital Video,* AP Professional, **1995**.

Mattison, P.E. *Practical Digital Video with Programming in C,* John Wiley & Sons, **1994**.

Ohanian, T.A. and Phillips M.E. *Digital Filmmaking – The Changing Art and Craft of Making Motion Pictures,* Oxford: Focal Press, **1996**.

Ozer, J. *Publishing Digital Video,* AP Professional, **1997**.

Pender, K. *Digital Colour in Graphic Design,* Oxford: Focal Press, **1998.**

Pender, K. *Digital Graphic Design,* Oxford: Focal Press, **1996.**

Poynton, C.A. *A Technical Introduction to Digital Video,* John Wiley & Sons, **1996**.

Slaughter, S. *Easy Digital Video – The Beginner's Guide to Everything Digital,* Abacus Software, **1998**.

Soderberg, A. and Hudson T. *Desktop Video Studio,* Random House, **1995**.

Summers, H. *Operating a Desktop Video Service on Your Home-Based PC,* McGraw Hill, **1994**.

Watkinson, J. *An Introduction to Digital Video,* Oxford: Focal Press, **1994**.

Watkinson, J. *MPEG 2,* Oxford: Focal Press, **1999**.

Wodaski, R. *PC Video Madness,* Carmel, IN: SAMS Publishing, **1993.**

GLOSSARY

ALIASING An inaccurate display of an image due to the limitations of the output device. Typically, aliasing appears in the form of jagged edges along curves and angled shapes

ALPHA CHANNEL An 8-bit data channel used for applying filters or special effects

ANALOGUE VIDEO The non-digital video signal generated by conventional VCRs and camcorders

ANTI-ALIASING A method of smoothing out jagged edges in bitmap images. This is usually accomplished by shading the edges with similarly coloured pixels to the background, thus making the transition less apparent. Another method of anti-aliasing involves using higher resolution output devices

ASPECT RATIO The ratio of width to height in an image or graphic. Keeping the aspect ratio means any change to one value is immediately reflected in the other

AUDIO RESOLUTION Quality of digitised audio, measured in bits

AUDIO SAMPLING RATE The audio equivalent of frame rate when digitising from an analogue source, measuring the number of frequencies into which a sound is broken. Measured in kilohertz (kHz)

AVERAGING Filtering process which takes the grey/colour value of each pixel and averages it with the values of surrounding pixels. The value of each pixel is then replaced with the averaged value

AVI Abbreviation for Audio Video Inter-leaved – standard format for digital video

BACKGROUND MATTE A full-frame matte of solid colour which can be used as a clip, for example when superimposing a title over a solid colour background

BITMAP An image format made up of a collection of dots or pixels arranged in rows

CHANNEL Classifications of information in a data file to isolate a particular aspect of the entire file. For example, colour images use different channels to classify the colour components in the image. Stereo audio files use channels to identify the sounds intended for the left and right speakers. Video files use combinations of the channels used for image and audio files

CLIPBOARD Temporary storage area shared by all Windows programs used to hold data during cut, copy, and paste operations. Any new data you place onto the clipboard immediately replaces the existing data.

CLONING Replicating one part of an image within or between different images

CODEC Short for compressor/decompressor. A codec is a mathematical algorithm which specifies the type of compression used during video capture

COLOUR DEPTH Number of bits delivering the colour information for each pixel. 1-bit colour depth means $2^1=2$ colours, 8-bit colour depth means $2^8=256$ colours, 24-bit colour depth means $2^{24}=16,777,216$ colours

COLOUR MODEL A mathematical way to describe and define colours and the way they relate to each other. Each colour model has a specific purpose; the two most common colour models are RGB and HSB

COLOUR PALETTE Number of colours the graphics system can generate

COMPLEMENTARY COLOUR Complementary colours are opposite in value to primary colours. If a colour is combined with its complement, the result would be white. For example, the complementary colours of red, green, and blue are cyan, magenta, and yellow respectively

COMPOSITE The standard analogue video format used by most domestic video equipment

COMPRESSION A method for making files smaller in size on disk. There are two categories of compression: lossless and lossy. Files compressed with a lossless scheme can be restored to their original state with no change to their original data. Lossy schemes discard data during compression and so provide less accurate reproduction

CONTROL LINE A line that joins two control points to establish a fixed path to follow during an animation

CONTROL POINTS Points placed upon an image or effect which identify starting, ending, or intermediate locations for objects during animation

DATA RATE Data per second, i.e. amount of data which a mass storage medium (hard disk or CD-ROM) saves/plays back per second or the amount of data processed during a video sequence per second

DATA TRANSFER RATE The measurement of the speed at which information passes between storage media (e.g. CD ROM or Hard Disk), and

the display device (e.g. Monitor or MCI device). Depending on the devices used, some transfer rates may offer better performance than others

DATA TYPE The way an image is internally described and represented by a computer. The data type of an image controls the amount of information that the image can retain and therefore its displayed appearance. Data types include: Black & White, Greyscale, Indexed 16- and 256- Colour, RGB True Colour and CMYK True Colour

DCT Abbreviation for Discrete Cosine Transformation. Part of the LLI JPEG image data compression: The brightness and colour information is saved as a frequency coefficient

DIGITAL VIDEO Digital video stores information bit by bit in a file (in contrast to analogue storage media)

DITHERING Method by which images with a limited colour palette appear to contain more colour. Most notably, Black & White images appear to contain near-continuous changes in tone (grey shades). By arranging pixels of different colours close together, dithering can simulate colours not directly supported by an image data type. The various dithering techniques differ in the way they calculate and arrange pixel values

DOTS PER INCH (DPI) A unit of measure for screen and printer resolution that represents the number of dots a line can print or display per inch. Also called pixels per inch (ppi)

DROP-FRAME TIMECODE Addresses the discrepancy between the SMPTE version of NTSC that assumes 30 fps frame rate and the actual broadcast NTSC standard of 29.97 fps by dropping two frame counts every minute for 9 out of every 10 minutes

DVD Digital Versatile Disc. A new storage medium for digital video, audio and computer data with a capacity of up to 4 Gb per disk

EDIT DECISION LIST (EDL) An Edit Decision List is a listing of all clips, effects, and transitions in a video project. This document identifies each clip's location, the mark in and mark out times, and how it relates to other clips in the project. Its primary use is as a reference when using conventional video editing equipment for the final project

FADING Making a superimposed clip more or less transparent; in audio, varying the intensity of the sound

FIELD All the even or all the odd lines in a video frame

FILTER A program which processes the information in a file to create audio or video effects

FPS Frames per second. Moving video images consist of a series of still

images, or frames, projected on to the screen in succession. To the eye, objects begin to merge at 4 fps and movement becomes smooth at 24 fps

FRAME A single image in a video or animation sequence

FRAME SIZE The maximum size for displaying image data in a video or animation sequence. If an image intended for the sequence is larger than the frame size, it must be cropped or resampled to fit

FULL-MOTION 25 fps for PAL video or 30 fps for NTSC.

FULL-SCREEN An image size of 768 by 576 pixels for PAL video and 640 by 480 for NTSC, excluding blank lines and sync signals

GRAPHICS FILE A file in which the data is composed largely of vector graphics. Vector graphics do not have a basic component, like a pixel, but are defined as lines between points, and fills between lines

HARDWARE CODEC Compression method which creates compressed di-gital video sequences. These video sequences need special additional hardware to be recorded/played back and offer a better image quality than data compressed with software CODECs

IMAGE COMPRESSION Method to reduce the size of digital image and video files

IN POINT The position of a clip's starting frame

INSET A video clip reproduced at a small size that plays on top of an-other clip playing in the background

INTERLACED The even lines and odd lines of a TV screen are scanned by the electron beam inside the tube alternately in rapid succession, hence the term 'interlaced'

INTERLEAVE An arrangement of audio and video to promote smoother playback and synchronization or compression. The standard AVI format equally spaces audio and video

JPEG Abbreviation for Joint Photographic Experts Group. Standard for image compression

KEY COLOUR A colour made transparent so that a background image can show through. Most commonly used when overlaying one video sequence on top of another, allowing the underlying video to display wherever the key colour appears

KEY FRAME RATE A method to help in the compression of video files, which works by assigning certain frames as key frames whose video data is completely saved at the time of compression. The video data of any

intervening frames between two key frames is then only partially saved. On de-compression these partial frames reconstruct their data from the key frames

LINK Creates a connection between two clips on the same or different tracks. When one clip is moved, the other clip moves to maintain its relative position

MARK Inserted in the timeline and used to align clips with certain points in time

MARK IN / MARK OUT In video editing, the mark in and mark out times refer to the starting and ending time codes that identify the portions of clips to be included in the project

MASK A mask isolates a portion or portions of an image for editing. By using a mask, parts of an image can be protected from unwanted changes. A special kind of mask allows the use of greyscale values to control how much protection is applied to an area

MATTE A matte is an image or video that isolates regions for other images or clips to appear through

MCI Developed by Microsoft as a means to play audio and video data. It is also used to connect a computer to an external video source such as a VCR or laser disc

MIDI Industry standard interface that allows communication between musical synthesizers, musical instruments and computers

M-JPEG Motion-JPEG is a high quality lossy compression format defined by the Joint Photographic Engineering Group for video.

MPEG A lossy compression format defined by the Motion Picture Engineering Group

NON-INTERLACED Image refresh method, in which the complete image is generated without skipping lines. A non-interlaced image flickers much less than an interlaced image

NTSC The video standard established by the National Television Standards Committee and adopted in America and Japan. An NTSC signal has a frame rate of 29.97 fps, each frame containing 480 horizontal lines by 640 pixels

OUT POINT The position of a clip's finishing frame

PAL Phase Alternating Line, the most common video standard used in Europe. A PAL signal has a frame rate of 25 fps, each frame containing 576 horizontal lines by 768 pixels

PAN To swing a camera to produce a panoramic effect or to direct the viewer's attention between subjects

PIXEL Abbreviation for *picture element*. Pixels are the smallest elements of a monitor image

PROXY FILE A Proxy file is a low resolution copy of an image or video file which requires fewer system resources to work with, making the creation and editing of video projects faster

QUICK TIME A video program originally developed for the Mac, used to create video clips in MOV format

RESOLUTION The number of pixels which can be displayed on a monitor horizontally and vertically. The higher the resolution, the more details can be displayed

ROTOSCOPING The technique of drawing on or painting individual frames of a clip

SECAM Sequentiel Couleur a Memoire is the video standard used almost exclusively in France

SMPTE TIMECODE Measurement of video duration as established by the Society of Motion Picture and Television Engineers. Each frame is identified in the form hours: minutes: seconds: frames

SOFTWARE CODEC Compression method to compress digital video sequences which can be played back without special hardware. The quality of these sequences depends on the performance of the complete system

SPLIT SCREEN An effect which divides the screen so that two clips can be played side by side

STILL-VIDEO Method where cameras digitally store photographs on floppy disks or in the computer memory

SUPERIMPOSE To place a transparent or partially transparent image or text on top of a video clip

S-VHS Improved standard for home VCRs using S-Video signals to improve the colour reproduction

S-VIDEO A high quality analogue video format used by professional and some domestic video equipment

TIME CODE The time code identifies the position of a frame in a video sequence with respect to a starting point (usually, the beginning of the clip). Its usual form is hours: minutes: seconds: frame. In a video project, there may be several different time codes. One time code refers to the overall project, while the others refer to each clip in the project

TRACKS The horizontal bars within the timeline window where clips are dragged and positioned. There are four types of track – video, audio, transition and superimpose

TRANSFORMATION Commands which allow for spatial effects like flip, rotate, and distort

TRANSITION An intermediate visual effect which binds two clips together

TRAVELLING MATTE A moving mask through which a clip plays

TRIMMING Adding or subtracting frames to change a clip's duration

TRUE COLOUR An image that contains enough colour to appear true to life. For an image, this normally means 24-bit colour, providing up to 16.7 million colours

VHS Abbreviation for Video Home System. System commonly used for home VCRs to record and play back images and sound using a $1/2''$ tape. VH systems use composite signals consisting of brightness and colour information

VIDEO CAPTURE The process of converting an analogue video signal into digital data that can be stored on a hard disk

VIDEO DECODER Converts analogue signals into digital information. A video encoder converts digital information into analogue signals

VIDEO FOR WINDOWS A Microsoft Windows system extension which records, stores and to plays back video sequences from hard disk

VIDEO SCAN RATE Frequency with which the video signal is scanned. The higher the video scan rate the higher the image quality and the less the flicker

WARPING A method of distortion based on a grid pattern. By moving the control points that appear at each grid intersection, you can control the distortion of the image

WEBCAM A small digital camera designed specifically for the purpose of video conferencing on the Internet

Y/C A signal consisting of two components: Y = Brightness information, C = Colour information

YUV Colour model in which Y delivers the brightness information and U and V the colour information

Index